FUNNY LADIES

"*Funny Ladies* is a unique insider's guided tour of one of the most hidden and opaque and loved of the arts—the *New Yorker* cartoon. Liza Donnelly gives us a truly comprehensive appreciation of the cartoon form, along with its history and its creators—with special emphasis on the women who have made us laugh (including the author herself). You can't ask for more—laughter and illumination within two covers."

—Edward Koren, *New Yorker* cartoonist

"This is my kind of broad humor."

—Signe Wilkinson, editorial cartoonist, *Philadelphia Daily News*

"For any fan of *New Yorker* cartoons, *Funny Ladies* is indispensable."

—Andy Borowitz, *New Yorker* humorist

"It's high time such a book was put together, and I can't imagine it being done better!"

—Gahan Wilson, *New Yorker* cartoonist

"Liza Donnelly is not just a pretty face. *Funny Ladies* is a hoot."

—Frank Modell, *New Yorker* cartoonist

FUNNY LADIES

THE NEW YORKER'S
GREATEST WOMEN CARTOONISTS
AND THEIR CARTOONS

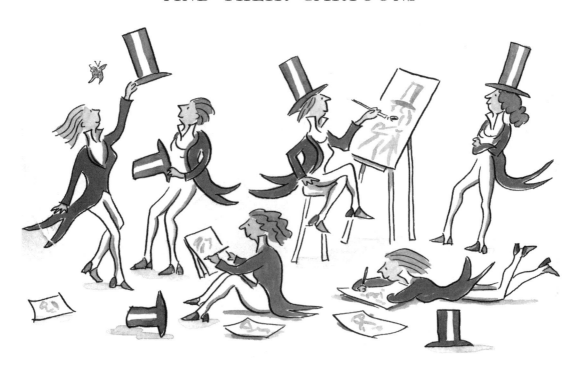

LIZA DONNELLY

FOREWORD BY JULES FEIFFER ◆ PREFACE BY LEE LORENZ

Prometheus Books

59 John Glenn Drive
Amherst, New York 14228-2197

Of the 143 drawings in this book, 82 originally appeared in *The New Yorker* and were copyrighted in the years 1925–2004. Inclusive by the New Yorker Magazine, Inc. Grateful acknowledgment is made to *The New Yorker* for permission to reprint.

Internal memos and correspondence from *The New Yorker* courtesy of The New Yorker/Conde Nast/www.newyorker.com.

Quotations from letters by Alice Harvey courtesy of Janet Aley; quotations from letters and an unpublished memoir of James Geraghty courtesy of Sarah Herndon.

Quotations from memos and letters of Katharine White by permission of the E. B. White and K. S. White Estates.

Quotations from letters of Mary Petty and Alan Dunn with permission from the Alan Dunn and Mary Petty Papers, Special Collections Research Center, Syracuse University Library.

Quotations from items held in the New Yorker Records and quotations from James M. Geraghty's unpublished memoir about his years at *The New Yorker* are reprinted with permission from

New Yorker Records
Manuscripts and Archives Division
The New York Public Library
Astor, Lenox, and Tilden Foundations

James M. Geraghty Papers
Manuscripts and Archives Division
The New York Public Library
Astor, Lenox, and Tilden Foundations

Published 2005 by Prometheus Books

Inquiries should be addressed to
Prometheus Books
59 John Glenn Drive
Amherst, New York 14228–2197
VOICE: 716–691–0133, ext. 207
FAX: 716–564–2711
WWW.PROMETHEUSBOOKS.COM

09 08 07 06 05 5 4 3 2 1

Library of Congress Cataloging-in-Publication Data

Donnelly, Liza.
 Funny ladies : the New Yorker's greatest women cartoonists and their cartoons /
by Liza Donnelly.
 p. cm.
 Includes bibliographical references and index.
 ISBN 1–59102–344–0 (hardcover : alk. paper)
 1. Women cartoonists—United States. 2. Caricatures and cartoons—United States—
History—20th century. 3. New Yorker (New York, N.Y. : 1925) 4. Title.

NC1428.N47D66 2005
741.5'973'082—dc22

 2005017190

Printed in the United States of America on acid-free paper

FOR MICHAEL, ELLA, AND GRETCHEN

CONTENTS

ACKNOWLEDGMENTS

dreamed recently that a woman cartoonist from the 1930s wrote me about her time at *The New Yorker*. I panicked—how had I missed her? In the dream, she had a foreign name that did not indicate her sex, so I felt vindicated and made plans to put her in my book. In reality, I tried hard to find every woman whose cartoons appeared in the magazine. In *The New Yorker*'s early years, many artists used initials for their first names, and thus it would have been next to impossible to find out whether they were men or women. I sincerely apologize if I failed to include someone in this book who should have been included. Sadly, I could not uncover much information about Mary Gibson, Dorothy McKay, or Roberta MacDonald.

A word concerning my criteria for cartoons. If the artist was a single-panel cartoonist of the traditional captioned variety, or if her work appeared with regularity, I included her in this book. During the 1980s, what was considered a cartoon became broader (no pun intended) and very different from what was thought of as a *New Yorker* cartoon. Cartoon editor Lee Lorenz had the vision to widen his definition of humor, and I believe this was significant in bringing more women into cartooning.

I wish I had begun this book ten years ago. So many of the cartoonists and editors of an earlier generation who knew the artists from the twenties and thirties have only recently passed away: William Shawn, Philip Hamburger, William Maxwell, Brendan Gill, Mischa Richter, Syd Hoff, William Steig, Andy Logan, and James Geraghty.

I interviewed many people, and I wish to thank them for their time and thoughts. Roger Angell graciously talked with me about his mother, Katharine White, and about Helen Hokinson and Mary Petty;

Alice Harvey's daughter, Janet Aley; Katharine White's daughter-in-law, Allene White; James Geraghty's daughter, Sarah Herndon; Nancy Fay's son, Stephen Fay, and her niece Nancy Harris; Rea Irvin's granddaughter, Molly Rea; and Alan Dunn and Mary Petty's niece, Pamela Dunn Ellis. Thank you to Frank Modell, who shared many of his reminiscences of the art department when he was assistant to editor James Geraghty. Harriet Waldon, secretary to Harold Ross, was very helpful in her letters. I am very grateful to Eldon Dedini, who wrote me his fond memories of Barbara Shermund. Eldon also spent countless hours photocopying letters for me that he and Barbara exchanged over the years.

Many thanks to Shirley Pierson at the Mendota Museum and Historical Society for endlessly answering my questions and sending me valuable information about Helen Hokinson. Swann Foundation's Martha Kennedy; the friends of Nora Benjamin; Rose O'Connor; John Michaud, Laurel Maury, and Erin Overby at the *New Yorker* library; Wayne Furman and the folks at the New York Public Library Special Collections; and Andy Pillsbury, Sumner Jaretzki, and Cory Whittier at the Cartoon Bank were all very helpful. Marshall Hopkins was a sport for being my liaison with many of the cartoonists. Julie Lillis and Cynthia DelConte for their photography. Anne Newburg for her writer's eye. Harry Bliss for his preliminary research on Mary Petty. And Nicolette A. Schneider of Syracuse University. Without Anne Hall, I would not have many of the beautiful photographs in this book, and I thank her for allowing me to use them.

I sincerely thank David Remnick and Bob Mankoff for supporting me over the course of this project.

I want to thank all the women cartoonists whom I interviewed and who donated their drawings for use in this book: Doris Matthews, Roz Chast, Huguette Martel, Nurit Karlin, Victoria Roberts, Barbara Smaller, Marisa Marchetto, Carolita Johnson, Emily Richards, M. K. Brown, Benita Epstein, Donna Barstow, Kim Warp, and Ann McCarthy. This has been one of the great pleasures of this project—getting to know them and their work. It has cemented some good friendships and hopefully started some new ones. Most of all, I thank them for their insights for this book.

Many thanks to Lee Lorenz and William Shawn for encouraging me and my cartoons. I greatly appreciate Lee's skill and creative insight as cartoon editor of *The New Yorker* for over twenty years. Lee brought many of the women I profile in this book into the magazine. I extend extra warm thanks to Lee for writing the preface to this book.

Jules Feiffer has been a cartoonist who I have looked to for inspiration for my entire

career, and I thank him enormously for writing the foreword.

Many sincere thanks to my editor, Linda Regan, for all her tremendous help and support. I am very grateful to book designer Bruce Carle and art director Jacqueline Cooke for their artistic eyes and sensitivity to my vision. Thanks to the amazing Chris Kramer, production manager, for her attention to detail. The entire Prometheus staff was a pleasure to work with. And I extend warm thanks to my agent, Denise Marcil, who has been by my side for over twenty years, championing me with generous exclamation points.

I would like to thank the women writers before me who explored the issue of humor and gender. Notably, Nancy Walker, Zita Dresner, Regina Barecca, Judith Yaross Lee, and Trina Robbins.

My daughters, Ella and Gretchen, were so patient through all of this, and I thank them enormously. In many ways, I did this book for them, even if they don't become cartoonists. And I thank my father, Orville Donnelly. Together with my mother, Elizabeth, they made me feel I could do anything.

And most of all, I thank my husband. Michael is my rock, my editor, my confidant, my wife, my sounding board, my research assistant. He cheers me on, prods me, questions my theories, applauds my efforts. We met over twenty years ago because of *The New Yorker*. The love we share for our art form and for *The New Yorker* is almost magical. ◆

FOREWORD

Jules Feiffer

Until this book, I never heard of Alice Harvey. Or Barbara Shermund. Mary Petty and Peggy Bacon, yes. Helen Hokinson, of course, and everyone who reads *The New Yorker* knows who Roz Chast is.

But selective memory seems to have left us with the impression that Hokinson and Chast are the Dynamic Duo of women cartoonists, and no one else counts nearly as much.

Wrong. And Liza Donnelly, in this revealing and eloquent discourse, proves that the conventional wisdom, as so often happens, is misinformed.

There may be an excuse for the rest of you, but this is my field, and I've been reading—and boning up on—*New Yorker* cartoons since I was a boy, and that goes back to FDR.

And I thought I was on familiar terms with all the good ones, from Arno to Ziegler. But then, how did I overlook Alice Harvey (". . . and what was that woman's name? You know, the one we liked her husband so much?")? Or Barbara Shermund ("If I were you, I'd *make* him respect my mind.")? Or Dorothy McKay? Or Doris Matthews? Or Victoria Roberts? Or Roz Zanengo? Or M. K. Brown?

Or Benita Epstein? Or Carolita Johnson? Or Barbara Smaller, whose caption to a cartoon may sum up the case perfectly: "Sex brought us together, but gender drove us apart."

Can it be that humor brings us together but funny ladies drive us apart? If Charles Addams was Charlotte Addams, would we still know her name?

If William Steig was Willa Steig, might she be a touch too edgy to have lasted?

And does anyone out there remember that mistress of dry, ironic, feminine wit, Sally (formerly Saul) Steinberg?

Or Jane Thurber's "The War between Men and Women"? Don't those nudging Thurber asides executed in that sly, undressed style make you a little uneasy with her subject matter? *What do these women cartoonists want?*

Only attention. Liza Donnelly, one of the best of today's *New Yorker* contributors, takes us to the heart of the matter. A lot of smart laughs to be found deep in the heart. ◆

THE OTHER SIDE OF THE DESK
PREFACE
LEE LORENZ

Liza's narrative well describes the field as experienced by the cartoonist, but how does it look from the editor's side of the desk? I hope my attempt to answer that question, based on my years as cartoon editor of *The New Yorker* (1973–1977), will be useful to artists in the field and reassuring to those considering entering it.

The cartoon editor's first responsibility is, of course, to supply the magazine with cartoons—hopefully funny ones. These come from two sources—the cartoonists under contract, about twenty-five in my time, and the unsolicited submissions, often two thousand a week, from the great army of hopefuls. When I succeeded James Geraghty as art editor, I inherited some of the best artists who ever worked for the magazine, including Charles Addams, George Price, Whitney Darrow, Saul Steinberg,

Mischa Richter, and Charles Saxon. In addition, there were the bright new stars of my generation—Donald Reilly, Warren Miller, James Stevenson, and Bud Handelsman. The regulars submitted weekly batches of fifteen to twenty ideas (James Stevenson routinely provided thirty or more).

Choosing from these, as well as from the unsolicited roughs, a pile small enough to bring to the weekly art meeting was the most difficult part of my job. Obviously the rejection rate was high. Although the final decision was made by the editor—first William Shawn, then Bob Gottlieb, then Tina Brown—it was my responsibility to announce the results to the artists.

It would be fatuous to say that it was as painful to deliver the bad news as it was to receive it, but this was certainly the least pleasant part of my week. Most cartoonists accepted the results philosophically. Bud Handelsman, on the other hand, always left

15

my office looking as if I'd shot his dog, and Ed Fisher once suggested to William Shawn that the cartoonists be allowed to edit their own work.

Even if they were greatly outnumbered by rejections, there were, thank god, plenty of okays. Working with the artists on their finishes was always a pleasure. The basic considerations were simple: where are we and who's talking? My suggestions usually involved nothing more than strengthening the characterizations or changing the venue (do two guys talking always have to be sitting in a bar?). Major surgery was rarely required, but these stories of redoing drawings again and again are not entirely unfounded.

To a cartoonist, a well-wrought caption is a thing of joy, and captions always received special attention—my predecessor James Geraghty maintained that the best captions had a distinctive "rhythm," and he had a marvelous gift for teasing these out. This was always my goal as well. It's important to add that any change to either caption or drawing was done with the consent of the artist.

The most challenging, and satisfying, part of my job was bringing new artists to the magazine. In the early days, artists like Peter Arno and Helen Hokinson literally walked in off the streets. I was never that fortunate, but I did have great success sifting through the "slush pile," that forbidding mountain of unsolicited material that arrived in my office each week. If the numbers (two thousand) cited above seem discouraging, it should be noted that every new artist I brought in to the magazine (over two dozen) was discovered this way. The list begins with Jack Ziegler and Roz Chast and continues through Victoria Roberts, Danny Shanahan, Robert Mankoff, Bruce Eric Kaplan, and, yes, Liza Donnelly. This search for fresh talent continues today under Robert Mankoff.

Although I retired in 1997, I recently received yet another batch of unsolicited submissions sent to my home. They were photocopies of rejected material accompanied by a note asking me to explain why they were deemed unsuitable for the magazine and a check for one hundred dollars to encourage a reply. Behind this bizarre request lies the even more peculiar but unshakable belief that selling to *The New Yorker* requires some kind of arcane knowledge: the conviction that buried somewhere in *The New Yorker*'s archives is Harold Ross's recipe for the perfect *New Yorker* cartoon. Like the Rosicrucian, cartoon editors are believed to pass these secrets orally from one generation to the next.

Unfortunately, I had to return the check.

There *is* a recipe for the ideal *New Yorker* cartoon, but it doesn't lie in a vault. It's revealed in the drawings published in the magazine each week, and it's as easy to state as it is difficult to achieve.

The ideal *New Yorker* cartoon is the happy marriage of a distinctive personal style and an original point of view. A fortunate few are born with these gifts. For the rest of us I pass along some sage career advice George Booth received from his mother:

🦋 Always stand up straight.

🦋 Act like you know what you're doing, even if you don't.

🦋 Finally, no matter what you're getting paid, give it plenty of oomph! ◆

INTRODUCTION

Liza Donnelly

February 2005

In the spring of 1977, a letter arrived in my college mailbox from Andy Logan, the City Hall Correspondent for *The New Yorker*. I had written Andy, a friend of my grandmother's, and she was kindly answering my missive. I had asked Andy if she would mind forwarding my drawings to *The New Yorker*'s art editor, Lee Lorenz, for consideration. Her letter to me was encouraging. "It's not a closed corporation," she wrote. "There is one point in [your] favor, I think," Andy continued. "I have been nagging [Lee] about there being so few women cartoonists and why does he think that is . . . and he really does need to keep an eye out for new young talent." It hadn't occurred to me until then that I was a "woman cartoonist."

Once I joined *The New Yorker*, I found myself in the company of a rich history of women cartoonists who brought unique and insightful approaches to humor. The women in this book found their way to cartooning from a love of humor and an attraction to the direct communication that the art form allows. Some wanted to share their world; others wanted to make people laugh. Each has a unique artistic voice. Some theorists believe that women humorists are more often storytellers than joke tellers, more interested in communication than in presenting cleverness. This has perhaps been true because of the marginal position of women's humor. However, as humor from women has become more acceptable in society, as it is today, such statements of difference no longer ring true. Huguette Martel believes all cartoonists are "moralists," and Alice Harvey sought "to be true." These elements are the layers underneath the humor, and a good cartoon rings true and evokes laughter. Readers have looked to *The New Yorker* cartoon for amusement and, in the process, often got a

19

lot more. Examining cartoons and cartoonists—after the hilarity subsides, if it does—sheds light on our world.

Intertwined with my passion for the art of cartooning is a lifelong love of *New Yorker* history—the people, the spirit, the phenomenon. *The New Yorker* Archives contain a treasure trove of history, and I enjoyed many hours immersed in the correspondence between artists and editors. The life of the magazine spans eight decades of American history, and its words and cartoons mirror our society. I thoroughly enjoyed getting to know the cartoonists in this book, some of whom I've met and others only through their letters and sketchbooks. How I wish I could ask Barbara Shermund some questions, follow Helen Hokinson around town for a day and watch her sketch the city, or go roller-skating with Alice Harvey. However, I was able to spend a day talking with Roz Chast and her birds and to watch Victoria Roberts artfully become one of her cartoon characters on stage. At the Algonquin, I lunched with Barbara Smaller (during which I laughed almost the entire time), had coffee with octogenarian Doris Matthews, and enjoyed drinks with Marisa Marchetto. Cartoonists are a rare breed, and looking closely at who chooses (although often it is not a choice, but a compulsion) to express themselves in such an unusual way is fascinating.

Dorothy Parker once wrote:

I had thought . . . that I should define what humor means to me. However, every time I tried to, I had to go and lie down with a cold wet cloth on my head.[1]

I have gone through countless cold cloths, yet upon completion of this effort have come away with a rich appreciation of and admiration for these extraordinary women. The women who became cartoonists for *The New Yorker* magazine from 1925 until the present were and are exceptional people. This book is a celebration of them and their work. I wish Andy were here to celebrate with me. ◆

THE EARLY INNOVATORS
1925–1930

"The publication of Kate Sanborn's anthology The Wit of Women *in 1885 was a direct response to the debate in America's literary community about whether women possessed a sense of humor. The debate . . . originated long before Sanborn sought to settle it and lingered long afterward. So pervasive was the idea that women were incapable of humor that works written by women were sometimes assumed to be written by men."*[1]

t took the persistent efforts of men and women over the course of fifty years to gain the vote for women in 1920. Some of these efforts were made by cartoonists, mainly female cartoonists. This movement promoting women's suffrage caused America to grapple with woman's role in society—certainly not a new concept—but a controversial one at the turn of the century. Cartoons, by nature, cut instantly to the quick of an idea; that is how they are meant to function. Whether the idea is funny, poignant, or both, a cartoon frequently intends to make people think as well as laugh. The female cartoonists who drew for the suffrage movement did just that, many of them drawing in response to the vicious negative visual images being published of women. Women have always been visual "objects" in society, often for their sexual marketing or appeal. The women who drew cartoons for the suffrage movement, however, sought primarily to gain the vote through their art. And at the same time, they opened up a visual dialogue of women's place in society as well as the discussion of whether or not women had a sense of

At the beginning of the century, a number of women were drawing comics for newspapers, most of which were about children. Kate Carew was one of the first women to draw and write a strip, *The Angel Child*, about a little girl who gets into trouble every day. In 1889, at the age of twenty, she was a staff illustrator for the *San Francisco Examiner*. She moved to New York City to draw caricatures for the *New York World* and was billed as "The Only Woman Caricaturist," drawing eminent individuals such as Mark Twain and Sarah Bernhardt. By 1911, she was writing and illustrating a page of political commentary and satire for the *New York American*. Nell Brinkley drew a daily panel for the *Los Angeles Examiner*, which captured romantic "girls" and their escapades in love and fashion. Women who drew comics for newspapers usually depicted children or beautiful women. Trina Robbins, in her book, *The Great Women Cartoonists*, suggests that Brinkley was, in actuality, a feminist, who managed from time to time "to squeeze in one important comment on working women, suffrage, and women in sports." Two early syndicated strips in the 1920s, *Ethel and Flapper Fanny* by Ethel Hays and *Gay and Her Gang* by Gladys Parker, moved away from the fancy style of Brinkley, drawing sleeker women with short hair—sometimes even wearing pants. Women were becoming regular "girls-about-town" and not just beautiful artifacts with lots of hair. These early female cartoonists were perhaps role models for the women who started at *The New Yorker* a few years later. Women cartoonists were beginning to write about the New Woman who was voting and working, and *The New Yorker* became a perfect place for them to publish.[2]

humor. Inspired by their lead, a fresh group of women began to draw cartoons in the newspapers, the "funnies," and eventually in *The New Yorker*.

A mecca for artists in the 1920s, New York City attracted young people seeking success in the world of commercial art, including women artists. The postwar commercial boom, with new jobs and innovative technologies, drew many to settle in the city. And, with the newfound feeling of freedom from gaining the vote, women were among those arriving with aspirations. Doors opened for women in many fields, and female artists tried their hand at comic strips, advertising, and illustration. At the time of *The New Yorker*'s birth, there was a youthful, vibrant energy in the city—men *and* women flocked to the urban center.

A native midwesterner, Harold Ross fell in love with New York, influenced by his new wife's enthusiasm for the city. He and his bride, Jane Grant, not long after moving to New York, talked about starting a fresh journalistic endeavor. Grant was already the first full-time city reporter at the *New York Times*, and Ross was editor of *Judge*, a humor magazine based in New York. They both were professionals in the

world of journalism. Still, Ross was not particularly happy at *Judge*, and his time there perhaps informed him of what kind of magazine he *didn't* want to create. American humor of the day tended to be unsophisticated. Ross saw a need for a new kind of humor that reflected the mood and energy of New York.

It's not insignificant that Ross's wife, Jane, was a feminist. Ross was a traditional man, and his early years in New York were formative in terms of how he felt about women. By marrying a woman who was a successful professional and who kept her job and her maiden

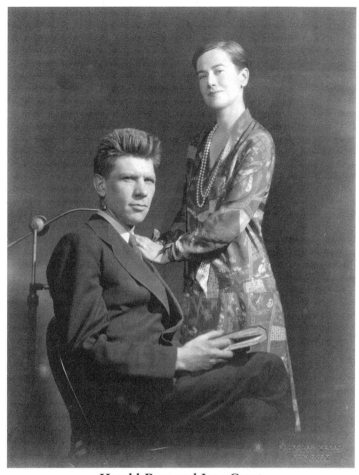

Harold Ross and Jane Grant
Image courtesy of Special Collections and University Archives, University of Oregon Libraries

name after marriage (in fact, she was one of the founders of the Lucy Stone League, the organization of women who pressed to keep their names), it is evident that he was somewhat comfortable with strong women. Early in their marriage, Ross and Grant started to conceive the idea of a new magazine, and it became one that would eventually hire many women editors, writers, and cartoonists. In his own words, Ross felt that "there would be no *New Yorker* today if it were not for her."[3] Ross's marriage with Grant nonetheless ended in 1929, perhaps because he ultimately became married to his magazine. But her influence was undeniable.

Rea Irvin
Courtesy of Virginia Irvin and Molly Rea

The circle of writers and editors that Ross and Grant knew allowed them to gather like-minded, well-educated sophisticates to run and contribute to their nascent enterprise. Having secured financial backing from the Fleischmann family (of the yeast fame), they now only needed talent. Ross and Grant envisioned a magazine that mirrored the urban vibrancy of New York City in the twenties, and they sought a more urbane humor. Ross wanted his magazine to be "distinguished for its sketches, cartoons, and humorous and satirical drawing in keeping with its purpose."[4] One of the most inspired decisions Ross made in those first months of hiring was to convince an art director named Rea Irvin to leave his position at *Life* and move over to his new magazine. As *The New Yorker*'s first art editor, Irvin understood quickly what Ross wanted. Irvin was an established professional who had a keen eye. He commanded respect from everyone and managed to make the magazine's art the element that drew readers to *The New Yorker*. He is perhaps the reason that the art in the early *New Yorker* surpassed the quality of everything else in the magazine and why he was able to fill it with the best comic artists of the day. Ross was heard to complain, "We need to get the words like the art!"[5]

The first cartoon drawn by a woman in *The New Yorker* magazine appeared in the magazine's first issue on February 21, 1925. Her name was Ethel Plummer. A Brooklyn native born in 1888, she eventually drew only a few cartoons for the fledgling publication. By the time *The New Yorker* was founded, Plummer was already established professionally, and, in fact, *The New Yorker* had sought her out. An early list of potential contributors included Plummer, indicating her status in the art circles of New York.[6] Her illustrations appeared in many of the national publications of the day: *Vogue, Life, Vanity Fair*, the *New York Tribune*, and *Woman's Home Companion*. Plummer was also active in the politics of being an illustrator, serving as vice president of the Society of Illustrators and Artists, and belonged to the Guild of Freelance Artists. In an article dated January 1930, the *New York Times* described a "supper dance" held at the famous Café des Artists organized by Plummer and others to help needy illustrators, and another time, they hosted a dinner dance to welcome visiting French artists.[7]

The first few months of the magazine were rocky—advertising and subscriptions were low. Raoul Fleischmann seriously considered ending his support. After a meeting with Ross, a group including Fleischmann, John Hanrahan, a "magazine doctor" they had been consulting, and Hawley Truax, a business advisor to Ross, walked out glum and despondent about the fate of the magazine. Fleischmann overheard Hanrahan say, "I don't blame Raoul, but he's killing a live thing."[8] The "thing" was, obviously, never killed. Fleischmann did not pull out his money.

Her association with *The New Yorker* did not propel Plummer to success as a cartoonist, as one might assume today. *The New Yorker* was just another magazine in 1925. Plummer disappeared from *The New Yorker* after a few cartoons, perhaps not feeling compelled to align herself with a humor magazine that was unsteady on its feet. She did not become a well-known cartoonist but rather continued as a respected illustrator.

That first cartoon by Ethel Plummer is an example of the kind of cartoon that was popular in the early part of the 1900s. Under the direction of Irvin and Ross (and, perhaps, other editors, as many sat in on the art meetings at one time or another), the art of cartooning evolved over the next few years. Drawn in a sketchy style that was popular at the time, it has two captions, or speakers. It is basically an illustrated joke, although not necessarily a funny one to today's readers. It succinctly mirrors the attitude of youth and the well-known generational clashes of the twenties, while it also points to the feminism

The difference between a cartoon and an illustration is of utmost significance to cartoonists. An illustration is a drawing that goes with a written body of work, a story. An illustration can be drawn in a cartoon style, but that does not make it a cartoon. A cartoon is a stand-alone entity of word and picture, with humor and/or insight at the core. Cartoonists can be illustrators, but illustrators, once they publish cartoons, are labeled cartoonists. Cartoonists tend to be independent sorts, free-thinkers, and loners, standing outside of society as observers. Illustrators, by definition, do not work alone. Their illustrations accompany text. So they're responding to the words usually written by someone else. There are many cartoonists who use writers' words for their cartoons, and so technically, they are illustrators. Still, whatever they are called, under any circumstances, they have to draw in such a way that the art meshes seamlessly with the words.

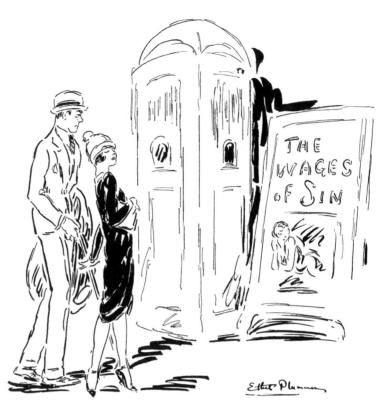

UNCLE: "Poor girls, so few wages!"
FLAPPER: "So few get their sin!"

of the day. The young girl is concerned with sexual freedom, and her uncle is concerned with wages. The cartoon pokes fun at the youth for her frivolity, while exposing the uncle's cluelessness to her meaning. In later cartoons, Plummer's work successfully moved into the single-caption format. The expressions of her characters' faces reflect the caption, instead of her simply displaying two talking heads. The editors at *The New Yorker* felt this old form of two talking heads needed to be changed. Some of the comic artists who helped change the cartoon format, as we know it, were women.

The art meetings were held once a week, if for no other reason than Rea Irvin came into the magazine only once a

week—since Ross could not pay him a large salary. Irvin was a calm man who had mature taste as well as confidence in his opinions. This contrasted with the constant questioning and uncertainty of Ross. Harold Ross always wanted to know what others thought about the art and perhaps even sometimes feigned ignorance to draw out opinions. The underlying question Ross put on the table was: "Where am I in this picture?" Not the I, Harold Ross, but the I of the reader. Had Ross had his way, he probably would have condensed the one-line caption to no-line. A number of artists eventually drew this type of cartoon. Rough drawings were discussed at great length, and suggestions were sent back to the artists for consideration, often after a week of the editor's mulling over a drawing. Beyond his regard for the art, Ross had enormous respect and genuine concern for the welfare of the artists. Nowhere is this clearer than in the letters exchanged between him and cartoonist Helen Hokinson.

Helen Hokinson (1893–1949) grew up in a small town in Illinois, the only child of a Swedish blacksmith turned machinery salesman. A quiet man who loved reading and playing the piano, Adolph taught Helen how to draw when she was very young. Her mother, Mary, a business school graduate, delivered her commencement address, extolling the virtues of a woman's right to participate in

The arrival of E. B. White to the offices of *The New Yorker* in 1927 may have contributed to the evolution of the cartoon. One of his early duties was to tinker with captions. According to Lee Lorenz, author of *The Art of "The New Yorker,"* the captions showed immediate improvement after his arrival. Lorenz states that the artists discussed this development at the time and that this change from a humorous anecdote to a one-liner required the artist to tell more in the picture.[9] The beautifully crafted sentences of many captions—possibly shaped by White—set an example for gag writers and raised the quality of the cartoon as the 1920s progressed to the next decade.

Helen Hokinson
Courtesy of the Mendota Museum and Historical Society

business.[10] Hokinson had a close relationship with both her parents. She ultimately came to embody characteristics of them both.

As soon as Hokinson could draw, she drew all the time. According to her mother, she liked to copy things as a young child,[11] and her early efforts won a few ribbons at the county fair. By the time she was in high school, her sense of humor began to emerge in her drawings—drawings not for public consumption, but for herself, in the margins of her notebooks. Her work had an innate humorous quality, with a quiet mocking tone, poking fun at teachers and students.

She soon sought to work in the fashion world and, in her headstrong way, demanded to be allowed to attend art school. She insisted on going to the Chicago Academy of Fine Arts, or, as she said, she wouldn't "go to college at all."[12] Her parents reluctantly let her go, expecting to see her back home eventually—she never did return home, except for visits. She attended both the Academy and the Art Institute of Chicago, studying fashion illustration, layout techniques, and cartooning. But it wasn't long before she and her colleagues—among them other soon-to-be *New Yorker* cartoonists Alice Harvey, Garrett Price, and Perry Barlow— were beckoned to New York as were so many other artists.

Hokinson soon became interested in the growing field of comic strips, and after

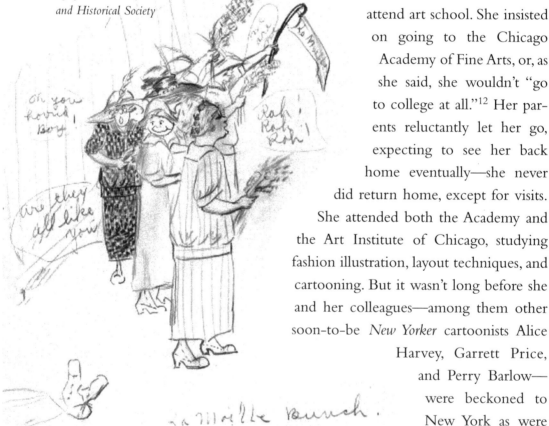

Hokinson sketch from high school
Courtesy of the Mendota Museum and Historical Society

several joint attempts with Alice Harvey, she drew a strip of her own that caught the attention of an editor at the *Daily Mirror*. Comic art was extremely popular in the twenties. Any number of women artists were writing and drawing newspaper comics, primarily targeted at female readers. Some of these strip artists were feminists who quietly expressed a viewpoint in favor of women's rights in their comics. Others were singularly concerned with children, homemaking, makeup, clothes, and glamour. Titles such as *Romances of Gloriette*, *Flapper Fanny*, *Gay and Her Gang*, *Molly the Manicure Gal*, and *Gentlemen Prefer Blondes* are a few examples. Hokinson began drawing a strip called *Sylvia and the Big City*, but it was probably no different from the others. She may have stopped drawing the strip because of the constraints of its limited readership. Her strip was popular at the Smith Club, a residency hotel for young women, where Hokinson and Harvey were living at the time, but when Hokinson watched the working-class girls reading it on the subway and not laughing, she knew it would be short lived. "It was terrible," she said to Joseph Mitchell in an interview. "One of the editors came over to me and said, 'Now, listen. Your audience is composed of the gum-chewers, and you've got to appeal to them.' I lasted five or six months, but in that time I saved enough money so I could look around for a while."[13] (Later, at *The New Yorker*, she would find another strong-minded editor, but by then she had found her voice, and any direction from Harold Ross came with his deep respect for her artistry.)

With some money saved, Hokinson continued to draw elements of city life in sketchbooks and enrolled in a course at Parsons School of Design, a

decision that directly altered the path of her life. It was a class in dynamic symmetry, a theory of composition that involved symmetrical triangulation, which she applied to her cartoon work. "It changed me entirely. When I am drawing now, sketching a person unawares even, I start with little rough triangular shapes and work out from that. It is wonderful for catching the gestures of people or the way they wear their hats or coats."[14] It somehow freed up her drawing, loosening her hand, while giving her sketches more structure. One day her instructor sent the students out to sketch in the streets of New York. Hokinson drew an elderly woman waving goodbye to a departing ocean liner. Upon her return to the classroom, her teacher, Howard Giles, laughed and immediately suggested that she take this and other drawings to the new magazine down the street.[15]

This simple drawing of a woman waving immediately won over Harold Ross and Rea Irvin. Her work had an ease to it: Ross recognized the humor in her line quality, but also in what she chose to draw. Ross purchased her first submission and invited her to return every Tuesday with more sketches for consideration. The lady waving was the first drawing of Helen's published in *The New Yorker*. As she continued to bring drawings to her editors, they published them as illustrations. They appreciated Hokinson's eye for documenting city life and began to send her on assignments to draw "assorted subjects such as circuses, zoos, children's dancing classes, reducing salons, opera first nights and other metropolitan phenomena."[16] She moved among the city's vibrant characters, chronicling

Hokinson

everything in her little pocket-sized sketchbooks. She carried them everywhere, even into a Turkish bath.[17] "At a Turkish bath, disguised as a customer, she caused some consternation by walking around, pencil at work on limp paper, sketching the other customers knew not what."[18]

Irvin and Ross heavily edited the art that was bought for the magazine. Humorous drawings for the early *New Yorker* were decidedly a committee endeavor ("nearly everybody on the staff sat in on them at one time or another")[19] and the captions were more often than not written by writers or editors. In this environment, the editors felt that Helen's work called out for the written word—even though the drawings spoke volumes on their own. Soon, they began adding captions to her illustrations; this evolved into a delicate dance of collabo-

Helen Hokinson
Courtesy of the Mendota Museum and Historical Society

Hokinson's early cartoons are signed H. E. Hokinson because she studied numerology and felt convinced that this combination of letters was lucky. For unknown reasons, she later changed her signature to Helen E. Hokinson.[20] Given that there is so much rejection and a lot of mystery about cartoons—what works and what doesn't—many cartoonists develop such superstitious habits.

ration between Hokinson and various editors. Helen was a willing collaborator and often contributed her own ideas or suggestions for captions. It was, by all accounts, a very successful arrangement. She was exactly what Ross was looking for. Her keen powers of observation and her ability to embed humor in sketches laid before the editors a wonderful palette with which to create a powerful cartoon. Hokinson recalled:

> At first, my drawings were printed with no captions. Then they began putting captions on them, and after a while I got the knack. I prefer no captions on most cartoons. I think it would be just as well if the cartoon told the whole story.[21]

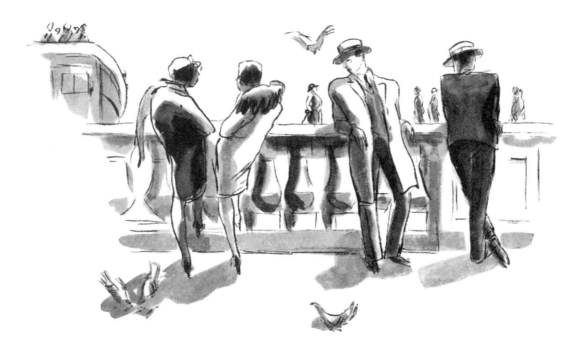

Most of Hokinson's early cartoons were of the old style of cartooning with two captions, and she continued with that form until the end of 1927. Her drawings conveyed a vitality in her figures. Hokinson's early depiction of women recorded them coping with daily life in the urban pace of New York City. As requested by the editors, she drew women of the "smart set" in museums, in shops, working, and juggling the trials and tribulations of their new world. Her drawings always retained a sense of humor and grace (though often making light of the older generation in the process). She brought these people and places to life.

As the cartoon evolved in the first years of the magazine, Ross and Irvin were trying to find ways to best use Hokinson's abilities. She was always

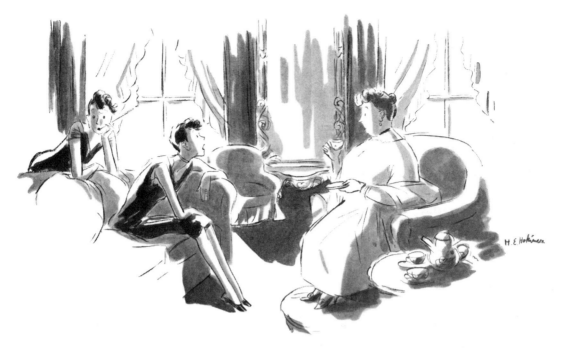

**"Mother, Dorothy and I've decided to go on the stage this summer.
We don't want to get in a rut."**

• • •

sketching around town. The editors routinely sent artists to events, oftentimes to provide sketches that would accompany an article—they acted, in essence, as visual reporters. Hokinson took on many of these assignments. The editors and she put titles on some of these drawings and captioned them. Eventually, they sought to create what was called a "series"—humorous observations about one particular subject. Editor Katharine Angell actually distributed a memo to various writers soliciting a "new series for Helen."[22] Angell wanted a series that would satirize a particular type and class of woman (yet without misogynous overtones). This type of humor can be seen throughout the magazine in the early years, among many of the women cartoonists. *The New Yorker* was to appeal to primarily upper-class, young urban women, and the cartoons reflect that.

An astute businesswoman, Hokinson worked hard but was not often seen to mingle with the "literary coterie"[23] of *The New Yorker*. She was not interested in the news, philosophical discussions, or in reading *The New Yorker* (a fact that she concealed from friends)—she just constantly drew from life and socialized with a small group of intimate friends, of which she was invariably the center. One gets the impression that "Hoky," as she was called by her friends, was well loved and had a strong quiet presence. She often donned a hat and a scarf (which concealed a large birthmark on her neck). She frequently

Katharine Angell
Courtesy of Katharine Sergeant White,
E. B. White Collection, 1899–1985.
Courtesy of the Division of Rare
and Manuscript Collections,
Cornell University Library

Katharine Angell came to *The New Yorker* in 1925 and immediately became an important force at the magazine. Ross perceived her as a cultured voice, having come from an old Boston family and having graduated from Bryn Mawr. He felt she lent a certain air of legitimacy and taste to his venture. She seemed to do everything at the magazine early on (in those early years many staff members wore numerous hats). And one spot she found herself in was attending art meetings. She lent a woman's voice to the caption writing and editing, as well as a calm, reasoned tone to letters sent to disgruntled, confused, or overworked cartoonists. According to Dale Kramer, in his book *Ross and "The New Yorker,"* employees referred to Katharine Angell as "a fine editor, but she also acted as mother to the staff." Kramer states that in Angell, Ross "met his match," that she had very high integrity. However, if she and Ross ever did cross (usually on small things), he was known to cry, "This magazine is being run by women and children!"[24]

began her conversations with the words "Guess what?" and loved to laugh. When she drew in public, she had an amazing capacity for being oblivious to those watching her, intent only on her subject matter. She lived with her mother, Mary Hokinson, in a Manhattan apartment on Nineteenth Street and later rented a small studio house in Wilton, Connecticut, where she and her mother gardened and cared for their cat, Swenson. Hokinson pursued her goals with determination, forever curious and searching for ways to express herself and the world around her. *The New Yorker* provided a perfect place for her to call her artistic home.

With talent such as Hokinson's, *The New Yorker* was beginning to come together, but Ross wanted further improvements.

"I'd love to buy this—but couldn't the artist change it?
My husband doesn't like codfish."

"Hokinson's cartoon narratives celebrated the independence and fortitude of the New Woman in their urban adventures. These characters spoke directly to *The New Yorker*'s female readership, unlike Hokinson's more famous matrons, whose displays of childish pleasure and extreme fastidiousness spoke to the male readership and . . . society as a whole."[25]

In a letter to contributors only a few months after the magazine was launched, he suggested, "The art in *The New Yorker* has been leaning toward the decorative rather than the illustrative. Henceforth we want to tend definitely toward making our art illustrative of *ideas*."[26] The cartoons became even more focused and crafted. Hokinson's captions started to really take form. Her drawings more pointedly captured life in New York in the twenties and chronicled mostly young women making their way in the big city in work and play. The women in her cartoons reflected the New Woman of 1925, struggling with roles that their Victorian mothers only dreamed of: combining lives of work with new freedoms in society and in marriage. The 1920s presented both an exciting and an unsettling time for women;

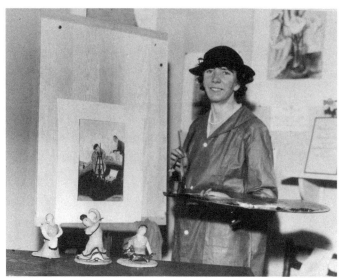

Helen Hokinson
AP Photo

the cartoons in *The New Yorker*, particularly those drawn by women cartoonists, spoke to the female readership. Their cartoons ushered in an era that covered women's interests in a more feminist way. They commented on what appealed to both sexes—indeed, the women cartoonists of the early *New Yorker* crossed the gender line in a way that had not been done before. Their humor mirrored and perhaps eased difficult times for women during this transition, and Hokinson's cartoons led the way. By the end of 1927, she hit her stride—the double-captioned cartoons were virtually gone, and her beautiful drawings flowed effortlessly with the captions, serving up a commentary and satire as gracefully as in a dance. The public began to fall in love with Helen Hokinson.

Alice Harvey and Helen Hokinson met in art school in Chicago. Harvey, who was born in 1894 just outside of the big city in Austin, Illinois, was the youngest of four children and the daughter of a trade journal publisher. She was a

In Hokinson's first actual cartoon, the image is a commentary on the relations between the sexes. In the cartoon, two men are photographing a woman, who has her back to us. The man not taking the picture has an expression that is directorial and conniving as he says "Now—!"[27] Presumably, he is the woman's boyfriend and he knows best how she should look. The cartoon is making fun of men and commenting on woman's plight as an object of men's constant gaze and control. It is so simple but speaks volumes in an instant. In another cartoon done around the same time, we see an elderly woman at a department store counter, contemplating a perfume called "Don't Love Nobody but Me." The cartoon works on several levels: it's hard to imagine the older woman wanting a perfume that evokes that sentiment, and the contrast is funny. Second, the cartoon is poking fun of her confronting the new sensibility of sexual freedom. The older woman is trying to ride the wave of the new sexual freedoms, but we know it won't happen. Third, the expression on the saleswoman's face is humorously apprehensive.[28]

· · ·

spunky, tomboyish girl, who gained local fame as a star basketball player. Even though Alice was tall and lanky, she was known as the high school's "fastest little forward." She loved roller-skating, a passion that stayed with her through adulthood. Later, when an ample-sized check came in from *The New Yorker* for a drawing, she and her husband built a circular sidewalk in the family yard—just for roller-skating. Her daughter remembers that her mother loved roller-skating so much that "she roller-skated all over Chicago."[29] While Hokinson may have drawn characters sitting and standing, one can see in Harvey's drawing, more often than not, a physicality and activeness in her line.

Alice Harvey
Courtesy of Janet Aley

After high school, Alice studied at the Art Institute of Chicago under Wallace Morgan. Like many illustrators of the time, she was classically trained, and like her friend Helen, Alice painted and drew from life. Following art school, the two shared a studio on North Michigan Avenue and sought illustration work wherever they could. At one point they drew a cartoon strip that concealed racing tips within the art. Harvey didn't feel it "proper" so they discontinued doing it.

Rooming together later at the Smith Club, Harvey and Hokinson drew illustrations for other magazines before starting at *The New Yorker*. In the meantime, they studied at Parsons School of Design with Howard Giles.

Alice may have worked more than Helen in those first years, however, doing illustrations for *Life*, *Judge*, *Woman's Day*, *McCall's*, *The Saturday Evening Post*, and *Harper's Bazaar*. This was the golden age of the magazine, and the opportunities seemed everywhere. Harvey was excited when she first heard of *The New Yorker* and sent in a few drawings. According to Harvey's daughter, Janet Aley, Ross reportedly

Alice Harvey
(at left),
Helen Hokinson
(third from left),
and two
unidentified
women
Courtesy of Janet Aley

called Rea Irvin into his office upon seeing Harvey's drawings and said, "This kid's got stuff, this kid can draw!"[30]

Harvey began working regularly for *The New Yorker* in November of the magazine's first year. She was not sent on assignment as often as Hokinson, but it appears Harvey got the hang of a one-line cartoon more quickly than her friend. Still, Hokinson's drawings conveyed humor in the drawing and in her choice of subject, while Harvey's more realistic sketches needed that line of text to bring in the humor. Harvey drew most of her own ideas, perhaps benefiting from the few months of observing the magazine before submitting work. It also seems as though Harvey's humor was more in her personality, not necessarily in her pencil line, as it was in Hokinson's. There are many ways humor can be evoked in a cartoon—ideally it should come from both the line and the words, and the two working intimately together. Alice Harvey was

known as a whimsical person: her whimsy was conveyed not in drawing, but in ideas. Hokinson, who most of the time did not write her own captions, shared her sense of humor through the tip of her drawing pencil.

Another difference between the two similarly trained artists was where they moved to

"They're discussing sex—
isn't that cute?"

during these years. Their environments perhaps influenced who they became as artists. Although they both started out living in the city, Harvey soon got married and moved to Westport, Connecticut. Hokinson eventually had a studio in nearby Wilton, in "a little pink house,"[31] but was often seen in the city. It's unclear how long she maintained an apartment there, but archival communication shows that she was in the city frequently throughout her career, while Alice

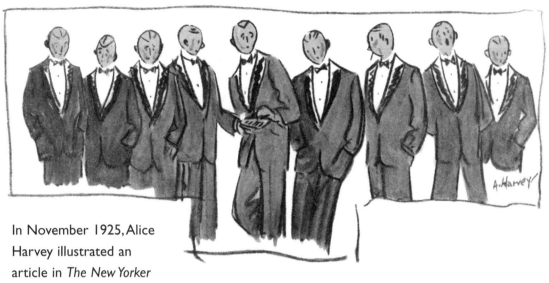

In November 1925, Alice Harvey illustrated an article in *The New Yorker* titled "Why We Go to Cabarets." It was written by a socialite, Ellin MacKay, and credited for bringing a lot of much-needed attention to *The New Yorker*. Jane Grant, with her connections to newspapers, managed to get front-page coverage of the article in various major papers. The piece, some now say poorly written, explains why the young social elite preferred cabarets to society balls. The essay, as Ben Yagoda points out, "danced on the surface" of class issues, topics that *The New Yorker* was beginning to address. MacKay asserts that she and her socialite friends go to cabarets "because we prefer rubbing elbows in a cabaret to dancing at an exclusive party with all sorts and kinds of people." The elite were choosing a new place to party because the society balls, so-called exclusive parties, were being attended by people outside of their social register.[32]

was not. Harvey began drawing country scenes: horse shows, regattas, houses, gardening; while Hokinson continued sketching city events. Harvey loved Westport and chose not to visit the city often—in fact, she asked *not* to be given city assignments, since she felt travel to the city was not worth the bother.[33]

Then there was the difference of marriage. Harvey got married in 1925 and began to have children soon after. This is reflected in her work—she was really the first cartoonist to draw regularly about life with children. Since *The New Yorker* was founded as a distinctly urban magazine, and one that was directly targeted to the youthful society of New York, Harvey's choice of subjects may have been a difficult concession for Ross. But one can

imagine it was a concession that he had to make. Many of the readers he initially sought in 1925 were, by 1930, marrying and moving out of the city and into the country. Ben Yagoda, in his book *About Town*, observes that "even as the magazine was obsessing over its home city, readership was beginning to spread out beyond it."[34]

Harvey's cartoons about family life distinguished her content from that of her friend Hokinson. Not being in New York City, however, may have been what distanced her and ultimately strained her rela-

"... and what was that woman's name? You know, the one we liked her husband so much."

tionship with the magazine. It is a tribute to Harvey's "spunk," however, that this distance, her marriage, and motherhood did not seem to bring her career to a halt until much later. She continued working for *The New Yorker* until the mid-1940s.

Helen Hokinson and Alice Harvey remained close friends.[35] Both were strong women in their own ways, yet the two had quite different personalities (as evident from letters and personal reports). Although Hokinson became more assertive in her later years, from correspondence, it appears she began her career amiable and easygoing in her dealings with *The New Yorker*. Harvey, however, came on strong and continued to be assertive and opinionated in her correspondence. It may have been that the editors put more demands on Harvey than they did on Hokinson, thus rousing Harvey to be forceful. The editors asked a great deal of their artists in those early years; the changes and fixes at times seemed endless. Ross would fuss over details in drawings and sometimes request so many changes (through various deputy editors, never through him) that some artists would inevitably become frustrated and complain.

"I'm so glad to be here
and see Mother married.
The time before I was sick."

But the changes they asked of Harvey often prompted her to
shoot back comments like: "You're all much too clever to fight
with, I feel foolish to have exposed myself to your delicate
irony—but I find I can't go on living without telling you that
you all give me a pain in the neck."[36] This letter was the first
of many that prompted Katharine White (Katharine Angell's
name after she married E. B. White) to become the liaison with
Harvey, and not Scudder Middleton (the art assistant) with
whom she had been corresponding. White's letters to Harvey
are almost overly sweet at times, asking her if she would be "an
angel" and change something. It appears that the tone worked,
because there were periods of friendly, humorous communica-
tion and great productivity from Harvey. She showed that she

Alice Harvey
Courtesy of Janet Aley

didn't lack confidence, frequently questioning their judgment of her work, and refusing to make changes. Apparently, though, she did make changes in some.

While both Hokinson and Harvey drew many cartoons about women, Hokinson's art concentrated mostly on the upper class, while Harvey's delved into the middle and working classes. Hokinson's humor was perhaps a gentler mocking. When Hokinson made fun of women, both genders could relate to the joke. If she satirized a young lady, it was on a *human* level—as if the artist were teasing the reader, man or woman. When Harvey trained her eye on women, the reader felt it was ridiculing a *certain type* of women; or when she satirized men, it was a *certain type* of men. Harvey's letters certainly show a hard-edged humor, and that trait comes out in her work. Janet Aley, Harvey's daughter, remembers: "Something always piqued my mother about Helen—when Helen would come to dinner she would never finish her plate, there would always be a little bit set aside. I was told that was polite."[37] Hokinson's cartoons were polite, and one feels that no matter whom she was satirizing, she always retained a certain old-world kindness and understanding. As a protégée of Ross, this is not surprising.

Though Hokinson's humor evolved at the magazine, her captions were written by others, mostly men. Harvey arrived near fully formed as a cartoonist, writing her own ideas, something that was not common, even for male cartoonists. However, by 1930, she began to ask for ideas: "Sometimes I get low on ideas. You send ideas to all my

friends and I am filled with envy. Send me some sometime. Give me a chance to think they're not funny!"[38] Later in life, as she became famous, Hokinson started to resent the control that the writers had on her work and asked for veto power on captions. In the 1920s, humor done by women cartoonists generally stayed in the realm of women. In other words, they drew cartoons about women doing things that women do. Their work did not go into the male domain

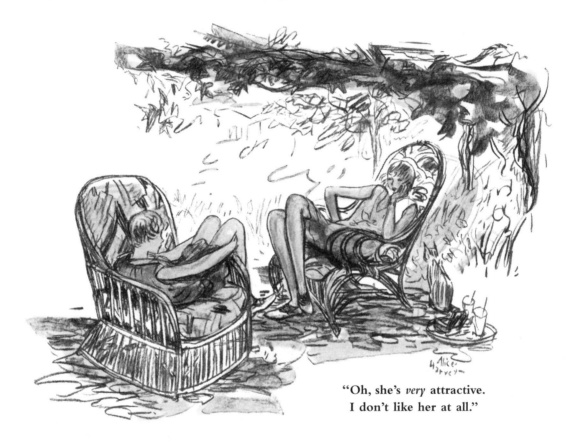

"Oh, she's *very* attractive.
I don't like her at all."

at the time. Hokinson and Harvey rarely drew cartoons about the business world or the stock market—although they made occasional exceptions. If any of these female cartoonists drew a woman in an office, then it would not represent "everyman," it would be a *woman* in an office. Hokinson's work began to transcend that (although it was not recognized at the time in that light), because her woman spoke for everyman. Eventually, women cartoonists branched out and began to write humor outside of the circumscribed world of women. But it would be much later.

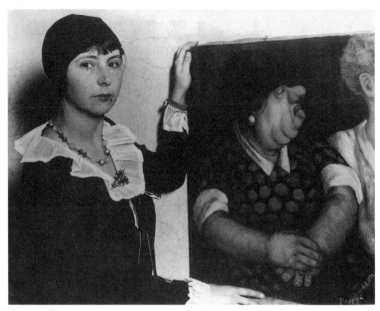

Peggy Bacon
Library of Congress photo

In the search for talent, Ross and Irvin brought in another classically trained artist who tried her hand at cartooning—Peggy Bacon. Rea Irvin had catholic tastes in art, and he may have sought artists who were similar. The combination of satire, strong draftsmanship, and visually interesting graphics proved to be very successful at the magazine. Bacon, like Hokinson and Harvey, was drawn to humor and *The New Yorker*. She shared with them a strong personality and an interest in a variety of creative endeavors. Though she did not have a long career as a cartoonist, she did enjoy a long and extremely productive career in other arts.

Peggy Bacon was born in Ridgefield, Connecticut, in 1895, the daughter of artists. She studied at the Art Students League and the New

Sunday on the Coney

York School of Fine Arts. She had just a few cartoons published in the magazine, but she did numerous caricatures and illustrations in *The New Yorker* over the years. Of all the early women cartoonists, she perhaps became the most multitalented, well-known artist of the group. She didn't concentrate her talents on cartoons, but on painting, drawing, poetry, and caricatures with accompanying acerbic essays. Her most distinguished works were the caricatures, for which she was recognized early on as a talent to watch. She was written up in the *New York Times* as early as 1929, "It is hard to see how any one—even a perfect stranger to whom Peggy Bacon is merely a name—could fail to respond to the summons printed upon the face of the announcement catalogue. At [her] best, [Bacon] is one of the most delightful [humorists] in America. The humor is delicious and thoroughly original."[39]

Bacon traveled among a group of well-known artists—Alfred Stieglitz, Alexander Calder, John Sloan, and George Bellows—and eventually became good friends with the well-known cartoonist Mary Petty. Her wit was strong and brutal at times, her take on celebrities and politicians unforgiving. Perhaps her voice was too strong for the delicate (although not always) humor of the single-panel cartoon. Her verbal wit shone in her essays and poetry. Regardless, her

Island Boardwalk

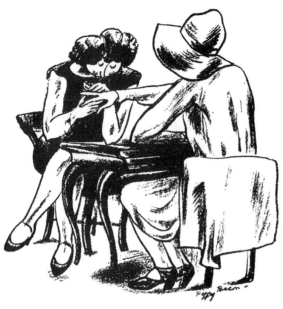

"... I took one look at his nails and I sez,
'Well, it takes all kinds to make a world.'"

success came in other areas, so cartooning was not a place in which she settled.

Letters to her from Katharine White and Wolcott Gibbs display an effort on the editors' part to find useful ideas for her, but they were not successful, nor were the ideas she sent them. They encouraged her, wanting her to contribute.[40] In a letter from 1935, White mentions to Bacon, "We are longing for spots, poems and all sorts of contributions from you."[41] Clearly, they wanted her to draw cartoons, but they did not continue to request more after her initial few. Bacon went on to write numerous children's books. A collection of her caricatures, *Off with Their Heads!* (after being awarded a Guggenheim Fellowship), was a huge success and made her known as one of America's preeminent caricaturists. In an article in 1935, she is compared to Honoré Daumier and Toulouse-Lautrec.[42] Bacon became a teacher at many schools, among them the Art Students League, the Moore College of Art, and the Corcoran Gallery School

of Art. The National Collection of Fine Arts at the Smithsonian gave her a retrospective in 1975. She died in 1986.

There were two other women at the end of the 1920s whose cartoons were very much in the mold of illustrators who also drew cartoons. Mabel Augusta Brigg, born in 1893, grew up on a horse farm in Homer, New York. She changed her name early on (after being teased as "A-gust-a-wind") to Nancy, after a popular song of the time, "The Legend of Nancy Brig." Nancy grew up to live an eclectic, artistic life. She married another artist, Clark Fay, a man who became a well-known illustrator for *The Saturday Evening*

In 1970, Bacon was included in a group show at the Whitney Museum of Art of works by women in their collection. Even at that late date, society was not ready to recognize women. Though the show contained art from Georgia O'Keefe and Louise Nevelson, among others, the *New York Times* reviewer reports the exhibition to be "contrived" and continues to state that until women "produce a trailblazer," they will not "gain recognition as creative equals to men."[43]

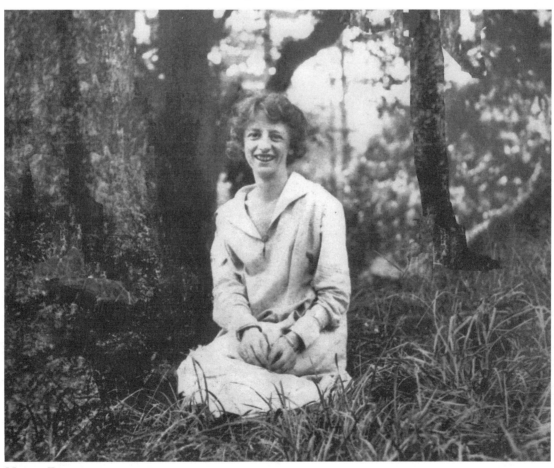

Nancy Fay
Courtesy of Nancy Wilson

Post and *Vanity Fair* (he had studied with the patriarch of the Wyeth family, N. C. Wyeth). Nancy aspired to work for magazines, and she achieved that. Her ambition, she told an interviewer at the time, was to illustrate a story that "does not contain the Cinderella motif."[44] Nancy and Clark lived

GETTING BACK INTO THE ART GAME.

Courtesy of Nancy Wilson

in Westport, Connecticut, a hotbed for artists in that era, and raised three children. They enjoyed a rather high life of parties and polo playing, becoming friends with F. Scott Fitzgerald, among others. Nancy eventually moved to France, where she died an early death around 1930. Her work at *The New Yorker* was concerned with women and children and displayed a wonderful clear humorous voice. Her early death robbed *The New Yorker* of a consistent artist.

Another early *New Yorker* cartoonist was Nora Benjamin, though *The New Yorker* became just a footnote in her artistic career. Born in New York City in 1899, the daughter of a steamship executive, she grew up to become part of the social artistic elite of Westport, as did a number of the cartoonists of that time. Nora was a well-educated woman, who honed her art skills at the Art Students League under Boardman Robinson, Charles Locke, and Kimon Nicolaides. Her favorite medium was lithography, but she was also a prolific oil painter, who worked outside well into

"But mother, where *do* babies come from?"

her eighties. Once widowed and once divorced, she
was a fiercely independent woman who, although
sociable, ultimately seemed to enjoy living alone. Friends
described her as a gentle, caring woman who loved Henri
Matisse and cocktails as much as her painting. She bought a house
in a commune in Israel later in life. Many of the books she eventually
wrote were children's books about Judaism and Israel, although she wrote
other children's books. Nora never lost her childlike love of life—at eighty,
she took her grandson for a ride on a Ferris wheel.

The drive to be a cartoonist needs to be strong, because it was and is hard work. It demands an ability to communicate with words as well as with visuals, something not all artists can do. In the late twenties at *The New Yorker*, many of the artists were asked to be extremely cooperative, working closely with editors in the re-working of the art and the words. The editors—probably under "instruction" from Ross and Irvin—were constantly communicating with the artists to select what had potential and to fix what they had already submitted. The art was working out well and the artists who stuck it out with the constant editing, did, in fact, produce wonderful cartoons. In an undated letter from the editors to art contributors, one gets a sense of the direction: "Generally speaking, ideas should be satirical without being bitter or personal; our secondary need being for ideas that are unusual, extravagant or 'nutty.' Situations should be plausible. Ideas should be literal and show how, unconsciously by their speech and acts, individuals of every New York type show up their hypocrisies [*sic*], insincerities, false fads and absurd characteristics."[45] In essence, artists were being instructed on how to do a *New Yorker* cartoon, because it had never been done before. Some artists, most likely, chose not to attempt to fit into this mold, because, after all, *The New Yorker* was just a fledgling magazine. The women who continued to draw cartoons for *The New Yorker* were team players, and the archives show many letters of collaborative discussion. Some of them came up with their own ideas; some incorporated ideas from writers, editors, friends, and spouses—often, as with the men, they tried both approaches. They generally created cartoons about women of all classes, although some trained their satirical eye on men.

Ross hired many female writers in the first few years of *The New Yorker*. There was Dorothy Parker, of the Algonquin Round Table set, who frequently published in the magazine. Janet Flanner started her column "Letter from Paris" (signed Genet). Lois Long began her columns with a nightclub series called "Tables for Two" and then continued with her well-known fashion column "On and Off the Avenue." And, of course, Ross hired Katharine Angell (later to become Katharine White when she married E. B. White) and paved the way for her to be a driving force in the top editorial ranks of the magazine. During the Ross years, there never appeared to be any bias against women at the magazine. Ross was extremely aware of the female readership, which was crucial to the success of the young magazine. By all accounts, although he loved the company of men, and sometimes gave the impression of not understanding women, he was sympathetic to women's rights. In a biography of Ross, Thomas Kunkle writes: "He loved women, respected them, admired them . . . but as he said himself many times, he never understood them. . . . At heart a nineteenth-century man, Ross had predictably Victorian attitudes about sexuality, virtue and women's roles," but he changed and grew to adjust intellectually to the modern, "independently spirited woman."[46]

"Did you ever see such a dumb bunny?
He doesn't even know a python from a watersnake."

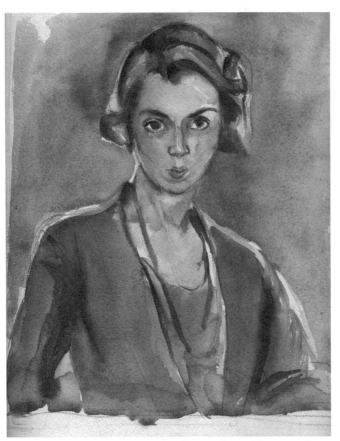

Self-portrait in watercolor by Barbara Shermund
Courtesy of Art Research Associates

One artist who enjoyed a highly productive career writing her own ideas and drawing them was Barbara Shermund. Her cartoons stand out among this group as being more feminist in attitude than those of her peers. However, her work has been largely forgotten. Barbara Shermund's story, gleaned mostly from her papers, drawings, and cartoons, illustrates how, in the middle of the decade, cartoons changed for women.

Shermund was born in San Francisco in 1899 into an artistic family—her mother was a sculptor and her father an architect—and she started drawing as soon as she could pick up a pencil. After studying at the California School of Fine Arts, she traveled, at the age of twenty-six, to New York City. Not planning to stay long, she ended up living in and around New York City for the rest of her life. She was something of a wanderer, living with friends in the city and the upstate town of Woodstock, never really having a set address until much later in life. She loved to travel, taking numerous trips to many parts of Europe, Canada, and the western United States. Whenever she traveled, Shermund was always creating art—cartoons, lithographs, paintings, and drawings.

As an artist in the city, Shermund most likely heard about *The New Yorker* as soon as she arrived. She started by doing spot illustrations,

and her first cartoon appeared in the first month of 1926, after she "was told [she] must write lines under [her] drawings."[47] After a few cartoons, her voice became evident—Barbara caught on to the form quickly. She drew mostly about the New Woman, demonstrating an understanding of the newfound independence while not being afraid to poke fun at her. Her women were alternately clueless and strong, depending on the cartoon. This was the state of women at that time—some were experimenting, coming out of the home, and speaking their mind. Meanwhile, the flappers among them showed disdain for an education and just wanted to have fun.

What comes through in many of the cartoons is that Shermund's women did not need men. Shermund still did not shy away from

Barbara Shermund
Courtesy of Art Research Associates

making fun of her sex throughout her career, though she clearly had a feminist attitude. Her cartoon women seem tougher and more self-sufficient than those of Hokinson and Harvey. Shermund's women openly discussed their thoughts about dating, marriage, and men, and often those thoughts were not typical of the times (or at least they were not thoughts that women shared in the company of men!). But here they were in *The New Yorker*. In a double entendre cartoon by Shermund, two women are lounging in easy chairs, smoking: "Oh, men are all right, I guess—if you have patience."[48] She is able to make a comment on men, while simultaneously making fun of the two women who appear to have nothing to do *but* have patience.

Shermund experimented with her style, although her drawings were predominantly strong and forceful. She was classically trained, and she displayed bold, loose lines and an assuredness not dissimilar to her contemporary Peter Arno. Her energetic brushwork and

Artistic expression or represen-
tation could be said to be the
voicing of feelings, thoughts,
and/or ideas. To say that a car-
toonist "has a voice" is to be
more specific. Some cartoonists
express humor but do not
convey a consistent manner of
thinking. Having a voice can also
be a combination of the artist's
attitude and the way in which

she draws. It is more obvious in some artists than in others. Hokinson's "voice" was a gentle
mocking of life in New York City, and this "voice" was clear through most of her cartoons.
Harvey's work did not present a "voice," but rather her cartoons were well-executed,
humorous drawings from no one particular viewpoint. Shermund's "voice" came through in
her outspoken young women. In both Shermund's and Hokinson's cartoons, their attitudes
merged beautifully with their style of drawing.

"A voice" is a consistency of viewpoint toward people and situations—and even life in gen-
eral. This is not to say that cartoonists without an artistic "voice" did not have a viewpoint—it
is rather that it was not repeatedly displayed in their cartoons. Later, in the 1970s, cartoon
editor Lee Lorenz said that he was looking for artists with a voice. Often he would be able to
spot such an artist after viewing thirty drawings; other times, it could take years of submissions
from the artist either for the voice to emerge or for the voice to be apparent. Ross and Irvin
never stated that they were looking for artists with a voice, but clearly they sought consis-
tency. Still, it may not have been as important then, because as the cartoon became a standard-
ized medium in the 1950s, many artists were simply cranking out jokes.

• •

dark gray washes are as gutsy as her cap-
tions. Hence the art and the words work
together well. Her very early cartoons
looked like lithographs, drawn in boxes
with heavy dark lines. Several times she
varied the faces of her people, drawing very
angular, stylized heads—but generally, her

long, lean characters show through the
variations of line. By the end of 1926, she
was drawing classic cartoons with one cap-
tion under the drawing. Shermund never
had a studio, but preferred drawing at her
kitchen table. She worked on large, twenty-
four-by-thirty-six-inch pieces of heavy,

rough watercolor paper, first sketching out an indication of where the drawing was to sit on the paper, then boldly painting over the light pencil lines (the lines were merely guides). Sometimes her brushwork—it appears that in her early work, she did not use a pen, but rather a brush—was wet and potent, sometimes dry and sketchy. From the beginning Shermund wrote her own ideas, sleeping with a pad and pencil under her pillow! She would then write out her concepts as lists on large pieces of paper. In addition, she made rough sketches on bits of paper that she held in cardboard folders along with potential

**"Well of course, I do say I'll never marry—
though, somehow, I've always wanted to be a widow."**

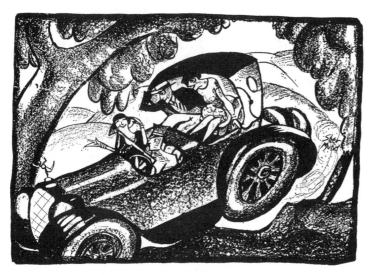

"I'm mad about dirt roads. They're such wonderful exercise."

captions and quotes, as if they had been overheard in the street. Her drawings, done from life, are wonderful, quick, and vibrant.

The editors published Shermund's cartoons frequently in the first few years of the magazine. Their letters to her indicate that she was well liked and sought after. Because Shermund traveled so much, Katharine White was often asking her when she was returning: "When are you coming back? We miss you badly."[49] The letters from Shermund to Katharine White and Scudder Middleton are often breezy and humorous: in one, written while living in the country in Woodstock, she writes: "I shall be here sometime longer—in fact I am so poor, I'll probably have to settle down here the rest of my life and get a job berry-picking or something." In several instances she was given an advance of money from the magazine, which she repaid through deductions from future sales.[50] In another, she complains that the ocean liner on which she was traveling was strictly enforcing prohibition and full of women, "all, apparently, from darkest Kansas with their petticoats showing."[51] In 1930, she traveled to many different countries in Europe, including France, Germany, Spain, Switzerland, and Czechoslovakia. An unidentified news clipping from that time states, "Miss Shermund's style is worldly. The foibles of various proud elements of society and intelligentsia are natural targets of her wit."[52] Shermund was a known and popular female artist and one of the most traveled female artists of *The New Yorker* group. Like Peggy Bacon, in an article dated 1931 in the *New Haven Register*, Shermund was described as an artist "often referred to as a modern Daumier."[53]

Unlike Hokinson and Harvey, Shermund displayed a sharply modern attitude in which a feminist tone cut through the surface joke. Because her

humor was new, I can imagine the editors disagreeing on what was and what wasn't funny. *The New Yorker* clearly wanted to reflect the times and appeal to a certain educated readership, and that group included forward-thinking individuals who were experimenting with gender definitions and politics. Shermund's cartoons mirror that, and she throws in her opinion as well. In a letter from Ross to Rea Irvin in 1928, Ross indicates a specific desire to humor homosexual readers.[54] In a cartoon of two women talking, the caption can be read two ways, straight or gay: "He's not abnormal—he's just versatile"[55] In another, two women talking say, "You know, I don't care for women. I guess I'm a man's woman."[56] This also has double meaning. Over and over again, her female characters, whether smoking or talking about sex (taboos for women), make fun of gender. Mae West later successfully adopted this attitude toward gender and sexuality when women turned their attention more to Hollywood.

Among the many cartoons of Barbara Shermund's that illustrate her feminist attitude is a double-captioned one, "A very brainy girl, that." "Hm—But she's not a bad sort, really."[57] This cartoon also has double meaning. The two middle-aged speakers reflect on a "brainy girl," who is not so bad despite her intelligence—but it also reflects the attitude among certain fun-loving circles that to be brainy was considered boring. This cartoon also shows Shermund's understanding of women's present and past roles in society.

Shermund would sometimes attack men

Courtesy of Art Research Associates

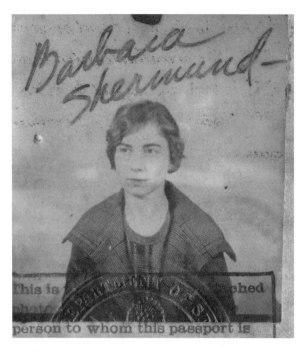

Barbara Shermund's passport photograph
Courtesy of Art Research Associates

Barbara Shermund
Courtesy of Art Research Associates

front and center. In another party scene, a woman is peering over to a snuggling couple and says, "Oh, I beg pardon—I'm just looking for my husband."[58] Or a man holding a woman with glee: "Look what I found—isn't she sweet?"[59] The women in Shermund's cartoons, as in this one, are often exposed as part of the problem— this woman looks pleased to have been "found" by the old man. But perhaps the best jab at men's attitudes can be seen in the cartoon of September 1928 of two men talking at the stereotypical male bastion, the golf course club: "She's an exceptional woman—thinks like a man."[60] (This predates Professor Henry Higgins asking "Why can't a woman be more like a man?") The decision to place these men at a club narrows the field of her target of ridicule and exposes that bastion for what it was (and may still be).

Shermund's comments on the conventions of women were frequent. She often set her cartoons in beauty salons and at jewelry and hat counters. She seemed to take great joy in exposing the

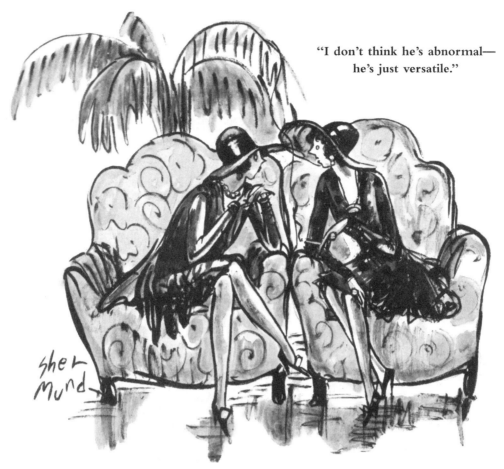

"I don't think he's abnormal—
he's just versatile."

routines women took on and the assumptions they made in order to attract men. "It's funny, the minute I put a few beads on I'm a different person.";[61] "I want some face powder to match my stockings."[62] In a cartoon from 1927, a woman is washing her face, and her girlfriend/roommate, standing to the side, says, "Dearie! You're not washing your face!"[63] This hit the nail on the head to such a degree that Shermund received a letter from the Marie Earle Salon on Fifth Avenue. ("Washing" one's face was considered harmful to skin in some female circles.) Not a critical letter—it was an offer to give her a complimentary facial treatment. By this time, April 1927, the advertisers in *The New Yorker* had become upscale and very tied into the readership, much to Harold Ross's dismay. He disliked the fact that there was a need for advertising. But as is often the case, when cartoonists make fun of a product or a politician, the recipients love the attention. The twenties began an era of rampant consumption, and *The New Yorker* rode the wave—in advertising and cartoons—to great success.

Barbara Shermund never married, although her letters indicate she had a few serious male love interests. Her attitude toward the convention of marriage, based on her car-

Cartoonist Eldon Dedini was a friend of Shermund's who met her at a party in the 1940s. Dedini felt that Shermund was almost "like a flapper," and said, "I couldn't help feeling like she was like her cartoons."[70] The flapper was a phenomenon in the 1920s—a woman who was fun loving and sexy, although perhaps in an androgenous way. The flapper was supposed to be a buddy to her man, partying to all hours, very much the antithesis of what women had previously been cast to be. The flapper was a perfect subject at this time for humor about, by, and for women, because, as a buddy, she could share in the same humor as men. Because she was "like a man," men could accept her jokes, and she was given "permission" to "get" their jokes—often sexually suggestive. The flapper and the joke-sharing were short lived, however.

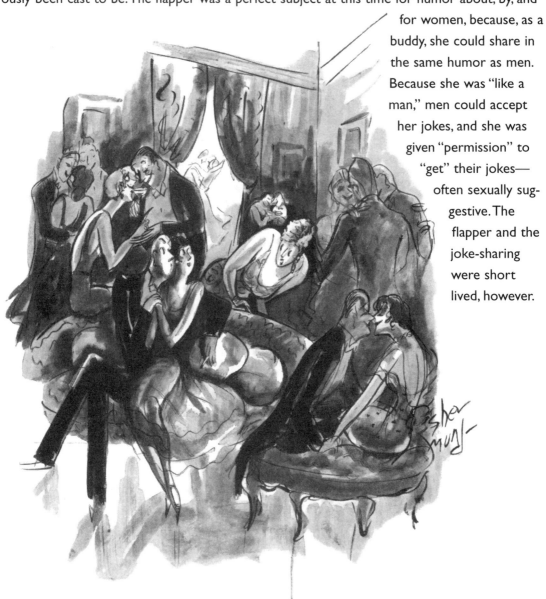

"Oh, I beg pardon—I'm just looking for my husband."

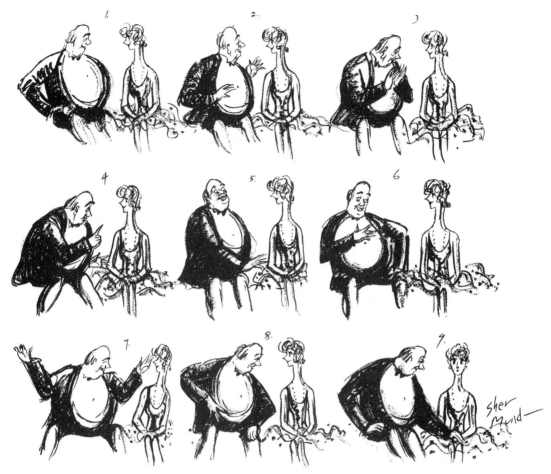

**"You're a very intelligent
little woman, my dear."**

toons, would be to laugh at it and deem it unnecessary. This comes through in such cartoons as "She's got married and she's awfully blue about it.";[64] "What! Not married yet?" "My dear, don't tell me you're *still* married.";[65] "Poor mama! She's so thrilled about my wedding.";[66] "And does Eloyse still sing?" "Oh, no—she's married now.";[67] "And why didn't you marry him?" "Oh, my dear, he crossed his T's so brutally.";[68] and "Yeah. I guess the best thing to do is to just get married and forget about love."[69] Marriage had been a straightjacket for many women for years, and for some, it was time to get out or avoid it altogether.

Of the women cartoonists, Shermund represented a beginning of a new stylistic phase of cartoons. It was one in which the artist was drawing in a more "cartoony" way. The basis of the cartoon came less from an illustrator's training than from a desire to draw car-

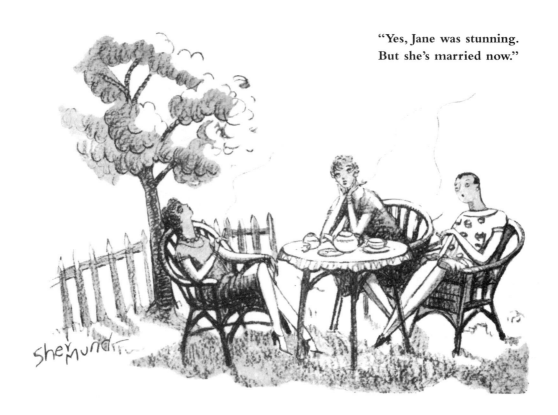

toons. Though her early work emanated from a strong art background, she evolved as a cartoonist within the magazine. Her strong female voice changed as did the tone of *The New Yorker*. Shermund's work changed in the forties, in style and in voice, yet the underpinnings of this change began in the thirties—her faces became stylized and less realistic, and simultaneously her humor became less poignant.

Up to this point, the women cartoonists at *The New Yorker* were all trained as artists. A woman arrived on the scene in 1927, however, who had not had art schooling, yet she still found a niche at *The New Yorker*. Mary Petty was a remarkable artist who followed her individual style to great admiration as a cartoonist. Her cartoons did not poke fun at gender issues, but

instead at class issues, something on the country's mind as it entered the Depression. The fun of the twenties was dwindling, and more serious matters were at hand to be made fun of.

Mary Petty was born in Hampton, New Jersey, in 1899. She came from a well-educated family—her grandfather was a doctor, and her mother was a schoolteacher before marrying her father, who was a rather gruff professor of law at Columbia University and New York Law School. Mary was one of seven children and had a difficult relationship with her father,[71] though she idolized him. The warmth she felt for her mother and for her siblings did not help to lessen her overwhelming feeling of that of an outsider within her own family. She spent "much of her time alone, reading, drawing and writing in her diary, . . . yearning to leave the mundane life of Hampton."[72] In a letter to her future husband, Alan Dunn, she writes: "It seems strange to me to watch these people—for though I appear to be one of them I feel apart—a watcher—on looking at people to whom I feel no call of blood."[73]

This feeling of being apart—an onlooker—is not uncommon in cartoonists. Helen Hokinson traveled through life with her sketchbook always looking at people as if apart from them. Mary Petty's cartoons convey the feeling that they come from someone who feels different, and her work *is* different. It took a while for Petty to develop her signature style of drawing and her voice, but when she did, she took her place in the hearts of many readers. Petty's feelings of distance from her family also had a political tone, for she complained in her letters about her family's simple cares and lack of social consciousness. She feared that she was "one of them" and screamed to "climb ahead" and out of there. In the same letter to Dunn, she confides:

Mary Petty
Horace Mann High School, 1918

And so I lag behind with them—somewhere I hear faint rumors that nations hold a peace conference. . . . Sacco and Vanzetti await a governor's word—but it grows fainter—fainter neath the more momentous events—not only in Hampton but in all these parts. All around I hear the voices of the people "Did you know he was put out of the Kiwanis?"—"Say, I thought someone told me you were going to let your hair grow!" . . . I do not want to be one of us—I want to climb ahead—I cannot reach your hand—save me—stretch back a little further or I sink beneath the Elks.[74]

One can hear the humor within her lines, but also a certain sense of urgency and guilt. The need for social consciousness that she and Dunn shared became the backbone of their marriage. (Dunn was a prolific cartoonist at *The New Yorker* just before Petty joined the magazine.) It was also an element in her cartoons.

Although Petty came from a family that appeared to value education, she completed only high school at the private Horace Mann School in New York. Her family lived most of the year on the Upper West Side of Manhattan, summering in Hampton, New Jersey. She "constantly"[75] drew as a child and did illustrations supporting WSS Stamps for the war effort in her elementary school yearbook. It was most likely after she married Alan Dunn that she set her sights on *The New Yorker*. Dunn was a trained artist who had studied at Columbia University, the National Academy, and the American Academy of Rome—his specialty being architecture. By the time they met, he had begun submitting cartoons to the new magazine. His first cartoons, beginning in August 1926, reflected life in New York City—they were about ordinary people living in the city and urban growth.

Mary Petty and Alan Dunn were married on December 8, 1927, and settled into a small, three-

Mary Petty in her senior class play—
Petty is second from the left, top row

room ground-floor apartment on East Eighty-eighth Street, where she worked on a small portable drawing board in either the bedroom or the kitchen. Petty was a thin, quiet woman, with a polite reserve toward people. She mostly wore black outfits topped with a small-rimmed black hat. She hand delivered her work to *The New Yorker* offices, and Alan's as well, since he never went to the magazine. (Alan was a rather nervous man, fearful of buildings that did not have what he considered safe fire escapes.) Many have termed the couple reclusive, but that is not entirely true, because they had a small circle of friends and enjoyed going to parties. Many of her cartoons are set at parties.

The couple had a remarkably close relationship and a "strong mutual interest in each other's work."[76] They wrote letters incessantly whenever Alan was away. In a letter from 1930, Mary writes to Alan that she spent a day "fighting with perspective since you were not here to show me."[78] He clearly was her only teacher, steering her away from formal art training. It is also true that he was a superb draftsman and one of the most popular *New Yorker* cartoonists at that time. Still, Petty's work became much more well known, partly because it became a world unto itself and captivated readers. She sold her first cartoon in October 1927.

Petty had a modest opinion of her abilities but was very protective of her creativity. Both she and her husband wrote their own ideas and became adamant about it. When

most cartoonists were using "idea men," they preferred to remain "pure" to their own artistry. She, in fact, turned down most concepts that were offered to her. In a letter from 1950, she explains, "This is not because I think my own ideas are that good, but because I have a fear that I might come to depend on others for ideas and thereby any ability I had in that line might become vestigial."[79]

"She's not going to divorce him quite yet. She thinks he has another book in him."

Frank Modell, a cartoonist for *The New Yorker* for many years and an assistant in the art department as he began his cartooning career, remembers Petty well. He recalls that "Mary was very powdered and wore unusual hats. She wore a lot of black—she looked like she should be married to Charles Addams, not Alan Dunn."[77]

Petty's early cartoons reveal her lack of formal art training. Throughout her body of work, the characters she drew were often awkward and out of proportion; however, the details in some of the interiors and of the clothes she drew were exquisite. A great many of her cartoons over the first five years reflected fashion and clothes, with young women trying on long elegant gowns. The odd combination, at times, of Petty's characters, details in furniture and clothes, and then strong overall perspective point to the possibility that Dunn assisted her in certain aspects of her work. Her characters and her line work eventually worked together, providing a unique voice that charmed many readers. She gained confidence as the years progressed, and as she drew more, she varied the settings of her car-

Writing one's own captions was not common at this time; many cartoonists used writers. It wasn't until the 1970s that the idea of using a "gagman" faded, and cartoonists almost universally took pride in writing their own ideas. Among younger cartoonists, if they took ideas from someone else, they didn't readily admit it. Cartooning eventually became a complete art form of ideas and words, created by one artist. Perhaps this derived from the art editorship of Lee Lorenz, who arrived at *The New Yorker* in 1973 and who brought in controversial new cartoonists. Or it came from the culmination of years of change in the art world itself—from that of traditional draftsmanship to cubism to abstract expressionism to pop to conceptual to graffiti to art that contained words. Cartoonists and their editors do not work in a vacuum and, regardless of the decade, are always sensitive to trends in art—not that the art world directly influenced cartoons (although the art world was a subject for cartoonists, most often in the 1950s and 1960s, a tumultuous time in the art world. And conversely, cartoons became a subject of the art world as in the work of Andy Warhol and Roy Lichtenstein). With the boundaries of art relaxed, the boundaries of what could be considered a cartoon relaxed as well. Traditional draftsmanship became less common among cartoonists, which opened up new ways to convey humor and ideas.

toons, from drawing rooms to country picnics to city restaurants. Petty's cartoons began to reveal her identifiable and charming style in the mid-1930s.

Petty was meticulous, not producing great quantities of work, but always producing finished drawings, never roughs. She was well aware of her being a very slow worker. In her first full year of working for *The New Yorker*—1928—she published only about one cartoon a month. Her subjects were primarily women doing "women things" such as shopping and decorating, but her interest in social concerns peeks through occasionally, as in her fourth cartoon, published in 1927: "No, no, Jones, leave the curtains open tonight. We must remember the poor people on the streets." Petty's sarcasm toward people's trivial concerns is evident in "The trouble is, Madam, most women pay so little attention to nail health."[80] Although Petty became known for her later cartoons with Victorian settings, her early ones are very much about the younger set in Manhattan, poking fun at their obsessions with clothes and at the rituals of dating.

What is most interesting about Petty's body of work is how it satirized the upper class. Snooty-looking men and women, wearing fur coats at elegant parties, were a staple of hers. Many of the cartoonists enjoyed using the wealthy as a forum for humor, but Petty's cartoons were at times so astute that they allowed the wealthy readership to laugh,

yet claim, "That's not *us!*" She became at times a voice in the magazine on behalf of the service class: her cartoons showed how utterly insensitive the rich ruling class could be toward their servants. She became famous for her drawings of maids (young ladies wearing fanciful butterfly-like outfits), trying hard to please sour

The New Yorker began a regular weekly feature by Lois Long called "On and Off the Avenue" in 1926, which was a fashion column of candid criticism. It was accompanied by an illustration or a cartoon dealing with shopping or often set in an upscale store. Hokinson, Harvey, Shermund, or Petty often did these cartoons and illustrations. *The New Yorker*'s "ability to deliver a large slice of Manhattan's upper crust to . . . advertisers was the key to the magazine's prosperity."[81] Ross saw this type of department as a "necessary evil" and "more or less of a nuisance."[82]

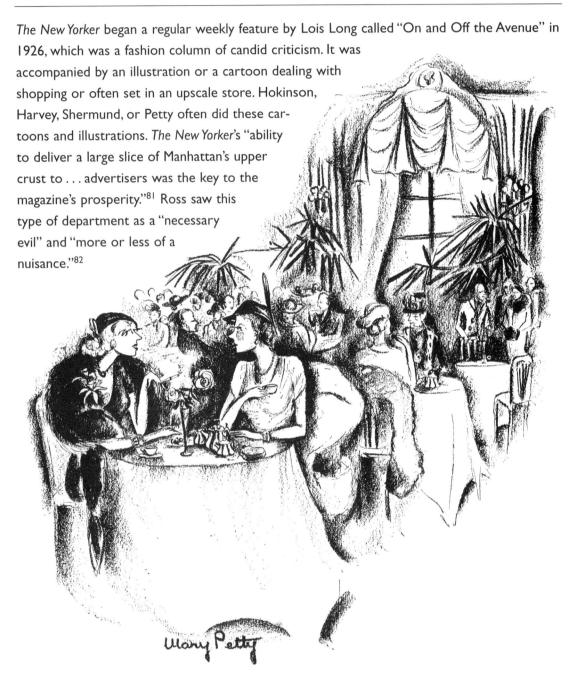

"Then his father paid me ten thousand dollars never to see him again.
It sort of gives you back your faith in men, don't it?"

"No, no, Jones, leave the curtains open tonight.
We must remember the poor people on the streets."

ladies and men who demanded attention and perfection.

Both she and Dunn pined for earlier times, "simpler times," the "brownstone days."[83] "My pencil seems to have drifted into a clearly nostalgic vein—[which] in all likelihood explains all that there is to what 'makes Petty'—just a love of the past,"[84] she said in a letter to an inquiring fan. As her work gained sophistication, so did her details. She was a master of detail in many things: furniture, clothing, buildings, and table settings. Her style moved from a heavy art crayon to thinner pen and pencil line with subtle crayon—which most likely accommodated her desire to create detail. She loved to study catalogues of nineteenth-century English and French

It is difficult to pick out one cartoon to represent Mary Petty's hat cartoons, for she did so many wonderful ones. Petty loved to wear hats, and her humor about them comes through in her drawings, as she makes fun of the silly variations of fashions that women wore in the thirties. She is also clearly poking fun at herself for this indulgence.

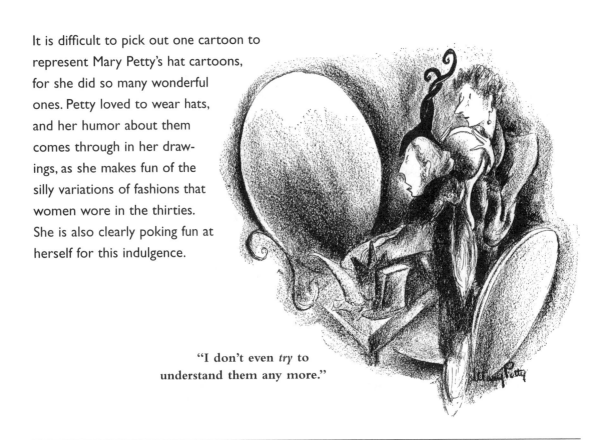

"I don't even *try* to understand them any more."

furniture, and that interest is reflected in her work.

Within these Victorian settings that she reconstructed, she satirized the aristocracy and their sometimes-strange family dynamics. She occasionally drew cartoons about men and their mothers, poking fun at both the domineering matron and the weakling male son. Once she received a letter from a reader, in reaction to a cover: "Is the artist being merely funny or is she trying to portray the Oedipus complex and the emasculating, domineering female?" The cover was far from scandalous—it was of an older woman and a young man at a fancy dinner table, with a painting above them picturing a young woman and her son, most likely the same pair in earlier times. (The writer went on to say, "Frankly, I was surprised to find that the artist was a woman. The conception and the portrayal is more in line with the masculine approach.")[87]

Helen Hokinson, Alice Harvey, Barbara Shermund, and Mary Petty continued drawing cartoons and doing illustrations for *The New Yorker* throughout the 1930s. The magazine's growth and earnings were steady, even as the country fell into the Great Depression. *The New Yorker* was untouched by the Depression financially until 1932, when profits were briefly affected.[88] The magazine did little in the way of covering this time of national hardship, however—something it has been crit-

Petty called the maid that she frequently drew on covers "Fay," and the old lady she served "Mrs. Peabody." Although within the volume of Petty's work these two characters represent a small fraction, they became identified with her and she with them. Perhaps this is because these two characters were most often seen on the cover. Fay was so popular that the bows of her apron became known as "Mary Petty Bows" and became a popular fashion for little girls in the 1960s.[85] Fay was a spirited character, lively in the face of mundane tasks. Petty explained her in a letter to a friend: "I have named her Fay as that name seems the one that most nearly expressed her quality—something rather gossamer and fragile, easily crushed and bewilderingly blown about by the harsh winds of life—yet very occasionally experiencing the unexpected touch of a benevolent zephyr which wafts her up to small heights of timid happiness."[86]

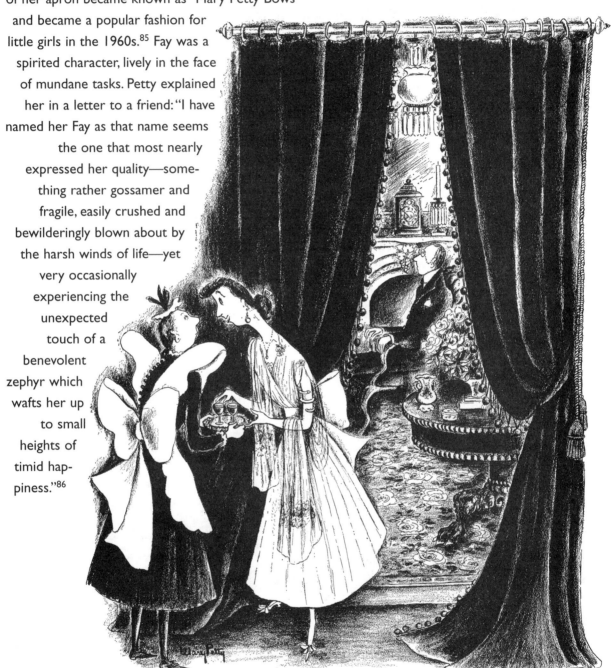

"Which one is the love potion?"

"Rubbish! Lots of children are unwanted. Your father and I didn't want *you*."

icized for in retrospect. In 1930 it was not entirely the same publication we think of today, which is somewhat more political. It was primarily a humor magazine. Ross felt that the serious subjects were for the other publications. *The New Yorker*'s upscale audience was, in general, not affected by the Depression, so therefore neither was *The New Yorker*. Hokinson, Shermund, and Petty drew a few cartoons that made reference to what was happening, but they tended to stay within the realm of their usual topics. With the Roaring Twenties behind them, the women cartoonists of *The New Yorker* began a slow adjustment to America's changing taste in humor. ◆

CHAPTER TWO

BUMPS IN THE ROAD
1931–1940

n 1934, a collection of humor was published titled *Laughing Their Way*. In an introduction to the book, the editors, Martha Bensley Bruere and Mary Ritter Beard, carefully present their premise: that the recognition of women humorists is something long overdue and something necessary to understanding the humor and the pulse of the country. Well reviewed, the book contains cartoons as well as prose and poetry, including the work of Helen Hokinson, Mary Petty, Alice Harvey, and Barbara Shermund. In a 1934 *New York Times* review, Robert Van Gelder states that women writing humor "has been going on for a long time, but it is only in the very modern stuff—most of it borrowed from *The New Yorker*—that one can find [something] to laugh about."[1] At this time, *The New Yorker* was at the cutting edge of humor, presenting the female voice in a

modern way. A few days later in an article in the *New York Times Book Review*, critic R. L. Duffus analyzes the book further to point out that the written content repeatedly pokes fun at other women who are not true to themselves, "the cute woman, the predatory woman, the sloppy woman, the woman who is so female that she ceases to be a human being, does in these pages, get it in the neck from her own sex. But who made her that way? Man did—perfidious man. Such, one feels, is the undercurrent behind these pages." Duffus goes on to say that the cartoons of Hokinson, Harvey, and Petty in this collection are "more biting" than the words. "Here the humor broadens out considerably. It is not asexual, thank God, but it is objective."[2]

These women cartoonists—Hokinson, Harvey, Petty, and Shermund to a lesser degree—had crossed a barrier in humor: they drew a woman as everyman, not just

"Feminism has become a term of opprobrium to the modern woman," wrote essayist Dorothy Bromley in 1927. "For the word suggests either the old school of fighting feminists who wore flat heels and had very little feminine charm, or the current species who antagonize men with their constant clamor about maiden names, equal rights, women's place in the world and many other causes . . . ad infinitum."[3] This phenomenon may have seemed very familiar to women of the 1970s and 1980s. As women asserted their rights, they lost audiences of traditional women and men. And women who were humorists were unquestionably in the camp of assertive women. Challenging the status quo, they seemed to some as threatening. Thus, the brief period of the 1920s when women achieved some parity and could make fun of men as well as their own sex began to slowly fade. By the 1940s, humor that made fun of women was not the friendly fire as it had been in the 1920s and 1930s. This may explain why some women dropped out of the humor business altogether in the 1940s.

• • •

everywoman. They made fun of their sex, and they satirized men, but it was a humor that could appeal to both sexes. At *The New Yorker*, these female cartoonists were given the opportunity to present the world of women as a valid topic for humor; of equal importance, they were given the opportunity to draw cartoons that occasionally moved outside of the typical sphere of women. These two subtle developments were groundbreaking for women in humor. For a brief period in the 1920s, women cartoonists were breaking out of the box that female humorists had been confined to—humor only about women, only for women. However, this new development began gradually to change as the decade progressed and as the country's taste became more traditional again. The change began with Hokinson.

Analyzing Hokinson's cartoons is a difficult endeavor because one is not always sure whose viewpoint the cartoon really reflects. Though many times she did a fully completed sketch of a scene, someone, several people—editors and writers—would then create a caption to go with it. In that regard, she selected the subject matter but someone else finished the concept. Other times, it was the reverse; she would receive a caption and then create an image to best carry it to a humorous conclusion. Thus this was a group endeavor until the early 1930s when Hokinson met a man who became her primary caption writer for the rest of her career. The collaboration shifted her work but made her even more popular with readers. Many cartoonists shifted their style of thinking as times changed. Some successfully adapted, but others did not, and their work faded from the pages of the magazine. Hokinson did not fade; however,

her work ultimately became less colorful. While she originally drew cartoons about city life and a variety of women, over the course of the eighteen years that she worked with Parker, her cartoons evolved into being only about heavy-set, middle-aged women. By the middle of the 1940s, Hokinson felt that the women she drew with Parker were misunderstood, even though adored, by the public.

Hokinson met James Reid Parker in 1931. Parker, a writer, was encouraged by a mutual friend to meet the cartoonist, who lived on Nineteenth Street in New York, just around the corner from his apartment on Gramercy Park. Since they both contributed to *The New Yorker*, the friend thought it was a shame they didn't know each other. Parker admired Hokinson, "above all others of her profession"; yet he was fearful that the meeting would prove to be disappointing. "I was half prepared to meet a worldly creature from the pages of *Harper's Bazaar*. She would be reclining on a chaise lounge and would languidly wave a formidable cigarette holder as she uttered devastating witticisms in a bored tone, or so I feared. Women like that were the fashion back then," Parker wrote.[4] What he did find at their meeting was "a slender woman with frightened eyes and an untidy hairdo [who] sat stiffly, twisting and mangling a tiny handkerchief in a fever of embarrassment.

. . . The Helen Hokinson of the drawing simply didn't seem to be in the room with us." They strived to find pieces of conversation. Parker learned interesting things about Hokinson—that she liked the writing of Trollope and the music of Gilbert and Sullivan, that she had spent several months working in Paris—but still the evening stagnated.

But when Parker mentioned a line of dialogue between two suburban women in a story he was writing, Hokinson remarked how it would make a good caption for one of her drawings. Parker said she could use it. She did, and the resulting cartoon sold to *The New Yorker*. Thus began a successful collaboration, which they both enjoyed tremendously. "Theirs was the happiest of collaborations," John Mason Brown wrote later in an article in the *Saturday Review of Literature*: "If Miss Hokinson's was the seeing eye, Mr. Parker's was the hearing ear."[5]

After their first sale, Hokinson wanted to compensate Parker, but instead, he suggested that they treat each other to dinner. They continued to do this for a year as they sold cartoons—going to the theater or dinner—until it was mutually concluded that the arrangement should be a business agreement. Hokinson and Parker met every Friday afternoon for work periods. They examined each other's work, reviewed rejected drawings, and planned the work ahead. Hokinson had developed a filing

system of clips and articles that Parker adapted for himself: under such headings as automobiles, dogs, children, elections, flower shows, she would file sketches, notes, and illustrations torn out of magazines.

The two became quite close. When one or the other was out of town, they would send postcards back and forth with sketches and ideas. Parker, in his memoir of Hokinson, writes of her powers of observation:

> The chief reason it was so entertaining to work with Helen . . . was that the spontaneity of her enthusiasm . . . to so many things, often expressed a rich delight in visual experience. . . . When Helen said "Look!" in a tone of the utmost excitement, it generally meant that she had discovered a tiny detail of some kind that she hoped I would enjoy. Her powers of observation were extraordinary beyond telling, and her talent for helping you to see what she herself saw was a great gift. It was as if the very genius of comedy took you by the hand and showed you things.[6]

Which cartoons were written by Parker is impossible to know, but this collaboration moved Hokinson's drawings away from being about young women and other subjects toward solely the elderly matrons and "club" ladies. These Hokinson ladies were curious, sensitive, and often quietly opinionated women—who desired to taste new adventures. When these women began to appear with regularity in her cartoons, they charmed readers with their love of animals, politics, traveling, and gardening; their ever-present quest to be in fashion (despite their size); and their wish to learn to drive. They didn't seem stupid, but rather sweetly naïve, and one could relate to them, either because of a mother, aunt, or friend who seemed similar or simply because one could recognize pieces of oneself in them.

As the Hokinson matrons became popular, many other cartoonists tried their hand at humor based on middle-aged overweight women. Dorothy McKay, a self-described "wife, mother and cartoonist" (in that order) was a very popular cartoonist for *Esquire*, but she only drew a few cartoons for *The New Yorker*. Born Dorothy Jones in San Francisco, she began nighttime art classes at the California School of Fine Arts

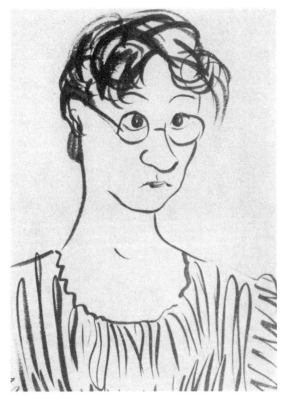

Self-portrait by Dorothy McKay

Hokinson's club lady cartoons were very popular, and it is this subject for which she is most known. Even readers today, who are familiar with Hokinson's work, think of her club ladies as her signature feature. She always contended, though, that the series was Parker's creation.

Hokinson and Parker consistently used the same scene, with almost the same women every time, who often remarked on current politics or social trends. It was as if the reader were looking in on a group of aging women trying to cope with the modern world, which turned out to be their appeal. For the reader, no matter what her age, however, the trends of the world are often baffling. So she can laugh at, at the same time she identifies with, the ladies in their struggles to understand and cope. Though the cartoons could be construed as somewhat unflattering of the women, they touch a nerve in everyone. They go beyond mere ridicule.

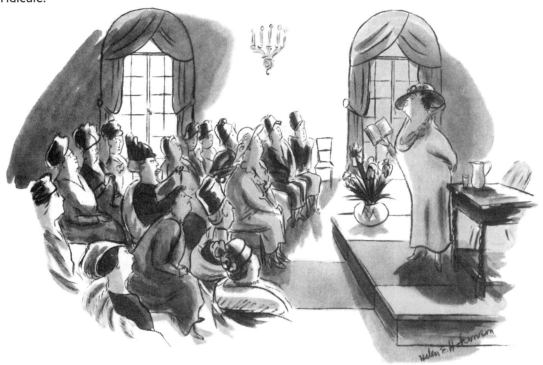

"I shall now quote the passages which I consider obscene."

• •

while still in high school. Her father was a minister and was disapproving when she proudly brought home her nude sketches from class. After eight years of study, she married Donald McKay, another cartoonist, and they moved to New York City's Greenwich Village. McKay worked as a secretary for various advertising agencies while studying at night at the Art Student's League. She explained that in 1930 she thought she would like to become an illustrator, but "editors didn't take her seriously

and still don't," so she "became a cartoonist unintentionally."[7] Intentional or not, she was very successful, working for *The Saturday Evening Post, Collier's*, and *Life* in addition to *Esquire* and *The New Yorker. Esquire* bought eighteen of her drawings at her first submission, whereas *The New Yorker* bought only six all together. McKay drew constantly, filling dozens of notebooks, and was once even arrested in Grand Central Station for sketching. Her "hobby," she says, was "scrubbing the floor and her pet aversion [was] cops . . . which probably accounts for the number of them you see in her drawings."[8] Her

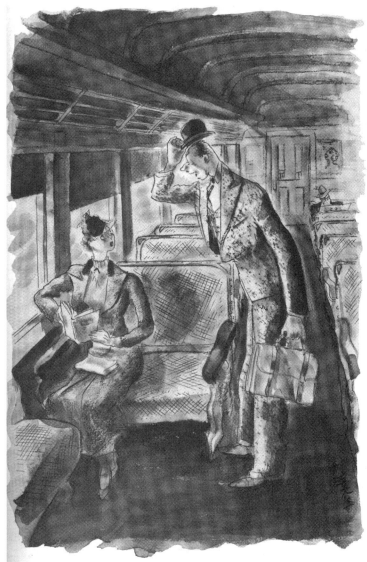

"Pardon me, is this seat taken?"
Cartoon by Dorothy McKay

work has an ease to it that suggests her training and persistent sketching.

In comparing her work to Hokinson's, however, McKay's ladies lack depth of expression while Hokinson's matrons have an endearing, complex quality. McKay's captions (most were written for her) are more one-dimensional—they just poke fun at old ladies. However, *The New Yorker* editors wanted McKay to become a regular contributor, so Katharine White wrote her, offering ideas and encouragement. In 1937, she was asked to bring in work each Tuesday: "Do begin 1937 with a resolve to

never miss a *New Yorker* art meeting for I think if you get into the habit of sending in one or two sketches a week you will soon find you are having at least a picture a week bought."[9] Sometimes, the editors would send McKay an idea, and she would draw a rough sketch, only to be told at a later date that the art meeting did not go for it. It must have been frustrating, despite the elegant and kind letters of rejection from White. The editors tried hard in many cases to match ideas with artists. Katharine White's letters show sensitivity to artists' drawing styles and the type of idea that would appeal to individual artists, as in this letter to McKay in 1936: "One of these [ideas] is a subtle and hard thing to do, but we thought it might just hit you. It is a picture of a woman ill in bed, a woman whose surroundings and appearance make it quite evident that she is not the kind that ever would lie in bed, or have her breakfast in bed, except for illness. Her husband is putting a tray of food on her lap and she is saying 'I dreamt of this for years.' Perhaps it is not your kind of thing, but then again you might like to try something new."[10]

McKay may have tried the drawing, but she grew tired of the exchanges. In 1938, in response to a rather complicated edit that seemed to remove any room for input from the artist, she wrote, "My confidence in pleasing *The New Yorker* Art Committee has just about gone. I admire the magazine and I think you're swell, but when it comes to my work it is apparent we don't agree as to what

is funny. So, let's skip it . . . for a while anyway. We're just wasting each other's time getting nowhere. Thanks for all your trouble and for your patience. When I'm feeling a little stronger, I may try again. With kindest regards, Dorothy McKay."[11] William Maxwell, the intermediary to the artists, responded that he understood and that McKay had put it "exactly as it is."[12] McKay continued to draw for *Esquire*. She and Donald McKay had a daughter, and she lived in New York City until her death in 1974.

Humor was slowly moving toward jokes aimed *at* women, something that evolved over the 1930s. The Great Depression shocked the country and turned back the clock in terms of relations between the sexes. It was true that women held more jobs than ever before, but the freedom of expression that they enjoyed in the 1920s began to decline.

The image of a woman in cartoons was slowly becoming that of either a befuddled simpleton or a man-chasing bimbo. Helen Hokinson's cartoons followed this path, although Hokinson did not consider her matrons stupid. Barbara Shermund's female characters moved from the wonderfully independent smart alecks to bosomy man-obsessed dolls. Her breezy feminist tone diminished, and her ideas became more and more standard—less about gender issues and the New Woman and more just about silly women.

In 1933 a new magazine appeared on the scene. *Esquire* was founded as a men's

In their book on female comedians, *Women in Comedy*, Linda Martin and Kerry Seagrave observe: "By the end of the 1930s the image of female comics had changed markedly, becoming more demeaning to women. Feminism had waned through the 1920s as the main focus of its drive and energy, suffrage, had been attained. The progressive image of the flapper had also faltered after the crash of 1929. Hard times became the economic rule. Men, threatened economically and in fear of losing their traditional masculine roles, turned women into scapegoats. They forced them into inferior or submissive roles."[13]

• •

magazine, focusing on style and clothing. But it was also a literary magazine, publishing the likes of Ernest Hemingway, F. Scott Fitzgerald, John O'Hara, John Steinbeck, James Baldwin, Philip Roth, and Dorothy Parker. *Esquire* also published a large number of cartoonists, many of whom came from *The New Yorker*. This is not to say that *Esquire* "stole" cartoonists from Ross, because many of the artists were able to draw for both *Esquire* and *The New Yorker*. The cartoons accepted by the two magazines were in fact drastically different—*Esquire*'s cartoons were more overtly about sex and relationships and not as sophisticated and subtle. Eldon Dedini, who regularly published in *Esquire* (and became a writer for Barbara Shermund) had difficulty selling to *The New Yorker* at first because Rea Irvin felt his work was "too grotesque."[14] Eventually, Dedini changed his style and sold many cartoons to *The New Yorker*.

Barbara Shermund and Dorothy McKay became frequent cartoonists for *Esquire*. McKay once wrote that *Esquire* dominated her work life from the moment she got

there. Shermund's work in *The New Yorker* had already started to drift toward the type of humor that the men's magazine preferred. When she got to *Esquire*, her work became transparently sexual, and her women were transformed to sweet airheads. Then there was the issue of editing. In contrast to *The New Yorker*, it may be that *Esquire* was not as picky or critical about its cartoons. *Esquire* cartoons were, on balance, bawdy cartoons. *The New Yorker* strived for something more complicated and, at times, nuanced.

This is seen in the quality of *The New Yorker* cartoons—the image of women aside—which was reaching new heights in the thirties. Peter Arno was their *star*: his graphically breathtaking images and biting humor stood out in the magazine like no one else's. Arno's cartoon women were voluptuous and gorgeous, often arm-in-arm with wealthy old men. James Thurber, who started at *The New Yorker* as a writer, began drawing cartoons for the magazine. His drawing style got attention for its naïve simplicity and his humor was well appreciated for often depicting domineering

women and wimpy men. *The New Yorker* cartoon was being fully noticed and appreciated by the readership—the cartoonists had truly become excellent masters of the art form. Many today refer to that decade as the "golden age" of cartooning. The financial success of the magazine and its artists (they were paid well) attracted new talent into the profession. The definition of what a *New Yorker* cartoon was had become clear, thus attracting many new and capable artists into the fold. The "golden age" did not bring in many new women cartoonists, however, and the reasons for this may be many. The rush of women entering the creative fields during the 1920s slowed in the 1930s, which alone could be the most important factor. The loose, undefined nature of cartoons at the beginning of *The New Yorker* may have allowed more freedom for women to enter and express themselves. This, combined with the increasing trend in the 1930s to depict women in unflat-

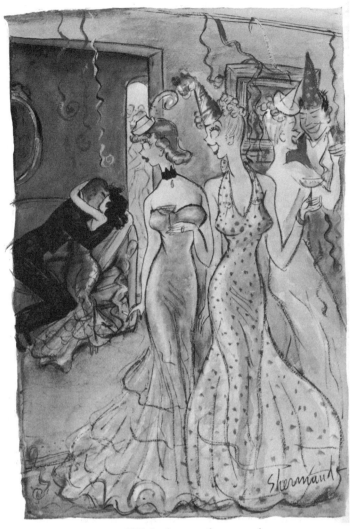

"He's the gentleman who came up to complain about the noise!"

An example of Shermund's non–New Yorker work
Courtesy of Art Research Associates

tering ways, may have influenced potential female cartoonists to look elsewhere to express themselves.

The cartoon-editing process at *The New Yorker* became more complex, seeming at times to be a long, complicated song and dance between the editors and artists. This was true for both men and women car-

The founding editor of *Esquire*, Arnold Gingrich, was so persistent in his efforts to acquire literary greats, he badgered Hemingway into contributing. Hemingway suggested they decide the issue over a shooting match, which Gingrich won; Hemingway ended up publishing *The Snows of Kilimanjaro* in *Esquire*. If Gingrich was persistently determined to get great writers, he was also persistent in getting great artists, for many of *The New Yorker* cartoonists drew cartoons for *Esquire*.[15]

• •

toonists, and the stress of this process was difficult for some. To judge from correspondence, Hokinson's cartoons were minimally edited. Her drawing was always good, and she had found a writer with whom she consistently created humor that appealed to the editors. Also, in letters between Hokinson and Katharine White and Ross, the warmth and care of the relationship is evident. But that was not the case with everyone. Mary Petty had difficulties and wrote in a letter to the art department that she wanted "to complain just a little. You know I did the architect drawing over four times and finally did the whole drawing over—all the time thinking it was alright in the first place—and now you tell me it's the idea they object to— why oh why did I have to do all that fussing then? Do you mean by 'better drawing'— that you want a tighter, slicker drawing or merely to clarify the composition?"[16]

The editors often asked the artists to continually rework cartoons and did not always articulate the desired result. Harold Ross's editing was at times labeled "hunchy" and not fully explained. "Artists were asked to try again and again without being given specific suggestions, until often they threw the drawing away in disgust," states Dale Kramer in his book, *Ross and "The New Yorker."* The committee endeavor of creating cartoons became mazelike: ideas came from outside writers, as well as the editors; ideas with drawings were submitted by artists; drawings without captions, looking for captions, were submitted by artists; and captions on drawings were always being reworked by both artists and writers.[17] Alice Harvey's reaction to the process was strong, and she did not hesitate to express her feelings to the editors. In 1931, she writes, "A very slight manipulation of the caption would do it and I know you are adept at that. *How* do I know!" And then further in the letter, she betrays her true feelings to art assistant Scudder Middleton, whom she doesn't seem to like: "And your public is intelligent, it really is. I'm one of them and if you all would use your heads as much as I use mine we'd get somewhere and I would get a check and I could pay the nurse so she

could go on taking care of my delightful children, so I could go on making miraculously excellent pictures for *The New Yorker*."[18] The artists got along better with Katharine White. It may have been that White had a better understanding of the process and the players, and had a gentler way of writing artists about rejections or changes. However, Harvey doesn't mince words with White, either. In a letter to White in 1931, she asserts, "I don't want to change my picture. You see—I tried all those things that you suggest and others—when I was making it—and this, from my point of view, is the best way and I like it."[19] She goes on to basically tell them take it or leave it.

Correspondence between Harold Ross and Harvey shines light on the process, the art of cartooning, and what *The New Yorker* was striving to achieve in humorous art. The following letters began when the editors refused to pay Harvey for a drawing she said that they asked her to draw:

> Dear Harold Ross,
>
> Do you know what your *New Yorker* boys are doing? Sending me an idea—asking me to illustrate it . . . [then] they say it's lovely but the idea is not fresh and new as it should be. So they withhold my check and tell me . . . surely [I] don't want them to pay for something they can't print. Well, I do, darn it! . . . You all asked me to illustrate the idea—I did it and did it well. . . . I can't afford to indulge your editors in a lot of temperament—this sort of thing has happened to me before and it's happened to other artists. . . .
>
> Most sincerely yours,
> Alice Harvey.[20]

In 1929, nine days after the stock market crash, the book *Is Sex Necessary? Or Why You Feel the Way You Do* was published by Harper and Brothers. Cowritten by James Thurber and E. B. White, it was a parody of the serious books on the subject being printed at the time. What is of note to the world of cartooning is that this is the first time Thurber had nationally published his drawings, and they became a huge success. Thurber was to become a cartoonist known for his commentary on the relations between the sexes, or the "war" between the sexes. Some of his cartoons were particularly stinging toward women, wives in particular, often depicting them as domineering, controlling, and, generally, poison for the male ego.

Dear Alice Ramsey [Ramsey was Harvey's married name]:

As promised, I am writing you further about that drawing. . . . What I think happened is that you were given the idea . . . and that between the time you got it and the time you drew it up the idea came in from some other source, to wit: Helen Hokinson. She had one with almost the identical idea. . . . I'll tell you what you do: send the drawing back here and see if we cannot get another caption for it here. . . .

Your letter brings up something which, to my mind, is a thousand times as important as a single drawing, however, and it is this. I'll begin at the beginning:

For years and years, before *The New Yorker* came into existence, the humorous magazines of this country weren't very funny, or meritorious in any way. The reason was this: the editors bought jokes, or gags, or whatever you want to call them, for five dollars or ten dollars, mailed these out to artists, the artists drew them up mailed them back and were paid. The result was completely wooden art. The artists' attitude toward a joke was exactly that of a short story illustrator's toward a short story. They illustrated the joke and got their money for the drawing. Now this practice led to all humorous drawings being "illustrations." It also resulted in their being wooden, run-of-the-mill products. The artists never thought for themselves and never learned to think. They weren't humorous artists; they were dull witted illustrators. A humorous artist is a creative person, an illustrator isn't. At least they're not creative so far as the idea is concerned, and in humor, the idea is the thing.

I judge from your letter that you apparently don't realize that you are one of the three or four pathfinders in what is called the new school of American humor. Your stuff in *Life* before *The New Yorker* started might well be considered the first notes of the new humor. I remember seeing it and being encouraged by it when I was thinking of starting *The New Yorker*. It had a lot to do with convincing me that there was a new talent around for a magazine like this. And now you speak of "illustrating jokes!" The very words in your letter to me. I always see red when an artist talks of "illustrating" a joke because I know that such a practice means the end of *The New Yorker*, the new school of humor, and all. Unless an artist takes ahold of an idea and does more than "illustrate" it, he's (she's) not going to make a humorous drawing. I haven't any quarrel with your work to date in this respect. You still draw Alice Harvey drawings and God knows give something to them, but I've simply got to run on this way when I hear or see the word "illustrate" in connection with a joke.

. . . Your letter and one or two similar complaints have decided me to try out something [new]. I have long felt that if I participated in the selection of an idea and then turned around and had to judge the drawing when it comes in, I am a disqualified judge. I can't be

both collaborator and judge too. Therefore, I am going to let [Wolcott] Gibbs go over the ideas . . . without me ever seeing them. . . . He will be turned over by *The New Yorker* to the artists to help them [pick] out ideas that come in. . . . [He will show] the artists an idea that may or may not hit them, the artist to draw them up only if they hit her—or him, and *The New Yorker* (meaning me as editor and final decider) to take no responsibility whatever for the merits of the idea, any more than me (I) take it for an artist's very own idea. This puts the buck directly upon the artist which, according to my way of looking at things, is where it ought to be. . . .

Pardon me for having written at such length. I got started and off I went, it seems. I'd like to talk to you about this, but how can you talk to anyone who retires to Connecticut and is never seen around, which is what most of our contributors have done? . . .

Sincerely, H.W. Ross[21]

Ross's words placated Harvey for a while. She wrote him back, expressing pleasure at hearing from him because "you had become nebulous to me—hearing of you only in such connections as 'Mr. Ross doesn't think this is funny.'"[22] The difference, she goes on in her letter, between illustration and humorous art "comes down, like many discussions, to a definition of terms. As a matter of fact—I hate always being humorous. What I like is being true—and knowing people and getting a thrill out of them and drawing it." Harvey continues:

It's too bad it's so hard to run a magazine but if you're going to be so frightfully ide-

alistic about it—you shouldn't change captions, and you shouldn't ask artists to change their drawings. I think the letter you wrote me, Harold Ross, was awfully nice—but full of bunk. . . . I really don't see what you or I or anybody else are going to do about anything. . . . You've done something perfectly swell—in *The New Yorker*, and I hate to obstruct your vision in any way. . . .

Thanks for bothering with me—after all I did appreciate being explained to. I'll co-operate—best I can—but you'd better not send back that picture.

Sincerely, A Ramsey[23]

The drawing remained at *The New Yorker* at Ross's request so that someone could try to write a caption for it. Harvey, still not paid, fired off another angry letter to Gibbs and Ross. Gibbs, in a humorous note to Ross, attached to her letter, asks: "Want me to run up to Westport and bump off this girl?"[24]

Ross *was* "frightfully idealistic" about his magazine. He understood that talent was the lifeblood of his ideal and treated his talent with care. He had respect for creative people, particularly if they understood his ideal. There were bumps in the road, as the exchanges above between Ross and Harvey show, each attempting to express strong opinions within a certain careful respect and affection. But the whole package that *The New Yorker* offered artists was "intoxicating"[25] and mythical—and it carried through over generations of creative people. Some understood it and wanted to be a part of it, others didn't and left.

"Ross operated his *New Yorker* less as a magazine than as a kind of great laboratory where associates were encouraged to pursue individual projects, yet in that pursuit advanced a common cause. . . . The editor encouraged people to write or draw what they wanted. . . . Everyone else, himself included, was to be at their service. Besides his faith, Ross gave his people strength and the comforting knowledge that he would always be there for them. Add to this Ross's intrinsic understanding that writers and artists are different from other people and must be treated—tolerated, he would more likely harrumph—as such. He believed that the same unique vantage point that made creative people insightful could also render them vulnerable, impractical, and maddeningly unreliable. 'I think he thought that people with talent didn't in general know enough to come in out of the rain,' said William Maxwell, 'and he was trying to hold an umbrella over them.'"[26]

The women cartoonists who began with *The New Yorker* in 1925 shared the idealism of the magazine and the youthful spirit and enthusiasm under which the magazine had been founded. Their cartoons continued to be published in *The New Yorker* in the thirties, despite the difficult editing. This process was a reflection of the editors' search for excellence, but its frequent chaotic nature was also symptomatic of the magazine's growth. Instead of a collection of artists pursuing expression and humor within the small environment of the magazine, artists had become over time a commodity for a growing and successful company. More writers and editors were involved with the selection and creation of cartoons. And, following the Great Depression, there was an evolution of humor toward deprecating women that was evident in the cartoons in *Esquire* and, to a lesser degree, in *The New Yorker*. This exacerbated the difficulties for women cartoonists. ◆

CHAPTER THREE

DECADE OF DEPARTURES
1941–1950

The *New Yorker*'s growth in the thirties resulted from an increase of quality in both the art and the written content. But as war threatened, the editors and writers braced themselves for change. The inner workings of *The New Yorker* were shifting, and they continued to do so as America entered the war. In 1939, the quiet, unassuming William Shawn was elevated to the post—virtually second in command—of managing editor. And James Geraghty arrived at the magazine to become art director, an addition that would eventually change the art department significantly. Both of these editorial changes reflected a new direction for the magazine, although not orchestrated, that would alter the tone of *The New Yorker* for decades to come. Essentially a humor magazine for twenty years, *The New Yorker* was forced to become more serious and cover the war.

Ross biographer Thomas Kunkle writes, "It was clear there would be no repeat of its [*The New Yorker*'s] performance in the Depression—no feigned ignorance, no smug detachment."[1] Ross, having been a war reporter in the First World War, was not only aware of how the Second World War would affect his male staff, but he also knew that the magazine would need new art and new viewpoints.

Whether James Geraghty was hired with all this in mind is unknown. In 1939, William Maxwell, a writer whose thankless job was to be the intermediary between Ross and the artists, invited Geraghty to meet Ross—Maxwell wanted to spend more time on his writing and wanted out of that impossible position. James Geraghty, a native of Washington State, had written some radio plays and was attempting to break into the caption-writing business for cartoonists. He had already written a few

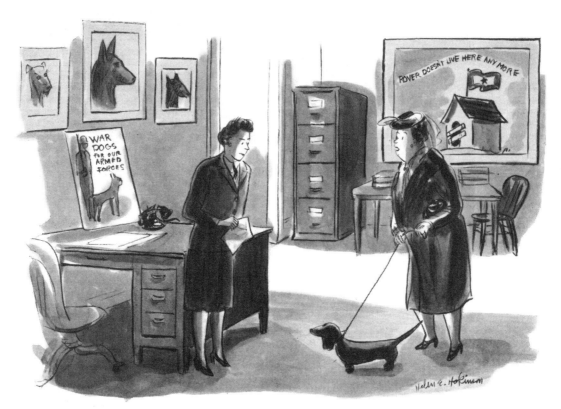

"I thought perhaps he'd be good for crawling under things."

ideas for Arno when he came to *The New Yorker* to meet Ross. Despite a thin résumé, Geraghty was hired and sat in on the art meetings. It's not clear how he became "art editor," but in his unpublished memoirs, Geraghty states that he simply began calling himself the art editor, even though he says he never really had any career aspirations in this regard.[2] Rea Irvin, although instrumental at the beginning of the magazine, had become only an advisee at the art meeting once a week and was unengaged with the process. Geraghty took over the art department and began doing everything—cover assignments, illustration assignments and sales, caption editing, and artist communication. Geraghty saw a need, and he filled it.

The process of creating cartoons thus evolved from a committee endeavor, as it had been for fourteen years, into

James Geraghty
Courtesy of Sarah Herndon

a dialogue between Geraghty and the artists. Staff writers, among other roles, still wrote for cartoonists, and Ross certainly had weekly input, not to mention the definitive word over what was bought and what wasn't. *The New Yorker* cartoon had now become a popular American institution, and the public was fondly familiar with what a *New Yorker* cartoon was. It was now a matter of keeping the art up to the standard that the readers had come to expect, and this was Geraghty's job. In his

memoirs, Geraghty explains, "Some talents couldn't work for us because our editing was too oppressive." He goes on, "What I was paid for was to oversee the production of funny drawings and to do this I had to have ideas for the cartoonists to draw."[3]

The control that Geraghty exhibited was what Ross needed as the United States entered World War II. Ross was concerned about the cartoons and how they would reflect the war, but Geraghty was not. In his unpublished memoirs, Geraghty quotes

The Tuesday art meetings routinely consisted of five people: Ross, Irvin (who in later years was seen dozing during the meetings), Geraghty, Daisy Terry (the general office manager and secretary), and an "art boy." Terry, a formidable presence, handed out knitting needles to be used as pointers and took notes that were distributed to artists. The "art boy" was to present the drawings to be discussed by setting them up on an easel. The "art boy" for a time was a young Truman Capote, and rumor has it that he used to hide drawings that he didn't like.[4]

Ross as saying, "We can handle the text, that's easy. But I worry about the cartoons." Geraghty continues, "He was right and he was wrong. He and his assistant William Shawn handled the text alright, producing what I regard as a body of classic reporting that should become a part of the world's great literature of action. But he needn't have worried about the pictures. The war and the rumors of war were indeed a shot in the arm to cartoonists always and ever in desperate search of material for new ideas. They jumped aboard the bandwagon. Everything changed. I was new and luckily for me newness was what was needed."[5] Some male cartoonists—most notably Charles Addams—left to join the service, as did others on the staff. Geraghty himself entered the Volunteer Officers Corp for three months in 1940 (handing over his office to artist Albert Hubbell for the duration). Ross suggested to Geraghty that he encourage artists who had either retired or drifted away from the magazine to submit new work. Ultimately much of this work was unpublishable, and the staff spent a disproportionate amount of time returning it and making excuses. The magazine rarely solicited work after that (until recently).

One female cartoonist joined the ranks of the magazine in 1940. Not much is known about Roberta MacDonald. Born in San Francisco, she came to New York in 1941, perhaps after selling drawings to *The New Yorker* in the spring of 1940. Her first cartoon was politically minded—concerning the Wagner Act—and not particularly funny to readers today. It reflects MacDonald's sensitivity to politics and the then mood of the country, a talent she demonstrated throughout

her early work for *The New Yorker*. Geraghty must have recognized this about her, and I imagine he was pleased to find an able cartoonist who not only was a woman, and thus would not have to join the service, but also clearly had her finger on the pulse of the politics of the time.

Most notably, however, MacDonald drew about women in the military and in the workforce, something the other female cartoonists rarely did. Her general attitude about these subjects, nonetheless, was fairly traditional. Still, MacDonald's cartoons about WACs (members of the Women's Army Corps) are refreshing, opening up discussion about what it must have been like to be a female in the male-dominated society of the military. She seemed to enjoy drawing army women standing at attention—in one, after being told by their female officer to "rest," they all get out their compacts and powder

Long, multipaneled cartoons are more likely to be generated from one artist's mind, because the pace and telling of the "joke" is visual. It is not a punch line that is written and handed over, but a humorous story communicated through imagery. Single-paneled cartoons can be looked at as shortened multipaneled cartoons. If the cartoonist can get all the information needed into the one image—what happened before the scene is set—she has a single image. Sometimes, however, several panels are necessary, as in the pacing of the setup for the "joke."

Self-portrait by Roberta MacDonald

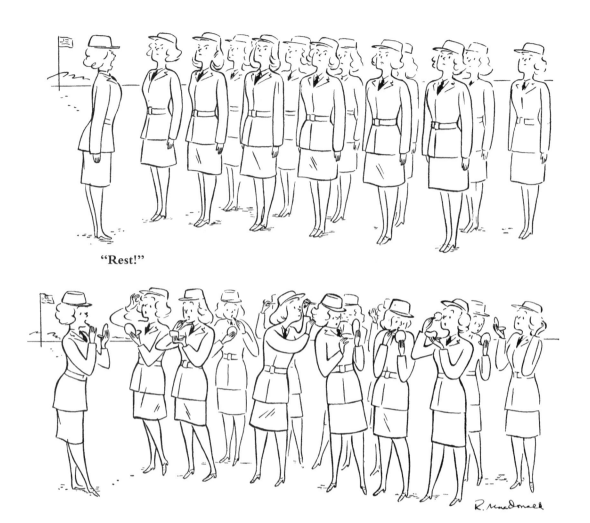

"Rest!"

According to Trina Robbins in her book *The Great Women Cartoonists*, many of the male comic strip cartoonists went into the service during World War II, so women took their places. The number of women working as cartoonists in the comic strip field tripled and remained high until the end of the 1940s. Women who entered the field of action comic strips often felt compelled to change their names to more gender-neutral first names. Robbins states that although there had been many women drawing comics for the past forty years without discrimination, "all the previous comics by women had been comparatively light—cute animals and kids, pretty girls without a care in the world, rotund grandmas pouting homespun philosophy. These comics might be considered 'girl stuff'—a genre men didn't care to work in or take seriously." Robbins contends that a woman entering the action comic field—something they began to attempt after the war—was viewed by some as "trespassing on male territory."[6]

their noses—a comment on women's obsession with looking good and the social necessity to maintain one's femininity.

MacDonald drew cartoons about women factory workers, but again, her take on the subject was based on the then assumptions about women. In one, women factory workers in jumpsuits are on a lunch break, but instead of eating pre-made sandwiches, as is the cliché, they are cooking their hotdogs on a factory burner. The joke is that women are never far from their stereotypical role, yet they can be creative in whatever situation. MacDonald did one cartoon about a woman getting a job in an office and then immediately asking for a raise—she appears clueless and ambitious. And the cartoon indirectly makes reference to women's low wages.

The cartoons that MacDonald drew concerning marriage and child rearing show how women in the forties were exhibiting independence, though the humor is often derived from knocking that independence. Her cartoon mothers are often forgetting their babies at the store, or, in one, a mother mails her bundled infant instead of her bundled package. In another, a woman visiting her friend in the maternity hospital asks, "But what will you do with it [the baby]

on the weekends?"[7] The cartoon is a comment on how women, now in the workforce, might view child rearing as a five-days-a-week job.

After the war ended, MacDonald seemed to have trouble selling cartoons to *The New Yorker*. It is possible that marriage got in the way—in 1944 she married music critic W. H. Simon (of the Simon and Schuster family).[8] In 1951, she called *The New Yorker* offices out of frustration, wanting to speak to Ross. She was advised to write him a letter; he was very ill and not around the office. It took her months to get up the courage to write. The initial source of her distress and need to speak to Ross was that, out of guilt, she could not sign the usual yearly contract that had been sent to her. In her handwritten, illustrated letter, MacDonald states that Geraghty told her that she had lost her touch and that both he and Ross felt her work was not suitable for the magazine anymore. Clearly, this pained her tremendously, and she expresses great love and fondness for both *The New Yorker* and Ross. In an in-house memo following her letter, the unidentified writer notes that Geraghty claims never to have told her "to stop submitting work, or that her work would go better elsewhere; what he did tell her, Geraghty insists, after seeing her illustrations in a Phyllis McGinley book of poetry, *A Short Walk from the Station*, was that she could make a fortune illustrating such books. Somehow, Geraghty guesses, she twisted his remark to conform to her accusation."[9] There is no document indicating her letter was answered; Harold Ross died later that year. MacDonald's cartoons stopped appearing in *The New Yorker* in 1952, but she continued to illustrate many books for adults and children.

MacDonald's experience with *The New Yorker* may have been the result of one or a combination of reasons. First, she may have opted out since she found illustrating books to be more lucrative. Second, it is possible that the body of ideas she submitted were not as good as they once

were. But we will never know. If one looks at what was happening in the United States at the end of the forties, it is not inconceivable to think that her humor about working women was simply not of interest to the readership; and Geraghty may have sensed this. Although more women were working than ever before—primarily in stereotypical female jobs such as teachers, nurses, and secretaries—more and more women and their families were heading to the suburbs and into domesticity. Once the war had ended, MacDonald may not have known where to go with her humor, though we really don't know if she was given the chance.

Another woman cartoonist whose work was similar to MacDonald's, and who

"It's probably a publicity stunt to get us to enlist."

began drawing for *The New Yorker* in the early forties, was Mary Gibson. Her cartoons appeared only eight times from 1943 to 1951, and the only thing known about her is her work. She, too, began by drawing cartoons about women in the military, which included subjects ranging from the stocking shortage to WACs needing a hairdresser. The one reprinted here is perhaps her most humorous cartoon, poking fun at both the military and the stereotype that women's only desire is to find husbands.

After the war was over, Gibson's cartoons looked more like Hokinson imitations and were concerned with insecure, middle-aged women. Gibson's drawings were not unlike other work found in the magazine—somewhat realistic depictions of people and environments. Her women's faces look like Shermund's women. And, although not badly drawn, Gibson's work doesn't have the ease and fluidity of Hokinson, Shermund, and Harvey. Gibson lacked a specific style, and that, combined with mediocre ideas (whether or not they were her own ideas is unknown), was not enough to keep her work in *The New Yorker.*

In the forties, the magazine was no longer a flippant humor magazine but one of world-class fiction, war reporting, and political commentary. Whereas the text of the magazine grew more serious, the cartoons continued to carry the humor— although, as noted before, cartoonists were

grappling with the war, too. Some artists used the magazine as a platform to attack Hitler. A number of cartoons depicted servicemen coping with international travel and missing their families. But most of the cartoons were more indirect references to how the war affected Americans at home. In 1942, *The New Yorker* published a collection of cartoons called *The War Album,* edited by Geraghty, which included work by Hokinson, Harvey, Shermund, Petty, and MacDonald.

If reorganizing the art department was a necessity, that did not mean that Geraghty's beginning at the magazine was always seamless. According to Kunkle, Geraghty had some "management shortcomings" and could be "abrupt and abrasive" with some of the artists.[10] He was capable of losing his temper. Once, while in disagreement with cartoonist Mischa Richter, the office exploded into a shouting match and the cartoonist was told to get out. Ross got wind of the scuffle and told Geraghty, "You're not paid to . . . blow your top. Let the fellows yell all they want. God knows we're tough enough on them that we should forbid them to talk back."[11] Alice Harvey, Barbara Shermund, Dorothy McKay, and Roberta MacDonald would all eventually leave after Geraghty became cartoon editor—throughout the forties or just as the decade ended. Mary Petty's work inside the magazine dwindled, too, and her

Below is a note written by James Thurber to Daisy Terry, the art department secretary. He is describing an "Imaginary Art Conference meeting, the subject being 'Is the Caption of the Hokinson Winking Man Picture Right?'"

A: She just says she wants to report a winking man. She doesn't say who he was winking at.

B: I agree. She is obviously too old and unattractive to have a man winking at her.

C: Yes, you're right. What about "I want to report a man I saw winking at a young lady"?

A: Much better.

B: Why just winking? How about "I want to report a man who has been annoying young women"? Takes in more territory, applies to more people. Many of our readers are young women who are annoyed.

A: Much better.

C: Shouldn't the woman in the drawing *be* this young woman? How about letting Garret Price do the thing over, with a pretty girl?

A: Much better.

B: No. I'd say have this same oldish woman drag the man she is talking about up to the officer and say "This man has been annoying my niece."[12]

last cartoon was published in 1955 (she continued to do covers until the mid-1960s, nevertheless).

Of all these departures, Barbara Shermund's slowdown of submissions troubled Ross. In a letter to Shermund, Geraghty said Ross was unhappy about it. She had begun accepting ideas in the mid-1930s from various writers and found it an easy road to take. *Esquire* readily published her work and she had a regular feature syndicated by *King Features*. In correspondence around 1940, Geraghty wrote her saying they'd like to send her ideas and that the reason they have not been buying was

> purely the fault of the ideas. We've gone over your scrapbook of used drawings and we feel sure that your recent ideas don't compare with the things you have done in the past. I would rather be frank about this than let you believe your work is any less appreciated or desirable than it ever was. Mr. Ross has asked me if I can't make some effort to get ideas for you here and of course I'm going to try. We don't get much in the mail that you could use. Most of the stuff that comes in is pretty wild but I may be able to direct some of our more resourceful idea people to think along your line.[13]

This must have been hard for Shermund to take: Geraghty is blunt, and his tone less than optimistic. He apparently sent her suggestions around this time, because a letter from a (vacationing) Shermund to him says, "Thanks for sending me the suggestions—I haven't done anything about them because I am up here for a rest—It's wonderful. . . . I was practicing snow ploughs all afternoon, instead of trying to put the first World War, and what we know of this one all in one drawing. I'll try again when I come back."[14] Shermund's letter reveals the complexity and standards expected at that time, and her reluctance to give it a go again.

There are many ways that artists approach drawing cartoons. One way is that a cartoonist acts like a sponge, absorbing the world around her and bringing her own sensibility to paper to create a humorous response to life. At best, this reflects an individual artist's humorous response or observation of life that others will find funny as well. Another method is consciously to select items from events and everyday life and place them into cliché situations, often exaggerating or twisting the elements to produce the humor. This second way of creating cartoons is more like a craft. Both methods can, of course, overlap—the sponge cartoonist sometimes uses "tricks" to create humor (such as rearranging words or choosing different characters), and the craft cartoonist needs a sensitivity to intuit what will be of interest/funny to others. Shermund's letter to Geraghty reflects her inability to continue in a manner consistent with the craft form of cartooning. Shermund, from 1925, was a "sponge" cartoonist, and her humorous responses to the world around her found an audience for a decade. But as the world changed and cartoons under Geraghty's editorship became more craft oriented, she could not easily continue. Her exasperation came from trying to put elements into a cartoon, such as incorporating world wars, something she was not accustomed to doing.

In an undated letter [most likely from the sixties], Shermund advises her young friend and writer, Eldon Dedini, about dealing with *The New Yorker*: "I remember when Harold Ross was editor of *The New Yorker*[,] one of the series of art directors [she means the various people who were liaisons to the artists] gave me a bit of advice—he said never to send in too many drawings at a time—just one or two—also, not to let Ross see me too often—Be a mystery, he said. But of course that was Harold Ross. He was head and shoulders above Geraghty but Geraghty is tough—I remember, when Geraghty was new he once referred to a finish[ed drawing] of mine as 'your sketch' and everyone laughed. I have done a drawing as many as twenty times to get any stiffness out of it and make it look as though I tossed it off in two minutes. I don't know why I am going on like this—just to tell you I know how it is, working for *The New Yorker*. The rejection rate is always high."[15]

Shermund's captions became less consistently one voice, perhaps because she began taking ideas from outside "gag" writers—as did many cartoonists in the thirties and forties. In a letter as early as 1932, Katharine White sent along two ideas

"that might appeal" to Shermund.[16] Perhaps the editors were trying to figure out how to best "use" Shermund's voice and drawing style, to help her with her own caption writing, and to increase her output. This was not easily accomplished because her feminist outlook was so new, and uniquely Shermund's, it was impossible to find a writer to re-create that. This continued into the forties, and as the number of male "gag" writers increased, it became even more difficult. Shermund eventually

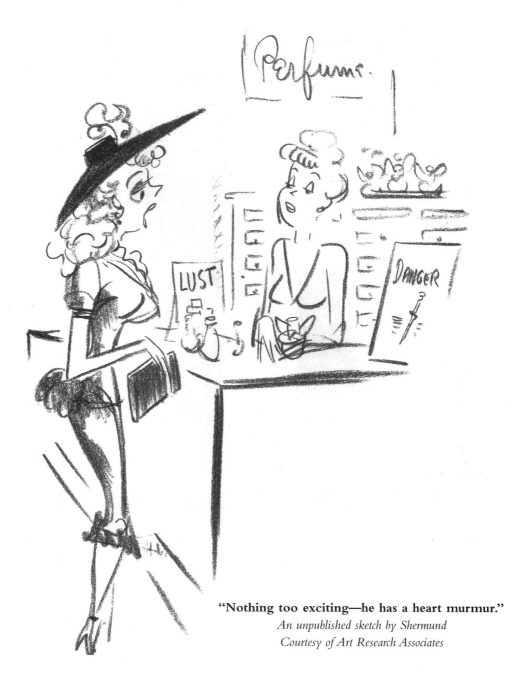

"Nothing too exciting—he has a heart murmur."
An unpublished sketch by Shermund
Courtesy of Art Research Associates

In another letter to Dedini (he eventually wrote a lot of her captions for her *Esquire* work), Shermund describes how she first began to take ideas: "You know, I used to do *all* my own ideas—years ago when I worked for *The New Yorker*—they used to take about three a week and I used to eat and sleep ideas—slept with a pad and pencil under my pillow. I would beg them to give me an idea once in a while but they'd say 'no you have plenty'—but occasionally they would give me one they had bought and liked. One day I had a letter from a writer who wrote, 'You did this idea and this idea of mine' and he wanted to see me to show me some. Well, my downfall, in respect to ideas—he kept submitting ideas and I thought it was fun not to have to worry about [them]."[17]

completely stopped writing her own captions, and the ideas—male viewpoints of what her cute young women were about—became better suited to the male magazine *Esquire*. Over time, her breezy feminist tone became diluted, and her ideas became more and more standard girl jokes—less about gender issues and more about silly, pretty, scantily clad women. She had perhaps succumbed to a world that was antifeminist in order to make a living.

Dedini suspected Shermund may have had a "falling out" with Geraghty, and whenever the two cartoonists met socially, she would ask Dedini, "How is Geraghty treating you?" This may have been an indication that *she* felt that she had not been treated so well. Shermund by 1945 had stopped working for *The New Yorker*, but she continued to work for *Esquire* and *King Features* for a few more decades. Barbara Shermund's journey as a cartoonist reflects perhaps what was happening to women who chose humor as a career. The twenties allowed a certain freedom of expression for women that was slowly suppressed by world events and a change in social attitudes toward women.[18]

Barbara Shermund lived the remainder of her life on the coast of New Jersey in a little house by the ocean. The letters she wrote to Eldon Dedini toward the end of her life reflect an artist who seemed defeated—*Esquire* stopped publishing cartoons in the fifties. *King Features* dropped her feature, and *The New Yorker* never published her work again, although she was invited to submit work.

Hokinson had begun her career in collaboration with writers. In contrast, Shermund began

her career writing her own captions and eventually took ideas from writers later in her life. Collaboration implies a give and take between two creative minds, each respecting the other's view. However, often, artists would just buy a gagman's joke and illustrate it—a method that could produce a funny cartoon but inevitably produced a less integrated worldview. The ideal cartoon is not just about the joke, although the laughter is central. It is also about a broader take on life. It often reveals a poignant or ironic observation that rings true to the reader about the world. This is best achieved by one artist with a complete or sophisticated vision, or by two artists collaborating, drawing on each other's humorous and darker strains of creativity. Hokinson's work was a wonderfully successful exchange between editors and writers (at *The New Yorker*, and later with her collaborator Parker) and her unique visual humor. Nevertheless, over time she became dissatisfied with that because, I believe, the cartoons of hers that *The New Yorker* printed became one-dimensional. The middle-aged ladies that she and Parker created became so popular that that milieu became almost all she drew. It is possible that the editors' desire for her to produce more of these sorts of cartoons may have stifled her evolving talent further. At any rate, her lack of control over her subject matter and even the captions became a source of contention.

The period between 1943 and 1944 produced a flurry of letters among Ross, Hokinson, Geraghty, Katharine White, and Hawley Truax (*The New Yorker*'s treasurer) concerning two issues: captions and money. At this point in time, it appears that Hokinson had less control over her

New Yorker cartoonists in the middle of the century commonly used "gagmen." With the tremendous popularity of *The New Yorker* came cartoon writers who aspired to write the captions; because many cartoonists were struggling to find ideas, they were willing to collaborate. The concept of a "gagwoman" was nonexistent. (If there were any, they probably would not have been called "gagwomen"!) This may have presented a problem for female cartoonists, for whatever voice they had was not always successfully duplicated by or matched with male humor writers. Generic humor about women—ideas concerning lingerie and hats and gardening—could be duplicated. But not humor that came from a personal vision—a voice—of the experience of being a woman.

The National Cartoonists Society (NCS) was started in 1946 by a group of cartoonists who enjoyed the pleasure of each other's company. From the beginning, it was founded as a "men's club" of comic strip artists and "gag" cartoonists, and they specifically did not want any women attending. This was not unusual at the time—there were several men's clubs in New York City that served as a model for the cartoonists. By 1949, the NCS had begun mounting exhibitions and speaking for charitable causes and, in that fall, had mounted a national tour to sell US Savings Bonds. That year, the president of the NCS received a letter from cartoonist Hilda Terry (a comic strip artist), who served as spokesperson for several other female cartoonists. In her sarcastic letter reprinted below, she asked that the organization admit women cartoonists, particularly because it had become a professional organization. Excluding women, she argued, was damaging to their careers. Barbara Shermund, Terry, and Edwina Dumm (a successful strip cartoonist since 1913) were the first three women to apply and be seriously considered for membership to the NCS. After intense disagreement among the members, two separate votes, and an attempt at blackballing, they were admitted in June 1950.

Gentlemen:

While we are, individually, in complete sympathy with your wish to convene unhampered by the presence of women, and while we would, individually, like to continue, as far as we are concerned, the indulgence of your masculine whim, we find that the cost of your stage privilege is stagnation for us, professionally. Therefore, we appeal to you, in all fairness, to consider that:

WHEREAS your organization displays itself publicly as the National Cartoonists Society, and

WHEREAS there is no information in the title to denote that it is exclusively a men's organization, and

WHEREAS a professional organization that excludes women in this day and age is unheard of and unthought of, and

WHEREAS the public is therefore left to assume, where they are interested in any cartoonist of the female sex, that said cartoonist must be excluded from your exhibitions for other reasons damaging to the cartoonist's professional prestige,

We most humbly request that you either alter your title to the National Men's Cartoonists Society, or confine your activities to social and private functions, or discontinue, in effect, whatever rule or practice you have which bars otherwise qualified women cartoonists to membership for purely sexual reasons.

Sincerely,

The Committee for Women Cartoonists

Hilda Terry, Temporary Chairwoman[19]

captions and had discussed this with Ross over dinner. In a letter afterward, she expressed gratitude for dinner and for their agreement that he would keep her in the loop. She states, "I am glad that I am going to see how captions will come out in *The New Yorker*. Sometimes it gave me quite a shock when I opened the magazine. A caption should sound spontaneous and when several people work over them they lose a lot of it. If, when the O.K.'d rough comes back to me, it could have the caption the way it is to be used, then I could draw it or not, and there would be no argument about it."[20] Ross, in a letter that seemed to have been sent simultaneously, states, "We agree that you ought to have your say. It will mean that we will have to settle on captions earlier than we have in the past and not wait till the drawing and everything are okayed and then start debating the wording of the caption. As I told you the other night, I'm all for artists taking an interest in captions if they will do so."[21] Then a few days later, Ross attempted to correct Hokinson on the spontaneity question, misunderstanding her, "I don't want to kill argument on them for God's sake. I'm for argument, or at least debate and adequate consideration (with tolerance on both sides), until we get them right. I suspect that you are wrong in your theory of how spontaneity comes about, however. As one who has been concerned with writing for practically a lifetime, I know that a sentence that sounds spontaneous seldom is spontaneous; it's usually something that's been worked over and thought over and been rewritten a lot of times."[22] It is hard not to read between the lines—let's have debate, but I ultimately know better because I have been doing this longer. Hokinson was not suggesting that captions be *written* spontaneously, but rather that they should *sound* spontaneous. Perhaps she was criticizing to some degree the writers at *The New Yorker* at that point for not writing the best, right, or appropriate captions for her work.

At the same time, Hokinson asked for a rate increase that would bring her payments up to the level of Peter Arno's. Hokinson was still one of the "preferred artists" on a list that the editors kept,[23] as were Arno, Addams, and Thurber. When she heard of Arno's rate increase, she felt it was wrong that his rate had increased while hers hadn't. She knew her value to the magazine and that she had been one of the pioneer talents. Katharine White, who had been brought into the discussions to appease Hokinson, agreed with the artist. A syndicate was courting Hokinson, offering her a daily cartoon, which reinforced her feelings that she should not sign the annual contract *The New Yorker* had sent her.

This caused a slight panic among the editors: how to please Hokinson and keep

her exclusively at *The New Yorker*. The editors consulted her contract, and Ross came up with a scheme to offer her a large sum of money for the rights to her cartoons past and present. In a letter to Truax, Ross describes his idea by beginning, "I have a scheme whereby she could be satisfied so far as finances go (although not so far as her ambition goes to become a priestess of the women's pages throughout the nation), and whereby *The New Yorker* might make a very good investment— possibly effect a coup. We do not have republication rights to the Hokinson drawings we have published during the last twenty years. We could buy these rights and pay her a large sum of money on account, in advance. Thus we would be tying up these rights against the possibility of starting a syndicate of our own sometime. I think the company might be justified in making such an investment purely on business grounds alone—aside from the fact that a sum of dough now might well swing Hokinson from her present plans."[24] He goes on to suggest that this (or something similar) could be offered to all artists eventually, similar to something that *The New Yorker* eventually did.

Hokinson appeared ready to withdraw from *The New Yorker*, according to Geraghty, who felt she was being "egged on" by someone. Geraghty offered his opinion that Hokinson should not get the higher rate.[25] It was perhaps after Hokinson spoke with Katharine White and their conversation was relayed to Ross that the issue was resolved. White reported to Ross that Hokinson's reasons for wanting to do the daily cartoon were to reach a wider audience and that she "felt discouraged that she had reached her financial top ceiling" at *The New Yorker*. White strongly advised the editors to give her an increase. But she also counseled Hokinson with the following reasons to stay with the magazine:

1. Fatigue, nervous strain, and interruption to normal life of *any* daily feature, quoting examples.

2. Disadvantages of her being typed as a woman page stuff, and the slight stigma attached to the artistic merit of any work by women, which is done for an exclusively feminine audience. (I told her I thought she ought to feel it as much of a comedown as I would feel it if I had to give up being editor of *The New Yorker* for being an editor of a fashion magazine.)

3. Likelihood of her name and her work as an artist growing *less* well known and *less* important by its becoming a commonplace thing, and talking of the many good artists who had made money out of syndicate work but who at the same time had lost their place as a leading satirical and humorous artist by working for newspapers.[26]

While Hokinson took time to make a decision, Ross encouraged her to do more collections of her work, writing that the country was in a "book boom." He even suggested to Truax: "We probably should buy Hokinson a chunk of jewelry or a fur coat or something. Those things have more influence than money, frequently." Ross was nervous: "We're worried generally and, specifically, for one thing, we'd like to change some of her captions without being scared to death."[27] Hokinson never did a daily syndicated feature and ended up signing with *The New Yorker* again. Geraghty reports in his unpublished memoirs that *The New Yorker* was "able to put her mind to rest by agreeing to pay her a not untidy sum in exchange for her agreeing to work for us alone."[28] Ross writes Hokinson, in part:

Mr. Truax has advised me about the contract . . . and I was pleased, relieved and glad. . . . I'm really and genuinely with you in your ambition for a larger audience and, incidentally, more dough. I think that you think men here don't know how women talk and that therefore we ought to accept your captions without question. Whether that is the case, or not, I will say that men know more than you may think. . . . Mrs. White is coming down to work in the office for six months, and I propose to call her into handling of your captions and get her advice and cooperation. She's a woman. She'll be here in two or three weeks.[29]

The concerns Hokinson had at *The New Yorker* were settled amicably. She was producing cartoons like clockwork—almost every week *The New Yorker* readership got its taste of Hokinson. The cartoons were skillfully drawn, and the captions well written, but one gets the feeling that they lacked the spark of her earlier work. Geraghty was known for trying to loosen up his artists, return them to an "earlier simplicity"[30] that he felt many had lost. (A cartoonist who knew Geraghty said that he did indeed try to do that, and he gained some enemies in the process.) If he tried with Hokinson, he did not get far, for her cartoons—while still loved by the public—began to look formulaic. The subject of her work almost exclusively became her plump matrons. These ladies seemed to represent a wealthy culture that surrounded Hokinson in Connecticut, ladies with nothing much to do except shop, try new odd ventures such as fencing, look for maids, and go to

club meetings. They were sweet, endearing women who read a lot, knew what was going on in the world, and, although they at times knew they were silly, also tended to see themselves as more important than was warranted. I believe Hokinson's original women—young, old, thin, or fat—reflected her view of life, and they represented everyman's quest for meaning in the face of an absurd world. But by the late forties, Hokinson's matrons had become a cliché, representing not much more than silly women living trivial lives.

Because of this, Hokinson sought new avenues to bring depth back to her women. In the midforties, she teamed up with well-known playwright Nancy Hamilton to create a play based on the Hokinson women. The artist even took a script-writing course at the Cosmopolitan Club, of which she was a member. Hamilton's script contained some unkind women characters that did not please Hokinson, and after many rewrites, the project was abandoned. Hamilton remembers the collaboration as one of the happiest experiences of her career, however.

In 1949, Hokinson scheduled a series of speaking engagements to try to explain her women to the public. In a *New York Times* article titled "Her Girls Upheld by Helen Hokinson," which reported on a gathering held at the American Women's Association, she denied that her drawings were "lethal or meant in an unkindly way":

"I like my girls," she said. "They don't say anything I don't say. To me they aren't superficial women seeking culture in an easy way. A stupid woman making a stupid remark isn't humorous, but an intelligent woman making a confused remark sometimes is. I rather admire my girls' point of view. And they don't resent it at all."[31]

Unfortunately, Hokinson's crusade to clear up confusion about her women was cut short. On November 1, 1949, Hokinson boarded a plane headed for Washington, DC, for a speaking engagement. She never made it to the talk. The plane crashed just before landing, killing all aboard. Her colleagues at *The New Yorker* were devastated, as was the public who loved her women even if they misunderstood them.

The 1940s was a decade in which many of the pioneering women cartoonists gradually left *The New Yorker*. Alice Harvey's work slowly disappeared from the magazine during this period. Harvey, a prolific painter, spent the remainder of her life in Westport, Connecticut, and died in 1983. Barbara Shermund, although Ross valued her highly, wrote in her correspondence of her difficulty working. Moreover, her persistent desire to get out a collection of her cartoons faded as she grew older. She died in a nursing home in 1978. *The New Yorker* did not run an obituary for her, nor did the *New York Times*, which was on strike.

The departure of so many female cartoonists in the 1940s, as well as the complete absence of new female talent from

"These are very nice, but we're looking for
the kind that eat their young."

1951 until the 1970s, causes one to wonder whether the societal or editorial environment—or both—was inhospitable to women cartoonists. It is not possible to find one reason, but rather a confluence of elements that may have contributed to their departure from their chosen profession: the combination of the shock of war, the changing focus of cartoons in the magazine because of editorial changes, the amount of editing, the increased use of gagmen, and the possibility that these women (who were all of a generation) were unable or unwilling to reflect the new American sense of humor that was based on a growing acceptance of women in solely domestic roles. ◆

CHAPTER FOUR

ABSENCE
1951–1972

In the years following World War II, *The New Yorker* became a more sophisticated publication. Its influence grew nationwide, and it was widely read and talked about. Among its readership, it took on the authority of a bible in guiding a path in the post-nuclear age. As *The New Yorker*'s writers strongly attacked the McCarthy communist purge, and then criticized the Soviet regime, the liberal elite who read the magazine took their cues. They read *The New Yorker* to learn how to think, and they read the ads in *The New Yorker* to know what products to buy. The magazine of the late forties and early fifties was a study in contrast, advertising for furs, vacations in Bermuda, and expensive liquor juxtaposed with serious articles and serious fiction. Readers of *The New Yorker* continued to love the cartoons, however.

Within the magazine, this period brought significant change. On December 6, 1951, Harold Ross died of cancer. Many inside and outside of *The New Yorker* wondered whether the magazine, so embodied by its founder, could continue on without him. Managing editor and right-hand man to Ross, William Shawn, became his successor, to no one's surprise. He was very different from Ross in personality and editing style. Compared to Ross's combative, blustery nature, Shawn was quiet and had an air of secretiveness and intrigue. Where Ross would delegate and collaborate, Shawn was a solo worker who liked control. Harold Brodkey (a writer at *The New Yorker* for four decades) described Shawn as "combining the best qualities of Napoleon and St. Francis of Assisi."[1]

The cartoons of this time reflected the country's increasing drift toward domesticity, as more and more cartoons about suburban middle-class life appeared in *The*

New Yorker. This wave was fostered by conformist pressures stemming from the McCarthy hearings, the growing fear of nuclear holocaust, and a postwar backlash toward women. The cartoonists of this period did not often pointedly question the status quo, but rather, they "[worked] within the bounds of the complacent national consensus of conformity, consumption, and success."[3] Although they also made fun of this new American way of life, certain comic conventions toward women continued, and the war between the sexes became focused within the suburban home. *The New Yorker*, while still an organization that hired many women writers and staff—and thus sustained women professionals—nonetheless often depicted women in a less-than-positive light in its cartoons. While an influx of new male talent descended on *The New Yorker* at this time, very few female cartoonists joined the magazine.

Among cartoon editor James Geraghty's regular contributors were only two women: Mary Petty and a newly arrived cartoonist named Doris Matthews. Matthews's work was multi-paneled and often captionless. Not unlike others cartoonists of the period, she, too, ridiculed the suburban husband and wife in the drawings that she sold to the magazine over a ten-year period.

Born and raised in Spartanburg, South Carolina, Matthews wanted to go into carpentry because her school didn't have an art department. Her principal advised her to go into "domestic science," but she didn't take his advice (she admits "I was never very domestic, I'm still not!") and found a college where she was allowed to take art classes. A painter, Matthews made her way to an artists' colony in Woodstock,

Some of the older generation of readers did not like the new direction *The New Yorker* was taking. Around the time of the publication of an article by John Hersey about Hiroshima, Helen Hokinson loved to repeat the comment of a woman acquaintance who said: "I've just read that long Hiroshima article from beginning to end, and I just wish you'd tell me what was funny about it!"[2]

New York, and then moved to New York City. Matthews began doing cartoons to make money to support her painting, which in the 1950s was not an unrealistic idea because there were many magazines that published cartoons. *The New Yorker* bought her work, and she became friends with the regular crowd of men who came to the office on Tuesdays. Despite being outnumbered by men, she says, "I never thought of myself as a woman cartoonist. Just a cartoonist."[4]

Matthews wrote all her own ideas, believing the idea to be the most important part of a cartoon. She worked endlessly on her drawings, perhaps because it was asked of her. But she believed then, and still does, that the first drawing was always the best. She remembers that Geraghty would have her redo a drawing over and over, and then "change his mind. And not one red cent for the work. . . . [It] was Ross who started the business of doing cartoons over and over again. He had a purpose. He knew what he wanted in the magazine. The others didn't, they were just following his lead, and it meant . . . a lot of work for a lot of people. [Geraghty] thought he was Ross."[5]

She eventually stopped cartooning because she didn't like what they were buying. She said they were cartoons "from the corporate world that I wasn't interested in."[6] Her cartoons satirize men and women equally and do not portray any feminist viewpoint in particular, except for a tone of slight mockery of suburbia and marriage. Matthews, now in her eighties, continues to paint and live in Manhattan.

The covers took on a clearly new tone under Shawn's editorship, becoming lighter (both in

Ben Yagoda, in his history of *The New Yorker*, *About Town*, states: "Nineteen-fifties America was home to more college-educated women than ever before, they were (for the most part) at home with more babies than ever before, and a significant number of them flocked to *The New Yorker*, representing as it did one of the few ways they could exercise—and in some cases advertise—their learning and culture." At *The New Yorker*, "Women readers continued to outnumber men for the rest of the decade. The studies also revealed that women were more likely than men to read more of the magazine than men. One Iowa woman . . . expressed a common sentiment: 'At first I thought I was reading it for the excellence of its fiction, but soon realized it was opening up a new world for me—a superior continuance of my dropped college years.'"[7]

Mary Petty, in a letter to a friend, wrote that she was "glued" to the TV watching the McCarthy hearings and that they had "a poisonous fascination." She also said that during the hearings, the magazine rented a TV but "took it away after a week because no one remembered that there was a magazine to put out."[8]

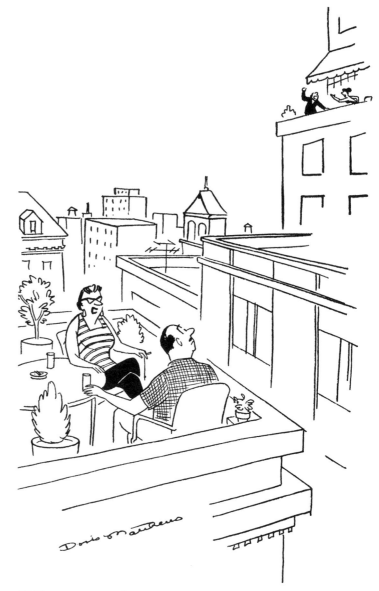

"Why must you always side with *him?*"

color and subject matter) and more decorative. *The New Yorker* hired illustrators and fine artists for its covers. From 1925 to 1989, women artists accounted for nearly half of the cover artists, a much larger proportion than women to men cartoonists. Until recently, cartoonists had always contributed covers to the magazine, including a few of the women cartoonists. Hokinson, who began painting covers for *The New Yorker* in 1927, had done sixty-nine covers (often two or three in one year); Barbara Shermund drew nine covers; Alice Harvey did three; and Mary Petty drew thirty-eight

In an article in the *New York Times Magazine* from 1957 titled "War of the Sexes in Cartoon-land," William McIntyre analyzes, in a rather tongue-in-cheek manner, the trend in cartoons. The entire article is about the cartoon male and his plight of being hounded by the cartoon female. "The cartoon American male is the truly second-class citizen in our matriarchy. He is subservient to femininity and to authority." He continues, "The cartoonists' American is completely controlled by females who shuffle about in hair-curlers and grubby dressing gowns while contriving ways to spoil the flavor of prepared foods." And he goes on like this, describing a horrible scenario of the wimpy suburban husband and the nasty, selfish, lazy wife, who likes nothing more than to shop, gossip, read decorating magazines, and spoil any fun. The author is anxious for the cartoon male to assert himself and get a mistress (instead of just sneaking out to get drunk), and asks if these creations are real. He surmises that because of the frequency of these characters, and the "fact" that these scenarios are "persistently funny," it gives proof that there is some truth to these stereotypes. "If the cartoon male is not truly typical, at least a lot of magazine readers think he comes pretty close—and that may be the same thing." He feels that there is "a measure of self-recognition" with the "harassed male" and that he is a good inspiration for cartoonists, "nearly all [of whom] are male."

This article illustrates the pervasive stereotypes found in cartooning during the fifties. McIntyre never mentions the plight of the poor woman, despite the article's title. However, as a humor piece, one can see how easy it was to simply laugh at stereotypes and not question the hostility inherent in the interdependent characters. The stereotypic cartoon male is weak, while the stereotypic woman was mean, lazy, hostile, and controlling. Most of the extreme cartoons he speaks of were probably *not* from *The New Yorker* but from other mainstream magazines that ran cartoons.[9]

• •

covers. In fact, it may have cemented the reputations of both Helen Hokinson and Mary Petty because they did so many and because their subject matter captivated the readership. Although Hokinson did not write her own caption ideas for cartoons, she did "write" her own cover ideas. The covers she drew always included her heavy-set matrons doing something romantic, exotic, or fanciful. Moreover, her soft easy colors combined beautifully with her images. For both Hokinson and Petty, the covers they did reinforced the public's concept of their work. For Hokinson, this meant that her matron was the sole character she became associated with, and similarly for Petty it was the waifish maid.

Mary Petty began doing covers in 1940, at Geraghty's suggestion. Petty did one or two covers a year, and for a while, she was able to manage the workload of doing both cartoons and covers. All her work, even her cover paintings, arrived at the magazine as finished products, and the magazine rarely

rejected her work. To a fan, she writes, "After the long and arduous time spent on their creation, I am always immensely cheered when someone looks on them with favor."[10] In 1945, she did two covers and five cartoons—a very busy year for Petty. Her covers almost always contained references to old New York society confronting the modern world, something she wrote about in letters to friends.[11]

The covers that brought the most attention to Petty were the ones she did that featured her maid character. She drew this young woman, whom she named "Fay," in her cartoons, but it was through the covers that this maid's persona became clearly defined in the public's mind. As noted earlier, she named her "Fay" because, she said, "that name seems the one that most nearly expressed her quality—something rather gossamer and fragile, easily crushed and bewilderingly blown about by the harsh winds of life—yet very occasionally experiencing the unexpected touch of a benevolent zephyr which wafts her up to small heights of timid happiness."[12] Both Hokinson's and Petty's covers are at times nostalgic and romantic, colored with a tinge of sadness. Hokinson's matrons are sweet, but sad because they often seem lonely in their persistent quest for fulfillment. Hokinson's covers are light and airy, lending a naïve outlook that one senses comes directly from the artist's heart, however silly

the matrons may appear. Petty's are at times darker. The romance she paints originates in the past; the sadness is in the subtext that this past is being replaced by an urgent modernity. Her character Fay represents a yearning spirit—as does Hokinson's matrons—in an ever-changing world. As noted, Petty is both nostalgic for the old "brownstone days" of New York and critical of the aristocracy that occupied many of those homes. Her criticism comes through in the contrast between Fay and her rigid employers. The viewer hopes that Fay will break free; similarly the viewer cheers Hokinson's matrons to break free of the constraints of their age and size. Interestingly, Hokinson's matrons might have been Fay's employers.

As the forties came to a close, Mary Petty continued to do covers, but she produced noticeably fewer cartoons. By 1948, she had no cartoons in *The New Yorker*, though in 1954 and 1955 she had one cartoon each year. Still, the Fay character appeared on the cover of *The New Yorker* at least once a year, and Petty continued to receive a great deal of adoring fan mail. In 1956, she sought a contract clearance from *The New Yorker* to market a doll based on Fay. A prototype was created, but the concept of merchandising the doll never reached fruition.

In 1964, her husband, Alan Dunn, said that she entered a "self-imposed retirement" from *The New Yorker* over a rejected

cover. It took her two more years before she painted another, her final piece for *The New Yorker*. It is a painting of her elderly aristocrat pulling a bellpull as it snaps and can be read as symbolic of the end of Fay and of Petty's *New Yorker* world. Geraghty said that "rejection upset Mary so much that things were never the same with us again. With Harold Ross gone, Mary was sure we didn't want her work anymore. I couldn't persuade her that we love her drawings as much as ever."[13] It isn't clear if he was writing about cartoon rejections (because her cartoon appearance ended not long after Ross died) or if he was referring to the cover rejection. Geraghty did advise the business department in 1953 that Petty's idea drawing and cover design agreement be allowed to lapse.[14]

Petty's departure from *The New Yorker* nonetheless may have been less about her not being able to take criticism than it was about changing times. In a letter from her husband to a friend in 1972, he writes, "Mary ignored all comment, fought off all publicity, and went her own head-strong way, drawing never to please critics or get ahead, but solely from love of her subject matter."[15] The modern world had arrived by 1966, and Mary Petty, James Geraghty, and William Shawn may have been unable to reach a compromise as to how to usher her artistry into the new world. Her contract had not been allowed to lapse, but had been reduced to a covers-only contract, and her payment per cover was reduced by more than half. In 1967, she returned her contract, unsigned.[16]

On December 2, 1971, Dunn returned to their apartment after dinner at the Century

Club—Petty preferring to dine at Schrafts nearby—to find his wife missing. She was located two days later at Manhattan State Hospital on Wards Island. Badly beaten, incoherent, and with no identification, Petty had originally been found in Harlem, perhaps having been driven there by her abductors. She never recovered from the incident, retaining only the "mental capacity of a three-year-old."[17] Because Dunn was unable to care for her, Petty was placed in a nursing home for the rest of her life. She died on March 6, 1976.

The fifties and the sixties was a somewhat bland period for *The New Yorker*.[18] The humor writing, in particular, could not match the stellar wit of the humorists that included Thurber, Robert Benchley, S. J. Perleman, and Nash, who had published in the magazine previously. In 1949, Ross, lamenting to writer Ogden Nash about the paucity of good writers, asks, "Yes, where are the young writers? The success, so-called, of this magazine is primarily a matter of luck. Within a year after we started we had White, Thurber, Hokinson, Arno, and within a few more years we had a lot more good people, humorists with a pen, pencil and typewriter. Now, by God, a whole generation has gone by and very few more have appeared—a couple of artists and not one (not one or two at the outside) humorous writer, I don't know if it's the New Deal or Communist infiltration or the law of averages, or what, but I do know that if I'd known how little talent was going to develop I'd have got in some other line of work years ago."[19] World events and a certain complacency may have contributed to the blandness and the dearth of humorists, but so may have Hollywood's and television's pull on writers.

The influx of talent in the cartoon department during the late fifties and sixties, however, was considerable—this group consisted of all men, except Doris Matthews. Many of the new writers were the first generation to have grown up with *The New Yorker*, and this was also the case with the cartoonists. However, the cartoons seemed, at times, formulaic: the repeated clichés of desert islands, talking animals, cavemen, prisons, and husband and wife jokes. The spark of the first generation of cartoonists was not clearly visible, as if cartoonists were trying too hard to be *New Yorker* cartoonists, rather than artists with a humorous outlook. There was still a reliance on "gag" writers. Although it is hard to criticize the amazing graphic talent of the cartoonists of the fifties and sixties, the cartoons of this period did not display the same innovative energy that the work from the twenties and thirties had.

The weekly art meetings were now just Shawn and Geraghty, and even there Geraghty was not as comfortable with

Dear Mary:

As we are about to eat the various things listed on the other side of this menu, we learn of the appalling things that have happened to you - You, of all people. We hope - we demand - that you get well as soon as is convenient to you.

We are:

Albert Hubbell
Charles Saxon
Jim Geraghty
Chas Addams
C. E. Martin
Stan Hunt
Bill Steig
Joe Mirachi
Mischa Richter
Jim Mulligan
Everett Opie
Robt. Day
Jim Hamilton
Barbara Nicholls

This drawing was done by a group of *New Yorker* artists and editors lunching together, probably on a Tuesday, after they heard about Mary Petty's misfortune. Jim Geraghty and his assistant, Barbara Nicholls, signed it, as did the following artists who also drew the cartoon: Albert Hubell (a cover artist), Charles Saxon, Charles Addams, C. E. Martin, Stan Hunt, Bill Steig, Joe Mirachi, Mischa Richter, Jim Mulligan, Everett Opie, Robert Day, and William Hamilton.

Courtesy of James M. Geraghty Papers, Manuscripts and Archives Division, New York Public Library, Astor, Lenox, and Tilden Foundations (and also Sarah Herndon)

With the influx of new cartoonists, it was Charles Saxon who really took Hokinson's place in satirizing the suburban middle-aged set (he even did club ladies of a different sort and a series that went on for two double-page spreads). Saul Steinberg, who arrived in the 1940s, set the ball slowly in motion for a new generation of artists who also think on paper. Peter Arno kept doing his cartoons with scantily clad women looking for wealthy husbands. James Stevenson, another newcomer, drew in the tradition of Hokinson. His series were often sketches from life with captions, often chronicling suburban life in a sad, humorous light.

Shawn's manner as he had been with Ross's "rough and tumble style." Both Geraghty and Shawn had strong opinions about the art in the magazine. But it was Shawn who, probably during the sixties, was responsible for phasing out the magazine's reliance on the gagmen. The cartoonists' use of gag writers was perhaps the reason for the repeated formulas. "Shawn felt strongly that *The New Yorker* should publish artists who created their own ideas, and this gave rise to a whole new generation of artists such as Ed Koren, Warren Miller, Jim Stevenson, Donald Reilly, Bud Handlesman, Charlie Barsotti, [and Lee Lorenz]."[20] This evolution eventually put the spark back into the cartoons as the sixties came to a close, and it began to open the door for new artists. At first, the evolution did not include women cartoonists. Whether women were simply not submitting cartoons, or whether their work was not being bought, is not known. Given the nature of the cartoons during the fifties, it is not inconceivable that women simply did not want to participate in the type of humor that was being conveyed in *New Yorker* cartoons at that time. But the complete answer is not known.

By the end of the sixties, the country was about to go through some major changes, as was the art department. These changes outside the magazine included a growing feminist movement, triggered by the publication of Betty Friedan's *The Feminine Mystique*. With this wave of change grew a mounting dissatisfaction among some women readers toward *New Yorker* cartoons. In his unpublished memoirs, Geraghty writes:

When women's lib came along I was in real peril. The libbers objected to so many of our cartoons I began to fear going out socially in New York for fear of bodily harm. I believed that women should be paid the same as men for the same work, and that if a woman wanted to be the president of anything she shouldn't be denied the job just because she was a woman. Since cartoons make fun of everyone they should, I thought, be allowed to make fun of women, or perhaps our magazine should go out of the cartoon business and concentrate on long articles by Elizabeth Drew telling us what we already know.[21]

It wasn't until *The New Yorker* hired a new cartoon editor that the door opened further and a few women cartoonists began to step through. This editorial change of a new cartoon editor, the relaxing of "rules" as to what a cartoon could be (begun by Steinberg and William Steig), and the decreased use of gag writers—all coincided with the second wave of feminism. As in the first wave in the twenties, women were expressing their experiences as women, and the magazine was receptive. Thus a slow new influx of female cartoonists at *The New Yorker* began. ◆

CHAPTER FIVE
NEW VOICES
1973–1997

I n 1973, when Geraghty decided to retire, Shawn selected Lee Lorenz as his replacement. A graduate of Pratt Institute of Art in New York, Lorenz began cartooning for *The New Yorker* in 1958. He never lobbied for the job of art editor, as some cartoonists did, and so was surprised when he was hired.

Lorenz sought to find artists with unique styles and voices. He says he "didn't try to shape" the body of cartoons, but "did feel that a lot of people were reaching retirement age or were reaching a point in their careers

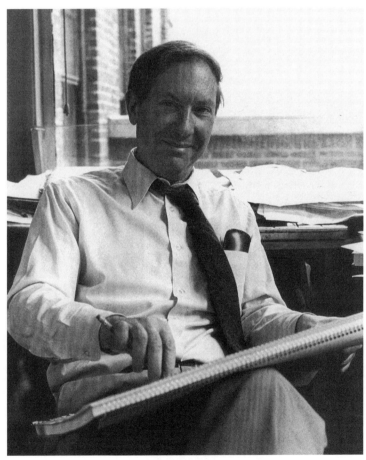

Lee Lorenz
Copyright Anne Hall

In an article in *Newsday* in 1971, William Shawn (who rarely did interviews) is quoted as saying "The amount of humor in the magazine has declined over the years. Not because we wished it to but because of the changing times and because there is less written humor around." Shawn expressed the belief that *The New Yorker* cartoons were "as funny as ever. . . . They probably contain more social and political comment than they formerly did—another reflection of changing times—but basically they still [are] what we always wanted our comic art to be: funny and truthful."[1]

Whether or not the cartoons did contain more social and political comment is debatable. But by this time, Shawn did try to convey to his artists—and I, as an aspiring cartoonist in 1971, felt this—that the aim was to strive for truth through humor.

[when] their stuff wasn't alive anymore—it was dated . . . it was beginning to smell fusty. So I was certainly looking for new artists."[2]

One of his early discoveries was Jack Ziegler, who opened up viewers' and cartoonists' minds as to what a cartoon could be. He sometimes used titles as well as thought balloons instead of captions: his ideas, compared to what the readership was used to, were odd.

His cartoons were so controversial at first that the department responsible for putting the magazine together each week deliberately left them out of the layout, that is until Shawn finally intervened. Lorenz also discovered another cartoonist whose work was quite different—a woman named Nurit Karlin.

Nurit Karlin grew up in Israel. While in the Israeli army, she decided to apply to art school because completing the application enabled her to have a few days off from the army. But clearly

Self-portrait by Nurit Karlin
Copyright Nurit Karlin

Lorenz expressed his views on why there haven't been more women cartoonists: "The profile of most cartoonists is [that] they're loners, they like to work alone. They don't seem to get nourishment from other people. My experience from childhood on, having three daughters, is that [women] socialize with their peers. They socialize in a different way and they don't fit into that profile, for certainly there is no lack of women humorists. Very few have chosen cartooning. I don't think it's a lack of opportunity. I just think it's the kind of life that most women wouldn't accept, wouldn't want to have. In my limited experience, women who work for newspapers seem to be much more aggressive about their careers—I don't mean aggressive as a negative—they're more career-oriented. They know how to operate in the world of journalism, which is pretty tough."

Lorenz continued that the women's movement of the late sixties and early seventies was very vociferous as it had to be to effect change. *The New Yorker*, while always feminist in its hiring of women, still received mail during that time from advocates for women's rights. One such letter, Lorenz remembers vividly: "I wonder if I could find that letter from NOW [The National Organization for Women]. It said 'We are watching you.' . . . I never took any of that seriously. That was sort of across the board, it wasn't just the cartoons, it was the whole magazine."[3]

<p style="text-align:center">• •</p>

there was more to it than that. She always drew as a child, and she had seen *The New Yorker* while growing up in Israel. After a few years of art school, Karlin came to the United States in 1964 to study animation. Through the help of an agent, she began working for the *New York Times* in the *Book Review* and the Op-Ed sections. She recalls that until her agent said she should try *The New Yorker*: "I don't think I thought of being a cartoonist. I did these things, and *The New Yorker* never crossed my mind."[4] She called the magazine, expecting to get an appointment with Lorenz, but was told to drop off her work. "With me, you know, if they hadn't taken one from the first batch, I wouldn't have gone back," she admits. With that first submission, Lorenz asked to see her.

Karlin sold a cartoon right away and was invited to come in weekly to show her work personally to Lorenz. Coming in every Wednesday—Tuesday and Wednesday were the two days for submission—with ten or so finished drawings, she joined all the other cartoonists who came in on that day for lunch. The group would then "do the rounds," walking from magazine to magazine showing their cartoons to *Ladies Home Journal*, *Audubon*, *Good Housekeeping*, and *Saturday Review*. *The New Yorker* came first, always, because it paid much better, was considered the pinnacle of cartooning, and gave the artists a measure of respect. Karlin says, however, that although she remembers being the only

When *The New Yorker* began in 1925, the art meetings fell on Tuesdays. This was the official day to bring in cartoons. At some point, most likely under Lee Lorenz, another day was added: Wednesdays. The new cartoonists were asked to submit their work on Wednesdays. Roz Chast and I began submitting on Wednesdays. I remember meeting Karlin, but she lunched with many of the older cartoonists. I ended up having lunch on a regular basis with other newer cartoonists: Roz Chast, Mick Stevens, Jack Ziegler, Bill Woodman, and Bob Mankoff in the early 1980s. (Later, I was invited a few times to lunch with the Tuesday group, known to us newcomers as the established older crowd. There, I was fortunate to meet James Stevenson, Donald Reilly, Charles Saxon, and others.) In the late seventies, before lunch, my group would "do the rounds," taking cartoons to magazines such as *National Lampoon, Audubon*, and *Cosmopolitan*. It was a fun time—often we would do extra things after lunch, such as play pool in a local midtown bar or ride the Circle Line Boat Tour around Manhattan. Wednesday was the cartoonists' Friday, so we often celebrated after a week of creative exertion.

woman "making the rounds," she felt she was treated "like everyone else" at the places where she submitted her work in person. When she received fan letters, however, they were often addressed to "Mr. Karlin."[5]

As cartoon editor, Lorenz remained respectful and minimal in his comments. The artists would individually go into his office and sit in a chair by his desk—after waiting outside in a small area with a couch—and he would silently leaf through each one's weekly "batch" (the common term used by cartoonists for their week's work). He would rarely say anything, let alone laugh or smile. This was true in his interaction with Karlin, with an added dimension. "Every once in a while I would bring something and Lee would say 'I'm not sure I get it' and I would try to invent an explanation. Sometimes it worked and sometimes it didn't. I remember once I did one and it was an hour glass with instead of sand at the bottom, there was an egg. He looked at it and said, 'I'm not sure I get it' and I looked at it and said 'I'm not sure I do either.' . . . He said, 'Huh, I like it anyway.'"[6]

Karlin's work was unlike anything else in *The*

Karlin said that Lorenz did not edit her work much. "When it's one panel, either it's there or it isn't," Karlin said. Her work is so visually oriented that she feels most people didn't get her drawings. "When you think about it, there were so few people who knew what they were looking at." One example of Lorenz assisting in a drawing of Karlin's was for the pacing of a multipaneled idea she had shown him. The drawing had three panels as she presented it to her editor; he wanted her to add a fourth. "Lee suggested that I add another panel. To me, that was the best lesson in rhythm. Like, you know, this was 'Ta, ta, TA.' And he made it 'Ta, ta, TA, ta.' His suggestion really made it. Now I can't imagine how I saw it without his change."[7]

New Yorker at the time, although it was in the same realm as Saul Steinberg's drawings. Steinberg's drawings, also captionless, were groundbreaking in that they were visual thoughts, and the ideas he put forward through his line made the viewer think in a different way. It was not always about being funny. Karlin's were also often amusing puns and made the viewer see life in a deeper way despite a deceptively sweet comment. For instance, Karlin's drawings were at times "cute," but the sentiment was not. "Some of mine weren't even funny," Karlin conceded.[8]

When asked how she gets her ideas, Karlin responded, "If I knew where they came from, I would be the first in line! I used to doodle. Then something would be there." At times, life would present her with the beginning of an idea, such as the one of the postman emptying one post box only to walk on and fill another. She asserts that in most cases, her characters could just as easily be women, but using women would result

THE LIGHT AT THE END
OF THE TUNNEL

in saying something unintended: "When you draw a man in a cartoon, at least in most of mine, he could very well be a woman. In other words, the fact that he's a man is that he is more generic to people. When you draw a woman, it's already a woman."[9]

In 1985, Karlin stopped submitting to *The New Yorker*. By then she had become extremely successful doing illustrations for newspapers and magazines, even animating some advertisements and publishing a collection of her cartoons in a book, *No Comment*. Illustration came easier to her: "I guess I wanted to do more illustrations. Which is in a way easier because the problem is defined, you just have to find a solution." About cartooning, she confides, "Here, you also have to create the problem."[10] Karlin continues to reside

The seventies, following the end of the Vietnam War, saw renewed energy and humor in the Talk of the Town section as well as in the fiction of *The New Yorker*. Woody Allen began publishing stories in the magazine in the late sixties, bringing a then–television humorist's wit into its pages. Ben Yagoda writes in his history of *The New Yorker*, "Shawn's magazine would always retain an element of high moral seriousness, but, free from the burden of opposing the war, it was able to reclaim a part of Harold Ross's birthright that had been lost, or at least misplaced—a lightness, a capacity for wit, a subtle solicitousness to the reader."[11] The cartoons began to follow in this way, opening up a beloved art form to a creative surge of innovation and experiment.

in Manhattan, drawing for the *New York Times* and other publications.

Karlin's work represents a further advancement for women in cartooning at the magazine. For the most part, women had drawn cartoons set in traditional female environments—the exceptions were those by Roberta MacDonald during the war years. But with Karlin, the change was complete. During the early to mid-seventies when Karlin began at *The New Yorker*, Lorenz was acquiring more unusual cartoons, such as the work of Jack Ziegler. Karlin and Ziegler paved the way for new approaches to drawing cartoons—already started by Thurber and Steinberg in the forties—and for the arrival of the next female cartoonist to be published in *The New Yorker*, Roz Chast.

Roz Chast was born in Brooklyn in 1954, in the middle of "the baby boom." Both of her parents were well educated—Chast's father was a high school French teacher, and her mother an assistant public school principal. They subscribed to *The New Yorker*, and Chast, who says she drew constantly as a child, was aware of the cartoons, particularly the work of Charles Addams. Her drawings in high school (she attended a large public school in Brooklyn) graced the pages of the school paper and literary magazine, but Chast says they were mostly "just doodles."

Doodles or not, Chast was accepted to the Rhode Island School of Design (RISD). It was an eye-opening experience for her, she says: "For the first time in my life, I was with a lot of people who were not only really, really talented, but in a way more talented than me. I came from a big public school where it was very easy to be one

Roz Chast
Copyright Anne Hall

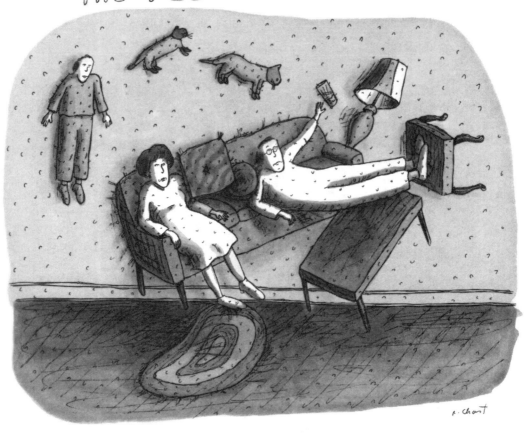

of the very few, if not the only, kid who drew. Suddenly I was in an environment where everybody drew. And everybody had been the talented kid in [his or her] school. It was very eye opening and humbling. Even though it was sort of horrible, I was prepared for what it was going to be like when I got out of school."[12]

While at RISD, she was told by her professors to forget her "cartooning" (Chast was not sure what to call it back then), and she experimented in other art forms. She tried graphic design, illustration, and finally settled on painting as a major—mostly because she lived with painters and was in love with the idea of being a painter. By her last year of college, Chast was quietly drawing her cartoons again, not telling anyone. The combination of painting and cartooning perhaps melded her sensibilities, for although she was not to become a painter by trade (and her drawings look as far from paintings as one could get), the way of seeing and thinking that comes with painting must have informed her drawings. Like many painters, Chast absorbed the

In a conversation with Chast about being a woman cartoonist, she acknowledges her place but wants not to be labeled as such: "I always had sort of mixed feelings. . . . In some ways, when it all comes down to it, we're feminists, but I think there was a lot of stuff I took for granted maybe because my mother worked and was a really strong woman. I signed my cartoons 'R Chast' when I submitted stuff to *The New Yorker*, so I don't know if they knew I was a man or a woman. I still get mail to 'Mr. Chast,' which really cracks me up. I think I didn't want to become a 'woman cartoonist,' I just wanted to be a cartoonist. Maybe it just takes longer [for that] to totally become a nonissue, whether you are female or male. Like if somebody's a writer, you don't say anymore, 'Alice Munro, the lady writer.' I don't like being ghettoized in that way, but I think it's definitely true that there are fewer of us in the profession than there are writers. Maybe there's a higher proportion of funny men to funny women. Maybe women have to tamp down. Also because sometimes being funny—sarcasm, all those things—they are not necessarily [considered] feminine virtues."[13]

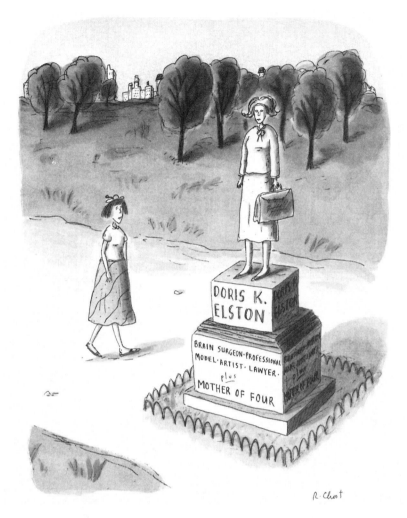

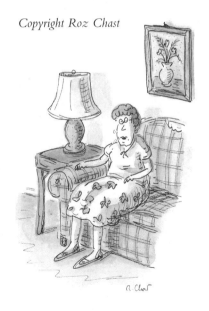

Copyright Roz Chast

world around her, and her cartoons are reflections of what she, as an artist, has taken in and finds humorous. Fellow cartoonist Jules Feiffer describes Chast as someone with a "painter's personality, more than any other cartoonist I know . . . her conversations are not linear. It's more full of impressions and notes and side-bars."[14] In an article in the *New York Times* about the cartoonist, Chast says one reason why she likes cartooning is that "it's not like Art with a capital A, so terribly pure. The criterion is, 'Is it funny?' not, 'Oh, it sort of fills that niche between Matisse and Julian Schnabel.'"[15]

Chast returned to New York City after college, hoping to begin a career in illustration: "I never thought I could make a living as a cartoonist . . . because the things that I thought were funny, I didn't know if anybody else would. And [my drawings] also didn't look like other cartoons."[16] But as she drew illustrations for various publications, her cartoon mind tried to take over. *Ms. Magazine* once commissioned her to do one illustration for an article on "How to Organize Your Closet," and Chast amused herself so much in sketching ideas that she brought dozens of drawings in for the art director. The magazine bought one, but the incident was a turning point for Chast, who then decided to take her cartoons to *The New Yorker.* She couldn't just be an illustrator; she had too much to say. After her first drop-off submission, Lorenz asked to see her. Chast says that she thought the meeting would boil down to one of encouragement, a "Keep up the good work, little lady" sort of meeting.[17] But Lorenz wanted to buy a drawing, and it was one that was a "really odd, odd, odd cartoon, almost abstract. It was so personal, the kind of thing that when you are doodling it makes you laugh, but wouldn't make anyone else laugh because it is almost untranslatable." All of the work in that first batch was nontraditional—she never tried to draw like the car-

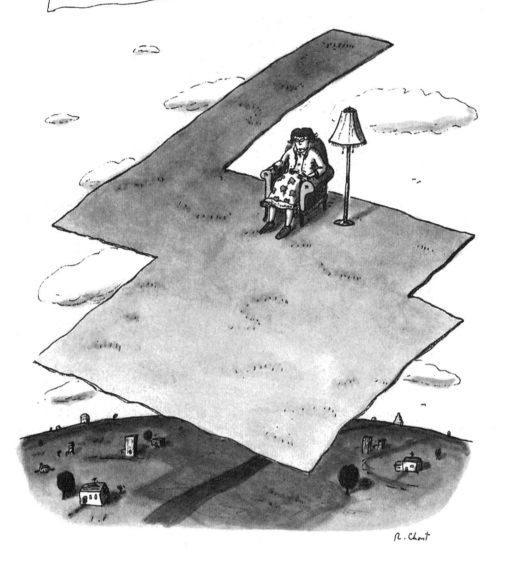

ALMA AND HER FLYING WALL-TO-WALL CARPET

toonists in the magazine. William Shawn, who shared Lorenz's enthusiasm for Chast's unique talent, said, "But how does she know they are cartoons?"[18]

Readers and fellow cartoonists did not know what to make of Chast's work. Many didn't like it, and Chast herself said at times that *she* didn't like her work. Her drawings were very small and the magazine had to enlarge her drawings to make them readable, and Roz didn't like the way they looked. Her tendency for doing tiny draw-

COMING SOON from
BIOLAB, INC.

GIGANTO. Avocados

Each weighs over one hundred pounds, but must be used within one day when opened.

HAWAIIAN HAM.

Pigs are bred with pineapples and maraschino cherries, to save today's busy cooks all the fuss and bother of having to assemble all that stuff.

WATERMELETTES.

Golf-ball-sized watermelons. Good for snacks, lunch boxes, etc.

ACTUAL SIZE

SUPERHOT. Jalapeno Peppers

50,000,000 times as hot as regular ones. Cannot be used in any known recipe.

KWIK-GRO. Chickens

These birds grow to their full size within fifteen seconds of hatching.

Hello!

BA-ZOING!!!

ALCO ROC.

One of nature's most nutritious vegetables - with an alcoholic content of 50%!

Copyright Roz Chast

Cataracts will become "cool."

It's kind of blurry — you'll *love* them!

There will be designer canes and walkers.

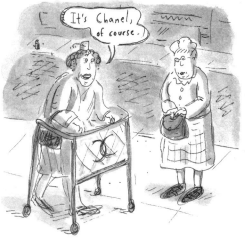

It's Chanel, of course.

An entirely new type of cuisine will spring up as Mexican and Thai foods disappear from view.

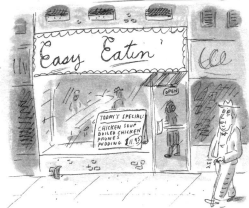

Books about what it's like to be 100 will be major best-sellers.

10% OFF

NEXT ON THE AGENDA

Copyright Roz Chast

ings reflected a mixture of feelings in Chast's desire to express herself. In conversation, she confessed, "I think I had this idea that if I drew really small, somehow it was less offensive. If I say things in a really tiny, tiny voice, no one will get upset! Maybe if I whisper it!" But some did get upset, and Lorenz says that he received angry letters from subscribers and comments from contributors. One fellow cartoonist wanted to know if Lee owed Chast's family money. Another asked Chast, face to face, "Why do you draw the way you draw?" Chast, in an uncharacteristic burst of self-confidence, replied,

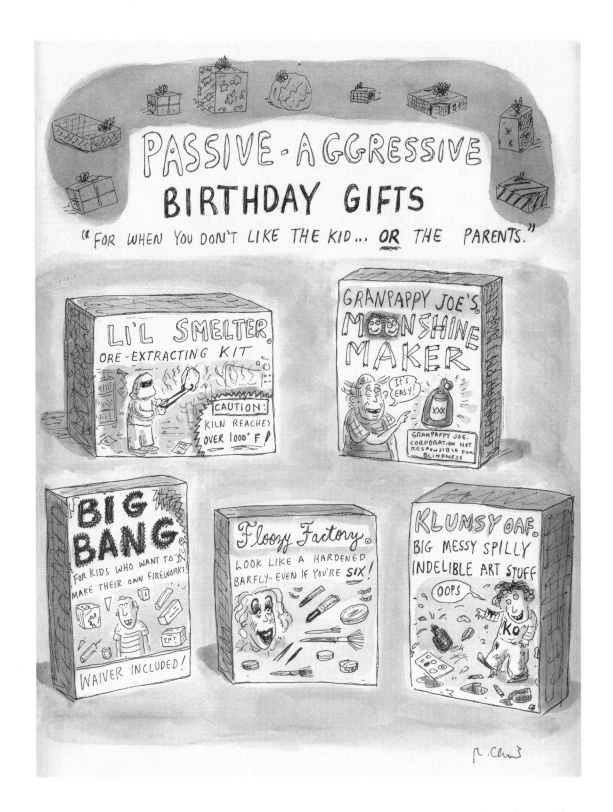

Copyright Roz Chast

Chast reveals: "Some of the things I think are the funniest are the tiniest details. When something's funny to me, *I* know it, it's not necessarily classifiable. In some ways that's why *The New Yorker* is so good, because I *don't* always know. When I finish a batch, I feel I'll never have another funny idea, that's it! Which is ridiculous, I've been doing this for twenty years. It's never been easy. When something works, its great. When you feel like you had a funny idea and were able to articulate it and make it what you wanted to say to articulate what you thought was funny . . . that's what I do it for."[19]

• • •

"Why do you draw the way you draw?" and slipped away into a corner and "practically cried."[20] What may have been disturbing to other artists about her work was twofold: first, her drawings looked to many like they were done by someone who couldn't draw at all; and although this was true of Thurber's work, too, it was still expected that cartoonists have a certain facility for drawing. Second, her humor was very specific and not following any known formula. Again, cartoons had come to follow a set

"The Glass Floor" is one of Chast's cartoons that reflects both the artist's temperament and the times. The title is a twist on the feminist phrase "breaking the glass ceiling." Chast and her generation of women were beneficiaries of the radical second wave of feminism. Thus, in a way, this second group is metaphorically above the glass ceiling (although not completely). However, Chast, by nature of her personality, is afraid to "make waves" and crack the glass floor and, like her early tendency to draw very small so as not to offend anyone, feels a need to be still. The woman in her cartoon—perhaps Chast herself—feels that in order to stay on top, it's best to be quiet.

format, and Chast made her own rules. This self-reference particularly annoyed those who thought they knew what humor was—and by extension—must be.

Chast's early cartoons for *The New Yorker* were snippets of insight. She put her inner world on paper, a friendly offering of a piece of her humorous view of the world. She still gets her ideas through free association while sitting at her desk and from little notes she writes to herself throughout the week, which she puts in a box, "kind of like a rainy day box for your kids." For Chast, the words drive the cartoon, but the pictures are equally important. Lorenz feels that Chast's work brought *The New Yorker* cartoons full circle and that her "blend of text and drawings takes us back to the twenties."[21] This blend of text and drawing represented a return to what many of the original artists and editors at the early *New Yorker* sought: a seamless marriage of thought, impression, words, and image all in one drawing. The humor within this marriage, at best, is a communication, an insight, and not simply a joke.

Unlike the female cartoonists of the twenties, however, Chast is more likely to draw about all parts of life, albeit in her particular sphere. She delves into literature, art, business, and politics, as well as shopping and domesticity. Her work was very city-focused in the early 1980s when she lived in Manhattan and Brooklyn, and many of these cartoons are fully understood only by other city dwellers. Some of her cartoons reflect a certain curious fascination with Middle America, in places like Nebraska, and also with women who know how to cook and drive a car (two areas she admits knowing little about). In 1984, Chast married humor writer Bill Franzen, and they moved to Connecticut by the end of the decade to raise their two children.

Chast's work slowly began to reflect her experiences as a Brooklyn-born woman attempting to become a suburban home-maker. She did cartoons about appliances and other household objects: in her world they were animate objects, good friends to send cards to, even playmates to dress up; at other times, they were objects to fear. Children are equally perplexing to the artist in her cartoons, as is her take on parenting. Chast and others from her generation became adults at a time when women were often expected to be able to do it all—the feminist movement had paved the way for this age group to go out and forge a career yet still be expected to marry and raise a family. Chast's work reflects that dichotomy. And although her drawings are often now characterized as the work of a "suburban mom," her work is far broader than that. Chast's work still defies categorization, and she continues to enchant readers of *The New Yorker.*

Another woman artist who began appearing in the magazine in 1978 was Roz Zanengo. If Shawn questioned whether Chast's drawings were cartoons, he must have equally been puzzled by those of Roz

Points of View

Zanengo. Zanengo's drawings were not funny, but rather visual poems. Because they clearly weren't spot drawings—they had words, usually in titles or balloons—and they weren't illustrations, the cartoon community at *The New Yorker* took her as one of our own. She was a very quiet woman, thin and fragile, and she resembled her cartoons. Lorenz admits "her stuff was odd" and said he "thought there might be something there, but it never happened."[22] Unfortunately, she and her work completely disappeared from *The New Yorker* in the early eighties.

About the same time that Chast began selling cartoons, my work was bought by *The New Yorker*. Unlike Chast, I grew up in a suburban environment, born in 1955 outside of Washington, DC, and couldn't wait to live somewhere else. I, too, drew a lot as a child, strongly encouraged by my parents, particularly my mother. My parents subscribed to *The New Yorker*, and my mother fit the stereotype of the fifties suburban mom who found *The New Yorker*, and all that it stood for, fascinating. When I was in sixth grade, she gave me a book of James Thurber's drawings, which I began copying. My mother laughed, so I kept drawing funny people to keep her laughing. I was hooked. She would also clip out the little spot drawings from the magazine and save them in an envelope for me, as if to say "You can do this." As a product

of a generation that did not encourage women to be funny, it may have never occurred to her that I could—and would —become a cartoonist. I was a quiet, shy girl, but my humorous drawings got attention.

Not thinking I could make a living drawing cartoons, I went to a liberal arts college to study biology. Eventually, my love of art—including doing my funny drawings—won out, so I majored in art. Wanting to be either a painter or a political cartoonist, I moved to New York City and found work at the American Museum of Natural History in the art department (where I did a wide variety of art, from drawing biological illustrations to sculpting and painting figures for exhibits). Still,

Copyright Liza Donnelly

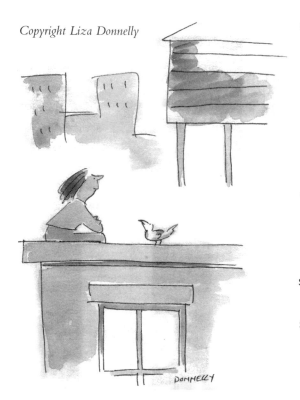

Many magazines published cartoons in the 1950s, 1960s, and 1970s—*Esquire, Look, The Saturday Evening Post, Good Housekeeping, Gourmet, Audubon, Cosmopolitan*, and *Playboy*. (*Playboy*'s veteran cartoon editor, Michelle Urry, has been a consistent supporter of cartoonists. She often threw parties for cartoonists and took them out to lunch. *Playboy* ran many cartoons, most of which were sexual and not infrequently sexist. Hugh Hefner had wanted to be a cartoonist when he was young, which may explain why the magazine ran so many cartoons). One market, *National Lampoon*, was something of a breeding ground for young cartoonists. An irreverent humor magazine, it could be considered one of the first outlets for off-beat, gross comics, text, and single-panel cartoons. It was in step with the sixties generation—my generation—that attacked the status quo politically, socially, and sexually. Barbara Smaller and I sold early, off-beat cartoons to *National Lampoon* (my first cartoon sale was, in fact, to *National Lampoon* in 1978). M. K. Brown and Shary Flenniken (who was also cartoon editor for a brief period) were two regular female comic artists there in the seventies. It was an outlet where one's stranger forays into humor were often appreciated. Another irreverent humor publication was *Mad* magazine, which began in 1952. It was not considered a place for single-panel cartoons, primarily because it had a regular staple of artists and writers. But it should be mentioned as a significant influence on the new generation of cartoonists who grew up in this time period—most kids who were interested in comics read *Mad*.

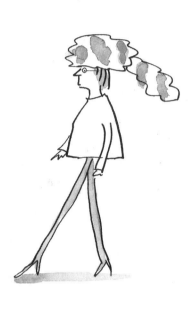
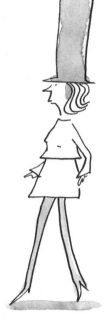

CHAPEAUX à TROIS DONNELLY

my mind would wander to my own drawing. While at college, I had sent some pen and ink work to *The New Yorker* and received my first rejection. That didn't stop me from trying again. I thought that *The New Yorker* was the best place to be: one could be quietly political (I had not discovered how to be opinionated yet) and still be an artist. I thought of myself as an artist, not a cartoonist, and certainly not a "woman cartoonist." I still carried the notion that gag-cartooning was not something I aspired to do. Perhaps because of having grown up looking at the cartoons in the magazine of the sixties, I perceived that I did not fit in, nor did I want to. By 1977, nonetheless, when I began submitting cartoons, the general feeling I received from the

**The New Yorker
Receptionist Window,
25 West Forty-third Street**

Most *New Yorker* cartoonists have stories of how they first submitted to the magazine. I would often stay up very late Tuesday night putting my finishing touches on the batch, which usually consisted of around ten cartoons. Wednesday, I would ride the subway to midtown and, as I walked closer to the office building that housed *The New Yorker*, my heart would begin to race. I continued on the elevator to the twentieth floor. There, a woman sat behind a glass window at the end of a sterile-looking lobby that had two office chairs and a long thin table. She would not look up immediately, but if you stood there long enough, she would, only to receive your manila envelope through the slot in the window. She would then look in a box for the manila envelope you had given her last week and return it to you. After a year of doing this weekly, I looked in my envelope, and there was a pink piece of paper, not the characteristic off-white rejection slip. It said "Holding I" in scrawled pencil. For a period, I would occasionally get this note in my envelope, but, inevitably, the drawing that was held was returned each time. Several cartoonists recount the same experience. Then one day in 1979, instead of handing back my envelope, the receptionist told me I was to go back to the office. I was terrified! When I got to Lee Lorenz's office, I don't remember what happened, but he said they wanted to buy one. I practically flew home.

magazine was that experimentation was encouraged.

My first years of selling to *The New Yorker* were slow. They bought about one a year and did not publish one until 1982. Still, I had sold to *The New Yorker* and felt that I was accepted and was gradually being brought into the fold. Back in those days, many new cartoonists broke into the magazine by selling an idea that would then be given to another established cartoonist—this was how Mick Stevens's and Michael Maslin's careers were launched at *The New Yorker*—but no women cartoonists started this way. My drawings were spare and loose, and I would often do a finished drawing dozens of times before I reached the level I thought was good.

My first four drawings were captionless. Someone once told me that Shawn believed the captionless drawings to be the epitome of a cartoon, and I felt the same way. It seemed a suitable form for me, as a mostly quiet person, a nontalker. Also, I wasn't interested in a traditional "gag" cartoon. Moreover, when I had lived in Italy at an impressionable age of fifteen, I had been heavily influenced by European cartoonists, many of whom use the captionless form. The captioned drawings in *The New Yorker* perplexed me; my focus, when looking at them, was on the drawing. My influences were Thurber, J. J. Sempe, Steig, Karlin, and George Price, all artists who used a simple line. I also loved the esoteric and idiosyncratic thinking that characterized artists like Steinberg.

It wasn't until the late 1980s that my cartoons began appearing more frequently. They were captioned by then, and the ideas they

RUNWAY WANNABES

DONNELLY

bought from me were mostly about food and relationships, with every fourth or fifth cartoon being politically oriented. The city in that decade was booming with "yuppies." Restaurants were popping up at an alarming rate. I found the youthful urban energy that swirled around me on the Upper West Side of Manhattan (Chast lived two blocks away and we became good friends then) amusing, and it was fun to satirize. I had become accustomed to the traditional form of cartooning and perhaps had found a way to make my style of drawing and thinking fit into that mold (and more to the taste of the editorship by then). Plus, captionless drawings can be elusive.

In 1988, I married fellow *New Yorker* cartoonist Michael Maslin, and we moved out of the city to raise our two girls. While my early work reflected my inner world and response to life, my cartoons evolved toward more of a re-action to my environment, whether it was the city, the country, or the domain of marriage and children. In the nineties, I began to bring my inner world back into the cartoons, and I decided to draw more women. My female cartoon characters spoke their minds; they were tough, in a quiet sort of way. I credit my mother, an outspoken woman, and James Thurber's gutsy, opinionated cartoon women for informing my female characters. As a child, I remember studying his women in fear and awe—*were* there women who said those things? Do *I* have to be that way? Not

DONNELLY

"Some wine with your vest?"

In 1980 a book of feminist humor was published called *Pulling Our Own Strings*, edited by Gloria Kaufman and Mary Kay Blakely. It was a collection of written humor and cartoons from women (though a number of the cartoons were from men) that were in-your-face feminist. The editors' goal seemed to be to collect humor by women that was obviously pro-movement and designed to demonstrate that feminists did indeed have a sense of humor about the cause and themselves. Included in the volume were contributions from Gloria Steinem and Nora Ephron. The humor directly attacked the status quo of the treatment of women and some men's inability to see what needed to be changed. One female French cartoonist in this collection, Claire Breteche, became well known for her cartoon comic strips about women's issues. Nicole Hollander also began appearing around this time (but not in this collection), and her comic strip *Sylvia*, which she self-syndicated, was very popular for its feminist and left-wing political humor. Hollander published many collections of her strip and continued to have a strong following. Much of the current edgy cartoon humor drawn by women is in comic books and comic strips originating from California.

"I hear their marriage is in trouble."

unlike others of my generation, I found the seventies and eighties a time of assimilation for me. It was when I began recognizing women's role in society while simultaneously trying to figure out a way to express myself within the parameters of a group of editors at *The New Yorker*. Not that I consciously wanted to be a feminist in my cartoons—I didn't—but I didn't want to suppress that desire, either.

The process of getting ideas is in many ways a mysterious one, but there are techniques that some cartoonists use. I have various notebooks for thoughts and words that I collect during the week, and five days a week I sit at my desk to formulate these pieces into cartoon ideas through drawing or wordplay. The dictionary and the *New York Times* are tools insofar as they provide words and concepts that spark ideas. My internal radar is looking for key phrases and

"Some kids at school called you a feminist, Mom, but I punched them out."

trends in the news and in society. These words or phrases can then be inserted into everyday situations, often twisted for surprise. An example is in my cartoon "Some kids at school called you a feminist, Mom, but I punched them out." This cartoon was done in response to a trend of young women bashing feminism as an old crusade —that is, it didn't apply to them. The little girl is defending her mother against what she and her peers think of as a slur—"feminist." Yet she embodies feminism in her assertiveness and confidence.

In another cartoon, a group is dining at a restaurant and a waiter asks: "Who ordered the special prosecutor?"[23] The waiter is holding a tray with a man. This was drawn during a period when special prosecutors were being frequently ordered for investigations. This is a pure play on words, with the extra added visual humor of the prosecutor sitting on the tray. It wouldn't be as funny if the prosecutor were simply standing next to the waiter. The timeliness of the idea is an important element—it carries a little bit more humor because of what was happening in the news at the time. Being able to grab an issue from

"Who ordered the special prosecutor?"
A rough drawing for a cartoon that appeared in The New Yorker

the news for a cartoon can be difficult, because you have to pick a topic that is present in readers' minds, but not overly so. And you have to have a sense that the topic is going to stick around for at least a week, or better yet, is timeless. One of my favorite drawings was my response to the terrorist attacks on the United States on September 11, 2001. A little girl says to her father, "Daddy, can I stop being worried now?"[24] While not particularly funny, this cartoon reflects the country's fears at the time. Yet the cartoon can be seen as timeless because of the frightening nature of the world.

Sometimes cartoons seem to come out of nowhere. Cartoons should not be forced, unless the forced nature is part of the joke, as in an obvious pun. I will often draw a scene and then put the drawing aside. When I come back to it with my head

full of words and phrases I have been collecting during the work period, I freely associate and put words in the character's mouth. In one such example, a woman is saying to her girlfriend, "I had a headache but he went away."[25] The obvious word switch is "he" for "it," but the humor is also in the speaker's attitude toward men.

Every cartoonist edits herself at different stages. Some cartoonists draw almost everything that comes to mind, and their batches may have some unprintable or incomprehensible cartoons. But this method also draws out the artist's sensibility and can often produce wonderful, classic cartoons. My tendency is to censor myself before I draw the image, not a good method for everyone. Learning to trust one's instincts and trust one's sense of humor—*and* trust one's magazine editor—is part of the process. That approach makes for a lot of rejections, but may be conducive to nurturing the artist's voice.

I now try to put a woman as the speaker whenever I can, in order to avoid the stereotypical everyman male talking. Today, the woman as depicted in cartoons, like the African American depicted in cartoons, *can* be everyman. Karlin's statement that when she was drawing for *The New Yorker*, she felt that drawing a woman made it less generic, no longer holds true. Car-

"O.K., everybody. Let's eat before the food gets dirty."

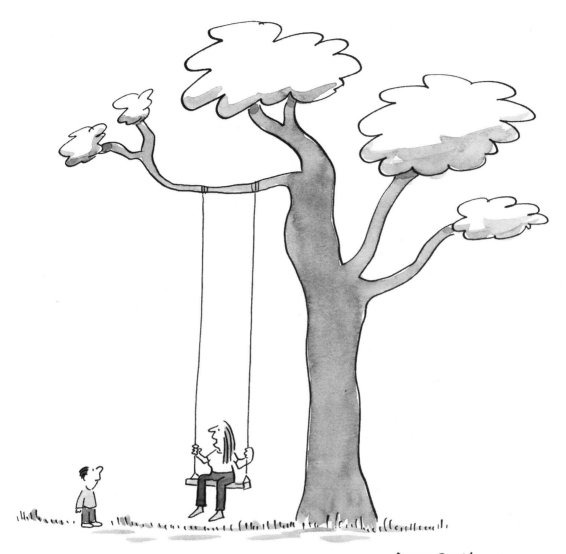

"Fun can happen to adults, too."

toons with a female character speaking can go either way now—she can be speaking as a woman about "women's things" or she can be speaking as every man or woman, period. ◆

CHAPTER SIX

THE MORE THE MERRIER
1987–1997

n 1987, *The New Yorker* underwent significant change. William Shawn, who had been editor for thirty-five years, was replaced by Robert Gottlieb, who, until then, was editor in chief of the book publisher Knopf. Gottlieb was well respected at Knopf and soon became so at *The New Yorker*. He was markedly different from Shawn, however, in his casual style and approachability. He wore sneakers and an open-neck shirt. He displayed statues of Elvis Presley and the Lone Ranger on his desk, and—the most obvious indication of his fascination with kitsch—he owned a collection of vintage ladies' handbags.[1] His editing style brought a more ideological point of view, so *The New Yorker* began running more political opinion than during Shawn's tenure.

Some critics had earlier argued that the magazine had gotten stale and stodgy and the articles had become too long—hence it

was time for Shawn to retire. The press analyzed the change of editorship in great depth and watched *The New Yorker* with interest to see what Gottlieb would do in terms of fiction, nonfiction, and criticism. Interestingly, none of these articles worried about the cartoons. But the cartoonists did.

Gottlieb had unusual taste in cartoons, which translated into new forms of what a cartoon could be. Lorenz admitted, "When Gottlieb came in, everybody panicked, including me, because we went through several art meetings and he didn't buy anything. The problem was he just had a different sense of humor. He loved puns. Gradually, I found some people he particularly liked. It's like anything else. And artists could figure out which way the wind was blowing. Bob [Gottlieb] became a little more accommodating, he wasn't inflexible. Quite a few artists came in under him."[2] The influx of talent included four new

Ann McCarthy
Copyright Anne Hall

women cartoonists—Ann McCarthy, Victoria Roberts, Stephanie Skalisky, and Huguette Martel.

Ann McCarthy grew up in New York City, a generation earlier than Chast and myself. She says she drew as soon as she could sit at a table, and in school she got excused from naptime to go draw. She can't remember a time when *The New Yorker* wasn't around her house. McCarthy says she didn't aspire to draw cartoons similar to what she saw in the magazine, but she knew she wanted to be as funny. She began her career as an illustrator, and at the suggestion of her book editor, she called *The New Yorker* to set up an appointment with Lorenz. He was familiar with her work and told her to "bring everything down."[3] She sold her first cover on that visit and began selling her drawings. Her cartoons are often visual puns and display her quirky outlook on the world. McCarthy did several involving inanimate objects—a pop-up toaster popping, throw pillows dancing across the page, as if thrown, each titled, respectively, "The Pop-Up Toaster"[4] and "Throw Pillows."[5] The titles related to the image, often as a visual pun or in an obscure and obtuse way. Always situated in a box, her scenes were meticulously drawn in detailed pen work. She never did rough drawings, but instead she always brought in finished pieces. "The ridiculousness of [McCarthy's] work is that someone would spend so much time drawing a joke," said Lorenz.[6] McCarthy stopped submitting in the early nineties, after Gottlieb left the magazine, and continues to live in Manhattan, where she paints and is writing a book on the history of penmanship.

The idea that a cartoon's humor was partially carried by the complexity or the details of the drawing was something that was shared by the women cartoonists who joined the magazine at this time. Drawing has always been an integral part of the cartoon, but with these women, it was just as much a tool for expressing their individuality as for carrying the humor. Whereas Karlin's simplicity was her trademark and Chast's naïve style was part of her voice, the four women who came in during the 1980s and early 1990s devoted more attention to the intricacies of drawing.

THE PEOPLE UPSTAIRS

Victoria Roberts came on to the scene with a distinctive way of drawing and a subtle wit. Roberts was born in 1957 in New York City, but her family moved to Mexico City when she was

four. Though she considers Mexico really her home, she lived in Australia from the age of thirteen. Both places contributed to her artistic sensibilities. Her early exposure to Mexican art, which she says was ever present in the culture and in her home, and her exposure to the cartoons of Australia, seem to merge in Roberts's drawings. She drew as a child, aware of *The New Yorker*, and grew particularly fond of J. J. Sempe's fanciful drawings. Her mother gave her a book of Steinberg's work at an early age, which she avidly studied, though perplexed by it. In high school in Australia, her class was shown an animated history of Australia, and for Roberts, it was a "eureka" moment. She realized what could be done with cartoons—they could tell stories, which she discovered was her primary interest. Roberts went to art school in Australia and was hired to do a feature of cartoon biographies of famous writers and artists for the *Nation Review*. Called "My Sunday," the feature ran for several years and eventually was published in book form, followed by two others in a similar vein. She continued to work for magazines and newspapers in Australia, creating a short animated film and a regular cartoon strip.

Because telling stories was her main passion, Roberts also became fascinated with the world of theater, almost joining the Wooster Group, an avant-garde theater group in New York City. But when

Victoria Roberts
Copyright Anne Hall

she moved to New York in the mid-eighties, her drawings attracted attention. She worked for the *New York Times* almost immediately, illustrating articles and doing pieces for the Op-Ed section. The attention Roberts got for her artwork seemingly made the decision for her as to her

Chanel Bags at Dawn

choice between theater and cartooning. She began submitting to *The New Yorker* sporadically, and after two years and no luck, she stopped. At the urging of a friend, she started again, and with the return of one submission, she got one of the infamous notes from Lorenz, saying "Please try us again." Six months later, she sold her first cartoon. With this, Lorenz encouraged her to submit more work and come in to the offices every week, which she did.

Roberts's humor combines wry amusement

"You're either too much like me, or I'm more like you than you are yourself."

with philosophical, poetic observation. The ideas are not usually laugh-out-loud funny, but combined with her fanciful drawing, they offer a unique voice. As with Chast's cartoons, the viewer feels that he is getting to know the artist behind the drawing. She makes her humor come out of the mouths of men and animals (she is an animal lover), but mostly, it is her plump, middle-aged women who do the talking. They are not unlike Helen Hokinson's women in their enthusiasm for life, seeking to try new things—if not in actuality, at least in their minds. Roberts's ladies are free spirits, yet unlike Hokinson's, they are not at all tentative about their interests. They share their opinion with a knowing, beneficent smile. This pithy wisdom, which her characters dispense, comes from deep within Roberts: she says that it's often from "something that's bothering

Roberts's cartoons were transformed from her previous work as an illustrator by the repeated weekly efforts she made for *The New Yorker*. For her, the drawing has equal importance to the ideas. But it was the structure imposed by weekly submissions to the magazine that helped her develop her cartoons into an integral whole. "Having the ideas is not the most important part, but the most fluid part of all of my work. Without a deadline, I won't do anything. Lee [Lorenz] said to me early on, don't edit the batch. Because a lot of the stuff is bad ideas or not even ideas at all, he said don't ever edit the batch . . . I'll get a bad idea or something that doesn't work and three months down the track, it's something. So it's been the loveliest kind of working, keep-you-alive kind of gift."[7]

This system of weekly art meetings that *The New Yorker* stumbled on in the twenties became a wonderful feature for the creative minds that drew cartoons. It enforced discipline on many artists who did not have it. But, more than that, it gave a structure for exploration—because drawing many ideas over time is the best way to find and form one's voice. From what might seem at first a questionable idea, the artist or the editor may find a promising spark. Such sparks can be nurtured and developed to become a consistent body of work. Lorenz and his artists found this kind of system to be a very useful tool, because by this time, the idea of a "gag man" had been fazed out. The trend was now for an artist to be both idea person and visual person. The cartoon became a well-rounded art form, as it had been for many in the beginning of the magazine.

Copyright Victoria Roberts

"I love a second wind."

"Don't worry, Howard. The big questions are multiple choice."

me, that you can't put down directly because it wouldn't be funny. But then . . . if it's distilled and refined, [it] comes out as something. As something true to life. Usually it's stuff I have carried around with me."[8] She is often surprised by what comes out of her characters' mouths, as if they were beyond her control. Her ideas would be much less effective, however, without her skilled drawing. Roberts's intricate designs of clothing and wallpaper and her whimsically drawn characters add a fantastical element to her cartoons—the viewer feels as if in another world, though the things her characters say ring true in this world.

When Roberts first discovered *The*

New Yorker, she felt an appreciation for what the magazine meant to a creative person, an appreciation that she still holds. She says *The New Yorker* "was a place where there was respect . . . where you could do whatever you did very, very well and sort of save yourself. . . . It wasn't so much the drawing, it was being able to say something. I felt there was a sense of wonder and if there was anything to be found in the world the people there were looking for it and would find it. And that's what's so marvelous about it. It still is." She goes on to say, "You know you're working for an intelligence that is quite something [when it] also respects who you are, that you can fall and you can

Victoria Roberts

"Yes, Harold, I *do* speak for all women."

Roberts's interest in theater illustrates that the connection of cartoons to theater is not as remote as one first might think. On a technical level, the captioned cartoon is like a miniature set with characters. The artist has to design the place for the action and create the characters that will act in it. They will have dialogue that is actually a moment in time—what comes before the caption is usually understood, as is what will be said following it. Cartoonists often are drawn to theater, like Roberts, who continues to act in off-off Broadway productions and is currently writing a one-woman show of her own. Pulitzer Prize–winning cartoonist Jules Feiffer and veteran *New Yorker* cartoonist William Hamilton are also respected playwrights who have had work produced on Broadway. In addition, *New Yorker* cartoonist

Bruce Eric Kaplan is a producer and writer for television, and *New Yorker* cartoonist Marisa Acocella Marchetto wrote a screenplay for television. The combination of words and imagery are the common denominator for these two seemingly different media, as is the desire to communicate thoughts and ideas.

Victoria Roberts performing

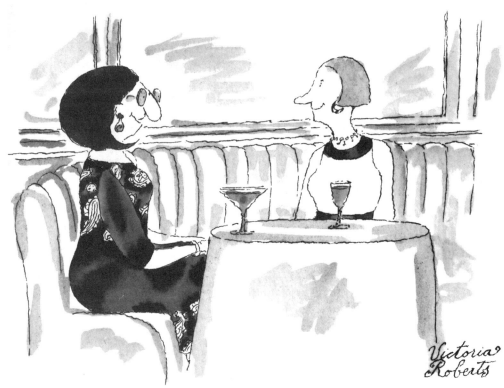

"I got married once—to avoid writing."

• •

learn. It's like, imagine what it would be like to dance for George Balanchine."[9]

When the cartoons of the magazine began to get less formulaic, as they had often become in the 1950s and 1960s, the discovery of voice was the thing to strive for. The women cartoonists of this period injected nuance to humor in a way that the magazine had not seen before. Under Gottlieb's editorship, Lorenz was on the lookout for atypical voices. When Pauline Kael, the movie critic, brought the drawings of a friend's friend to his attention, he immediately called the artist. Huguette Martel, a native of Paris, was astonished by the call, and equally shocked that they

bought her work. "I thought it was weird that they took me, I could not believe it, could not understand it, but I loved it!"[10]

Martel came to the United States as a young girl on vacation in 1957. On a whim, she applied to the Cooper Union Art School, was accepted, and has lived in New York City ever since. Her passion was painting, and her five years in college spanned the height of the New York School of Abstract Expressionism—a movement she admits that she sought to "get out of." In this effort, her paintings were (and are) loosely figurative, but not abstract. She told stories in small paintings, which she would place together to form a whole. Martel also

ings (by way of Pauline Kael) to *The New Yorker*, and although they did not buy them, Lorenz encouraged her to bring in more.

Martel says that at an early age, she was attracted to "British humor—*Alice in Wonderland, The Wind in the Willows*—which is very different from French humor. There was something about Anglo-Saxon humor that [I] liked."[11] She contrasts the two types of humor by saying that French humor, although cerebral, is very different from British humor. Though she likes them both, her work reflects her preference for British humor. Martel's drawings are quietly humorous and often endowed with an extra dimension that is not always clear. She believes cartoonists are by nature "moralists" and that cartoons are "amazing, like shortcuts to what's happening." She gets her ideas visually, and it is the pictures that suggest the words and ultimately the finished cartoon. Lorenz often had to edit her words since, as she admits, her love

Victoria Roberts

"I hate to break it to you guys, but it's kinda the same up here as it is down there."

loved writing prose, and the two—art and words—merged fifteen years ago when she created a fake dictionary in ink. Encouraged by a friend, she sent some draw-

Huguette Martel
Copyright Anne Hall

of words made her a "great explainer." And he would advise her not to *try* to be funny. Her work in *The New Yorker* was unusual and, when Gottlieb's tenure was over, Martel's work was no longer bought by the magazine. She continues to live in Manhattan, teaches French part-time, and paints full-time.

Stephanie Skalisky considers herself lucky, she says, because she knew that she wanted to be an artist for as long as she can remember. Born in Sacramento, California, in 1960, her mother and teachers recognized her artistic talent at an early age—so much so that she was given the opportunity to paint in a separate room from the other students. This preferential treatment from teachers helped her get through high school, which was an "exercise in survival," according to Skalisky. The art teacher let her hang out in the art room to paint. Skalisky says that she "developed an eye for the unusual . . . [and literally] fell down a lot because . . . [I] was looking at other stuff."[12] Skalisky went on to receive a BA and an MFA in art at Sacramento State University. This unusual vision of Skalisky's was what attracted Lorenz to her. When he saw her paintings at an exhibit while visiting California, Lorenz invited her to submit drawings to the magazine. In 1989 he bought four out of the first batch she sent him.

Babies Who Became Famous, and Why

Napoleon
Mother's pet

Lady Godiva
Overdressed

Jacques Cousteau
Liked his bath

Hamlet
Colicky

Alfred Hitchcock
Easily spooked

Jackson Pollock
Messy

Cartoonists use many materials, but generally, they stick to simple pen and ink. Some use rapidiographs (mechanical pens), others use dip pens, ballpoints, brushes, markers, or charcoal. For gray tones, the common medium is black watercolor or watered-down ink, while some use gray magic markers. A few draw directly in ink, others draw over pencil sketches, and still others use a light box to do the ink work from a sketch onto higher-quality paper. Martel has a very unusual method of working. Because she says that she can't draw well (though many would disagree), she coats a piece of good bond paper with artists' white-out, and she then draws her image on top with a French crow-quill dip pen. If she makes a mistake, which she says she does frequently, she scratches the image away and starts again. This technique also gives her drawing a rough texture, a look that she likes—almost like a painting in ink.

Skalisky's work has been described as similar to Roz Chast's—a journalist once commented that her work was like "Chast on drugs." Both artists have a very specific way of looking at the world and responding to it. Skalisky's work is not unlike other contemporary art—it is edgy and can make the viewer uncomfortable in its odd juxtapositions of elements and in the manner in which it is drawn. She gets her ideas by "listening to the news and looking at the [objects she] has collected around the house, [and] listening to people when they didn't know [she] was listening. . . . [She] writes ideas on bits of scrap paper . . . hundreds of little pieces of paper in stacks or in the car written on gum wrappers." She admits: "Sometimes a post-it would by chance be stuck to an article of clothing, without my knowledge, making for interesting conversations with grocery store clerks." Her humor, she says, comes from the women in her family, a sensibility "that is instilled" in her. She calls it "an odd mix of neurotic, sarcastic off-color humor that even when I was a kid was very funny to

me and very accessible. I think it's a survival mechanism that genetically got passed on to me."[13]

Skalisky never paid much attention to *The New Yorker* until Lorenz contacted her, only looking at it at the dentist's office. However, she was completely surprised when the magazine bought her work. "I thought it was a joke, cartooning was the last thing on my mind and especially not for *The New Yorker*. . . . I never thought of *The New Yorker* cartoons as art. I was surprised that other people did and would actually pay money for them."[14] The buying and publishing of Skalisky's work was perhaps an attempt on the part of the editors to break out of the cartoon format and bring the art form into a new realm. But its singular style also made it vulnerable at the magazine—after a very successful

It really looks great on you... it's just these damned Cubist mirrors!

three years of publishing drawings in *The New Yorker*, Skalisky's work was no longer of interest there after Bob Gottlieb left in 1992. She continues to paint and works teaching art to disabled adult artists in Sacramento.

The resignation of Robert Gottlieb came after months of discussion with the owner of *The New Yorker*, S. I. Newhouse. The Newhouse family had bought *The New Yorker* in 1985 and, after replacing Shawn, had hoped the magazine would take on a new image and thrive. Although the editorship of Gottlieb brought changes and a limited amount of attention to the magazine, Newhouse sought further change. Many thought *The New Yorker* still had the aura of the old institution—a bit stuffy and old-fashioned—and Newhouse, according to the *New York Times*, felt that Gottlieb "was unable or unwilling to see the

New Yorker artists and editors in the *New Yorker* offices, 1991. From left, back: **Anne Hall, Arnie Levin, Liza Donnelly, Mick Stevens, Stuart Leeds, Lee Lorenz. Middle row, seated: Jack Ziegler, Huguette Martel, Michael Maslin, Bob Mankoff, Sidney Harris. Front Row: Kathy Osborn, Sam Gross, Roz Chast, Victoria Roberts.**
Copyright Anne Hall

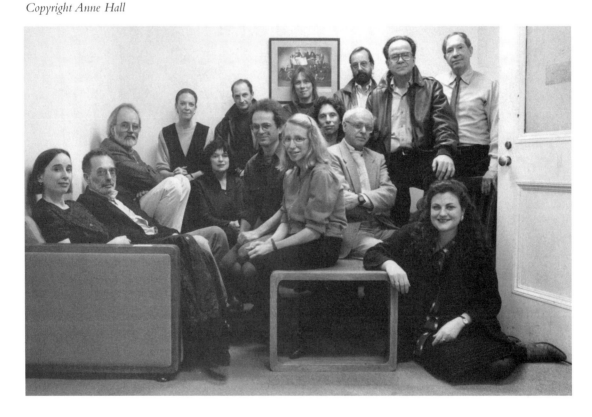

need for further evolvement."[15] He replaced Gottlieb with Tina Brown, the Oxford-educated editor of *Vanity Fair*.

Brown had a highly successful career as editor of Britain's *Tatler* and then *Vanity Fair*. She was known as a witty writer and a good editor, but she was a controversial figure because of her genius for publicity. She knew how to bring attention to whatever endeavor she tackled, which many believed is the reason why Newhouse hired her to head *The New Yorker*. Her focus on celebrity in the pages of *Vanity Fair* caused many associated with *The New Yorker* to be nervous about her taking the helm. There was a tremendous amount of press surrounding the hiring, and some contributors and staff even quit the magazine in protest. Brown reassured the public and her new staff that she was not going to make *The New Yorker* into another *Vanity Fair* and said it "will be cerebral but more relevant, timely. I want it to have an edge, to be irreverent at times. And I hope to encourage wit."[16] She derived her inspiration from the pages of the early *New Yorker*, and the impression was that she would bring a sassy tone "not completely alien to the spirit of Harold Ross."[17] Some of Brown's changes to the art of the magazine were quick, and some were gradual. Brown hired a woman, Françoise Mouly from *Raw Magazine*, to be the first cover editor, and the covers soon became very graphic and at times

Photo taken right after Tina Brown became editor. From left, Michael Maslin, Ed Sorel, Liza Donnelly, Tina Brown.

controversial. The cartoonists waited, patiently, to see what would happen next, reassuring themselves that *The New Yorker* could not be *The New Yorker* without cartoons, and they were right.

In fact, Brown liked and understood the importance of the cartoons, and, shortly before becoming editor, she arranged for a meeting with the cartoonists who were under contract. Roz Chast remembers attending the meeting "with fear and loathing"[18] and did not feel reassured until Brown bought some of her work several weeks later. About twenty-four cartoonists, young and old, attended the meeting, and Chast remembers the new editor saying she "didn't like cartoonists who were wooly"—a term Chast thought was in direct reference to her (and, of course, Ed Koren thought Brown meant him). In fact, several cartoonists' work stopped appearing in the magazine after Brown became editor—notably that of Ann McCarthy, Huguette Martel, and Stephanie Skalisky, among others. Lee Lorenz, however, describes the meeting in his book *The Art of "The New Yorker"* a little differently: "Tina expressed her desire for cutting-edge humor and extreme timeliness. Sex was definitely in, and whimsy and puns were definitely out. Franker language and more explicit drawing were acceptable if they sharpened the joke. Tina's remarks were to the point, and during the question-and-answer period her responses were both sharp and funny. The artists emerged . . . with their spirits considerably buoyed."[19] At the first art meeting, Chast recalls Lorenz telling her that Brown "acted like a kid in a candy store, buying things right and left."[20] Some new cartoonists began appearing— among them a woman, Barbara Smaller.

Barbara Smaller grew up outside of Chicago as the daughter of an electrical engineer and a homemaker. Born in 1953, she had five siblings. Smaller absorbed a sense of humor from her mother's slapstick way of coping with the hectic household. She admits she was something of an odd child.[21] At eleven, she put her collection of funeral ads on her wall to no one's notice. Her parents, she said, left her mind alone.

Barbara considered what she thought were her four career options: "I could be a nurse, a teacher, a secretary, or a social worker. I didn't want to be a teacher because I hated school, I didn't want to be a social worker because I felt that was pandering to the system, and I didn't want to be a secretary because I couldn't do anything that involved panty-hose."[22] She chose to go to nursing school but soon quit and worked as a nurse's assistant to pay for art school at the University of Illinois, having only so much money at a time to attend. She eventually graduated in 1996, the year she sold her first cartoon to *The New Yorker*.

It wasn't until 1977 that she realized her desire to draw cartoons. She had

One of the innovations that Brown brought to the magazine was the idea of producing "theme issues" that pertained to one category or medium. In 1998, the first Cartoon Issue was printed, in which many of the pages were devoted to cartoons and writing about cartoons. That first Cartoon Issue had a large photograph of all the cartoonists (those who were able to attend the shoot), including Chast, Smaller, Roberts, and me—the four women drawing cartoons at that time. A photo of the late Helen Hokinson, along with several deceased male cartoonists, was hung on the wall. One controversial issue was the Women's Issue, guest edited by Roseanne Barr. I had two cartoons published in the Women's Issue, one of which was altered, unbeknownst to me until it came out. In the cartoon, someone had doctored the female speaker by giving her lipstick and more hair. A note (not for me, but intended for another staff person) written on the back of my cartoon said that the woman was "not feminine enough, looks like the man's son." The women I draw often have short hair and are thin—apparently too boyish for some. This aside, Brown's desire for changes for the cartoons, on the whole, was welcome to me. She wanted more topical humor, which I loved to do, and many of those that I sold were a bit feminist in tone. I sold more cartoons per year under Brown than under any other editor.

The set of the 1998 cartoonist photo shoot. From left, Mick Stevens, Danny Shanahan, Michael Maslin, Roz Chast.

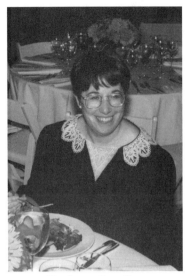
Barbara Smaller
Copyright Anne Hall

loved comics as a child, especially *B.C.* (which she says she shoplifted), but did not see *The New Yorker* until the age of sixteen, while she was at a friend's "upscale" house. She also saw Thurber's book *Men, Women, and Dogs* around that time and was attracted to the "sideways humor," a reference to the indirectness of some of Thurber's wit. The seed of cartooning had been planted early, but it did not surface as a career option until she was in art school. She then began submitting to magazines.

Though *The New Yorker* did not acquire anything at first, she sold cartoons to *National Lampoon*, the *Guardian* (a left-wing publication where she had a regular comic strip called *White Collar Crime*), *Cosmopolitan*, and *Chicago Magazine*. Smaller's interest in writing humor led her to want to try stand-up comedy. She loved the writing, but not the performing; and although it went better than she

expected, it was a stressful venue. Female comics were few and far between. Moreover, Smaller found the male comics hostile: "It was right before Andrew Dice Clay [hit the scene]—there was a real backlash. My husband would make a point of going with me [when I performed]."[23] Smaller left stand-up and began to submit work to *The New Yorker* again. Finally, after a few more years of trying, the magazine bought one cartoon—Smaller's timing was right this time.

From the start, Smaller's cartoons showed a sensitivity to the social climate of the times. To this day, she makes fun of just about everyone, but particularly the upper middle class. A politically aware person (she majored in art and labor studies at college, where she did a series of drawings on labor leaders who were women), Smaller says she usually puts at least one political idea in her weekly batch. Her work in the magazine, however, generally represents her take on relationships and raising children, and she can be biting. The adults she draws are self-conscious and shallow, as in the cartoon of the couple remarking, "Richard and I are planning on taking some time off just to enjoy our purchases."[24] Her cartoon children, spoiled and precocious, represent the results of a new trend in parenting, as in the one of a mother saying to a friend about

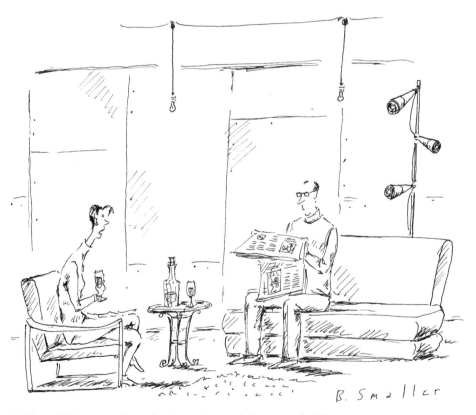

"When did we go from being edgy to being cranky?"

"I've decided to focus all my dependency needs on you and only you."

• • •

her toddler, "His first words were, 'Been there, done that.'"[25] At other times, her insights into parenting are caustic but on target, as in the cartoon of a mother saying to her daughter, "Your attitude is sucking all the fulfillment out of motherhood."[26] Smaller gets under her people's psyche and exposes them. Her take on the New Woman is equally scathing, from the twisted feminist attitude of a woman in bed with a man, remarking to her husband, who is at the door, "So now you're going to tell me what friends I can have?"[27] to a woman, in the kitchen saying, "If it says to add water, and I'm the one who adds it, I'm cooking."[28]

Routine is critical to Smaller's success in writing her cartoons. She starts with ideas that hit her as she sits in coffee shops around her Manhattan neighborhood. This morning ritual by a coffee shop window—she prefers being out in New York, rather than at home, because there's "a certain amount of tension when you're outside"—is where she writes approximately six ideas: "I feel like there are index cards in my head, and I'm just sort of flipping through. It's not like it's a full-time job, if you add up

B. Smaller

"Larry is white male, but he hasn't been able to do much with it."

The seventies and eighties were liberating times, but many pockets of society still resisted equal rights for women, and comedy was one of them. Though many new talents came onto the comedy scene, women comics had a hard time getting booked. Rick Newman, co-owner of New York's Catch a Rising Star, talked about the sexism at his club: "Back in the mid-1970s, when we first started seeing young female comics, a lot of agents and managers who came to the club . . . couldn't accept them." Comics like Sandra Bernhard, Lily Tomlin, and Gilda Radner were breaking into the business, but it wasn't easy. Many were labeled "hostile" or "too masculine." Jan Hoffman, a writer for the *Village Voice*, wrote that comedy's "form and substance have been defined by men. Its manner is . . . brazen, loudly aggressive. . . . To be a comic is to wrestle with a classic feminist dilemma: Is her goal to succeed in the traditional male-dominated circuit world, or to break from it altogether, and find a comic language and venue to accommodate her own divergent humor?"[29]

the hours, but it certainly takes a lot of energy. It wears you out doing it. You just have to be quick about it. It's a lot of mental work."[30] These written ideas go in a small notebook, which she takes home. During the week, she does the drawings and refines her ideas in the process. She has boxes and boxes of these notebooks, which she dips into each week for ideas that are yet to be used. For her finished drawings, she opts for a crow-quill pen and a light box. She never uses gray wash for her cartoons because she says she likes the fact that people can reproduce her work and use it for whatever they need. A friend once told her that one of her cartoons was "everywhere" at a protest rally in Washington, which pleased Smaller immeasurably. Her style of drawing is a scratchy approach that distinguishes her from most other cartoonists. It also lends a feeling of detachment to her characters. One can't really get a focus on them, and this works well with her humor—that of a detached observer.

Smaller likes to think of herself as a cartoonist "who happens to be in *The New Yorker*, not a *New Yorker* cartoonist." This is because she came to the

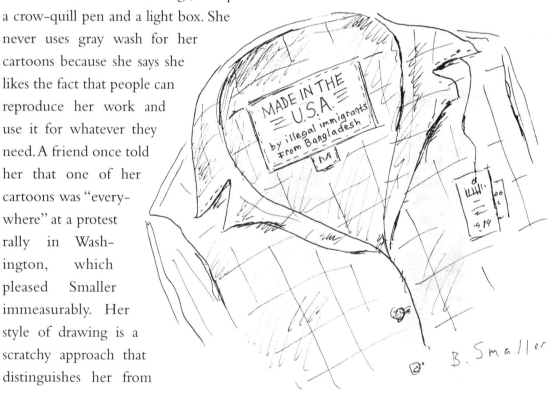

"I'll pay you double what my parents are giving me to tutor me."

•　　　•

magazine late in her career, she says, and feels it's safer. "People in my building have no idea [what I do for a living], although they get *The New Yorker*. I think it [would upset] them if they [knew]. [If] you don't fit the image, they sort of write you out. I think they'd rather have you married to a *New Yorker* cartoonist." She is conscious of the way that the public has forgotten certain female comics, so perhaps she is bracing herself to be forgotten. It perplexes her that there aren't more women in her chosen field. "It doesn't make sense . . . it fits exactly, it's a good way to work, like women writers." She knows "tons of funny women" and feels "the idea that women

The text on the menu board reads:

SMOOTHIES
STRAWBERRY
BLUEBERRY
KIWI-BANANA
PINEAPPLE

"Sex brought us together, but gender drove us apart."

aren't funny is just bizarre." But the small number of women in humor prompts Smaller to philosophize: "Men are very threatened by women being funny because of guilt—because they make fun of women, they assume women are making fun of men. So they don't want that to happen. You are supposed to be laughing at *funny* men; they don't want to give you a chance at laughing *at* them. Women laughing at men is probably more upsetting."[31] Still, Smaller has found her niche to be funny, quietly and somewhat anonymously, in the pages of *The New Yorker*. ◆

CHAPTER SEVEN

THE FUTURE
1997–2005

n 1997, staff cartoonists were notified that there would be a significant change in the cartoon department. Lee Lorenz was to retire, and Tina Brown had chosen veteran *New Yorker* cartoonist Bob Mankoff to replace him. A native of the Bronx and formerly a doctoral candidate in experimental psychology, Mankoff brought a keen business sense to *The New Yorker*. He had founded the Cartoon Bank in 1991, a reprint house, and later sold it to *The New Yorker*. Moreover, as a seasoned cartoonist himself (a cartoonist with the magazine since 1977), he had an understanding of what it was like to be a cartoonist. Mankoff says, "The fact is, everybody . . . assumed that cartooning was on its way out. This [was] going to be the last generation that was going to do it."[1]

Brown hoped that Mankoff would breathe new life into the genre that they both perceived as aging—that is, new life in terms of talent and financial growth for the magazine. And he brought a new concept to the table that appealed to her: "I told [Brown that] I didn't think the job was actually, overwhelmingly, mainly about picking cartoons . . . because if you get enough cartoons, anybody can pick them. The question is how are you going to keep getting cartoons from the present generation and the new generation. How are you going to keep this to be a vital art form. You had to provide an economic infrastructure for it and you also had to raise the profile of cartooning. . . . It made a lot of sense at one time in a changing environment. I see it very much as a publicity position as well as a functional position."[2]

And there was press surrounding Mankoff's hiring. In their statements, he and Brown expressed the desire to raise the profile of cartoons and, in the process, bring in more minority and female cartoonists.

From Left, Bob Mankoff, cartoonist Michael Maslin, writer Hendrik Hertzberg, and Liza Donnelly

"Cartooning seems to be a very male outlet," Brown conceded in an Associated Press article.[3] Many of the older cartoonists' work faded away when Mankoff took the editorship, but he also found new artists. And within a year, he published two more women cartoonists, M. K. Brown and Marisa Acocella Marchetto. Both of these artists were already publishing elsewhere when their work began appearing in *The New Yorker.*

Mary K. Brown was born in Connecticut and spent much of her childhood in Canada. She quips that she began drawing "as a baby," and as a young girl, she was attracted to the power of being able to make adults laugh. Her mother, in particular, was her best audience. She grew up with a sister and two brothers, all of whom drew. Brown would copy her brothers' war drawings and watch her sister create ball gowns and other fashions. Eventually she found her own artistic path doing caricatures of the Canadian locals and drawing animals. She remembers reading her brothers' comic books, and when the first issue of

Mad appeared, she says "it was a revelation to my brothers and me."[4] She was so enamored with the publication that she sent a cartoon and wrote Harvey Kurtzman (the editor) to offer her services as an artist. Kurtzman replied in a week. He said that she wrote a very funny letter and asked her, "Why don't you come to New York so we

M. K. Brown
Courtesy of M. K. Brown

can study you?"[5] Brown, a high school student, did not take him up on the offer, but she was very encouraged by his letter.

After high school, Brown studied art at the Norwich Academy and the Silvermine Guild, both in Connecticut. This classical training, combined with exposure to Canadian humor and storytelling (as a family, they spent summers in New Brunswick), led her to cartooning. Brown believes that "Canadians possess a wonderful storytelling ability. And they have a sly sense of

humor. The stories that [my aunts and uncles] told were so vivid and funny that I'm sure it affected my imagination and created a thirst for more, even if I had to generate [more by] myself."[6]

Brown describes her cartoons as "surreal," because they contain at times odd juxtapositions and dreamlike images, as if one is watching her mind wander into an imaginary place. She gained a strong following for her regular comic strip *Aunt Mary's Kitchen* in *National Lampoon*, which started in 1972. Although she is well known as a comic strip artist, her work for *Lampoon* included single-panel cartoons, and this led her to submit to *The New Yorker*. Mankoff began acquiring her work in 1998. Her cartoons in the magazine were the traditional captioned variety, but they had a quirky attitude. The low acceptance rate of her work forced her to stop submitting and her work stopped appearing. The environment for more unusual approaches to humor was beginning to change. She has written and illustrated many children's books and published cartoons in numerous magazines. She has written for television and had an animated strip on *The Tracy Ullman Show*. Brown was once married to the cartoonist B. Kliban, and they had a daughter. She

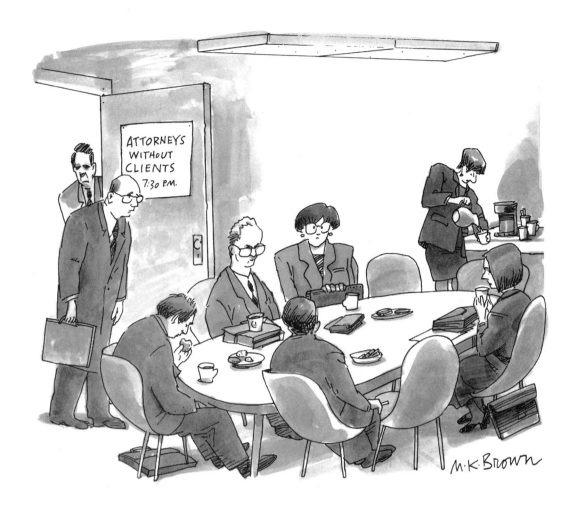

now spends most of her time painting and is compiling an anthology of her work, titled *Funny Weather*.

Marisa Acocella Marchetto was born in 1960 in Elizabeth, New Jersey, the daughter of a pharmacist and a shoe designer. At a very early age, she copied her mother's fashion drawings. While she loved the fashion part of these sketches, she had a private desire to make the women in her drawings talk. The family did not subscribe to *The New Yorker*. But one summer they rented a house in Bermuda that had been the summer home of James Thurber. Mar-

chetto was captivated by his drawings hanging on the wall and spent many hours that summer looking at issues of the magazine scattered around the house. Earlier, she had developed a love for "girl comics," as she calls them, like *Brenda Starr* and *Tiffany Jones*. But as with so many cartoonists, the thought of it as a career was pushed aside and lay dormant while other more "realistic" choices were made.

She explains that her desire for a successful career emerged when she realized that her mother had quashed her own budding career in shoe design to be a

Marisa Acocella Marchetto

mother. Marchetto wanted to "pick up where Mom's career left off."[7] With this motivation, she went to art school at Pratt Institute, hoping to begin her journey into fashion design; instead she left school early and went to work in advertising. Unhappy, Marchetto decided to try cartooning and wrote a graphic novel, *Just Who the Hell Is She Anyway?* (published by Crown in 1994), based on a strip she did for *Mirabella* magazine. She also briefly did a cartoon strip for the *New York Times*, called *The Strip*.

What inspires Marchetto is the ridiculousness of a certain segment of society in New York City. "I think you draw from your world," she says. "My people are a world I see in New York, some of them I really like, and I'm sort of making fun of [their] superficiality. Some of them are my friends. There is a little bit of me in there. I can be superficial. I like to observe women. . . . I'm totally fascinated by [them] because I think right now they have the power—the way they use their sex as power."[8] Marchetto's cartoons depict a society of women that unashamedly use their gender to wield power. Not a new concept, by any means, but Marchetto is highly aware of them and brings them to the reader's attention through humor. Many a cartoon has been drawn about manipulative businessmen; Marchetto's work exposes this sort of human behavior on all fronts. Her main goal is to find truth and irony in human behavior.

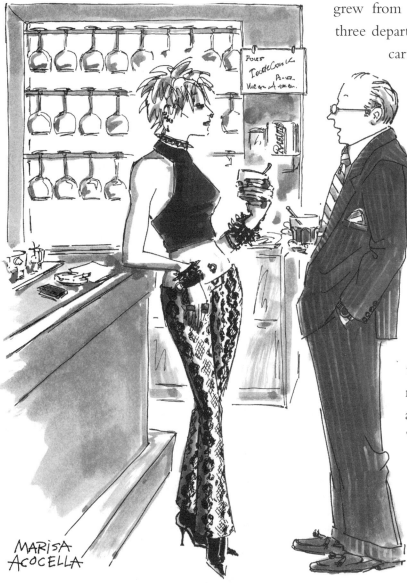

"C'mon, Sugar, take a walk on the mild side."

grew from a two-person operation to three departments with large staffs—the cartoon department, the illustration and cover department, and the photography department. The magazine had graphically exploded, and the cartoons often seemed buried amid illustrations and photographs. Mankoff reflects that at times the magazine was and is "busy and frenetic . . . with competing formats, not only, of course, cartoons, but . . . the magazine now has photos, illustrations and a million other things."[9] This new visual smorgasbord, he feels, at times, dictates that the cartoons be more forcefully humorous in order to stand out.

One constant during this period was the weekly cartoon meeting. Mankoff and Brown presided over the meeting, and often a third editor, such as Nancy Franklin or Rick Hertzberg, attended to add another perspective. Brown's impact on the cartoons was visible in the increase of topical and political humor and in the addition of color to cartoons. (I was asked to do one of the first

During the year that Marisa Acocella Marchetto began her relationship with *The New Yorker*, change rocked the cartoonists' world again. Tina Brown announced that she was leaving the editorship to start a new company with Miramax. During Brown's tenure, *The New Yorker*'s art department

color cartoons of that period.) Furthermore, Brown brought in comic strips, and Chast, Roberts, and I, among others, experimented with that form. With Brown's resignation, many were fearful of who would come next, but their fears were allayed when S. I. Newhouse hired *New Yorker* writer David Remnick.

Under Remnick, the consensus is that *The New Yorker* runs more smoothly and is neither flashy nor interested in celebrity journalism. Remnick, a Pulitzer Prize–winning author and journalist, brings a friendly calm to the offices of the magazine. He grew up with *The New Yorker* and is at once respectful of its past, keenly aware of its role in the present, and looking toward the future. And cartoonists like him. With his and Mankoff's joint editorship of the cartoons, they have indeed brought in more young talent, and in that regard, Mankoff feels that he has achieved a goal of raising awareness of the art form to a

"Stop smiling. You're downtown."

Among the women who created comic strips published in the mainstream media in the eighties and nineties were Lynn Johnston and her strip *For Better or Worse* and Cathy Guisewite, known for *Cathy*. Both of those highly popular comic strips were primarily concerned with domesticity and relationships—traditional venues for women. However, some women cartoonists chose to syndicate their own strips, allowing more freedom of expression than would be possible working for a large syndicate. They included, among others, Lynda Barry, Marian Henley, and Nicole Hollander. According to Trina Robbins in her book *The Great Women Cartoonists*, many women who wanted to tell a story with their comics have gone into comic books. The sixties and seventies saw a surge of underground women cartoonists, most notably Diane Noomin and Aline Kominsky, who in 1976 created semiautobiographical comics called *Twisted Sisters*—chronicling the inner turmoil of "bad girls." The advent of the graphic novel has since allowed even more possibilities for cartoonists to expand their ideas. Marjane Satrapi, who published a few of her comic strips in *The New Yorker*, has been very successful in this medium. Female political cartoonists, however, are still in the minority, the most well known of which are Pulitzer Prize winners Signe Wilkinson and Anne Telnaes.

Copyright Benita Epstein

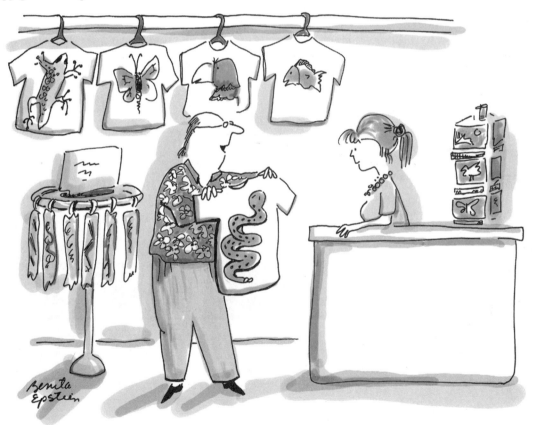

"Do you have this in something a bit more endangered?"

younger generation. This young group includes a few female cartoonists, although Mankoff says he is not satisfied with the number of women he has brought into the fold. Early in his tenure as cartoon editor, he bought the work of two women, Donna Barstow and Benita Epstein. More recently, he enlisted Kim Warp, Carolita Johnson, and Emily Richards to join the ranks of women cartoonists.

Benita Epstein was born in 1950 in Los Angeles, California. She was one of six children in a busy home that always had a *New Yorker* lying around. Epstein recalls her mother telling her that when the magazine first came out in 1925, she rushed to the store to buy it. All of Epstein's siblings were artistic as children, and they enjoyed drawing cartoons. As the youngest, Epstein said she began cartooning by copying her older brother's cartoons, and eventually she and her sisters created their own books of cartoons, poking fun at people. Nonetheless, she never thought about drawing cartoons for a living. Epstein instead went to college and chose to study entomology in graduate and undergraduate work. Her studies led her into a career in science, but then one day on a lark, she decided

to take a workshop with the cartoonist Eric Teitelbaum. At the end of the class, she was hooked, and within a few weeks, she had sold her first cartoon. Epstein placed a few cartoons with *The New Yorker* in 2001, but she has since set her sights elsewhere. She says that the markets for cartoons outside of *The New Yorker* are so different that she felt she had to make a choice.[10]

Donna Barstow was born in Chestnut Hill, Pennsylvania. She drew frequently as a child and thirsted for cartoons, poring over her grandmother's copies of *The Saturday Evening Post*. In college, she studied drama and always "had an idea to have [her] own world." Her passion for cartooning stems from wanting to re-create the lighthearted view of life that she remembers from the cartoons she read as a child. Barstow lives in Silver Lake, California, with her canary, and has had one cartoon published in *The New Yorker*. Barstow's cartoons also appear in *Barrons, Reader's Digest,* and the *Harvard Business Review*.[11]

Carolita Johnson was born in 1965 and grew up in Queens, New York. Although her parents, who thought she was talented, wanted her to become an artist, Johnson worried about making a

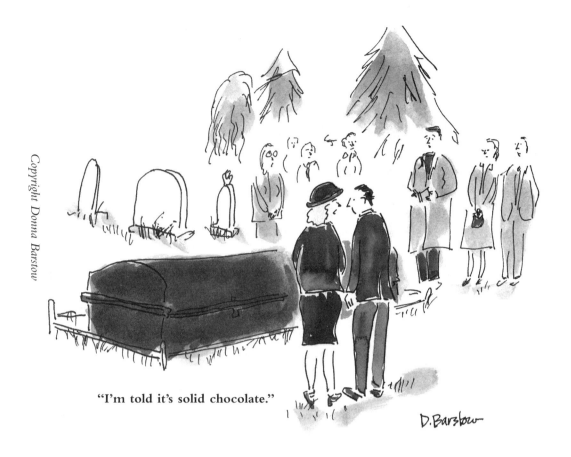

"I'm told it's solid chocolate."

D.Barstow

living and preferred to study literature. Nonetheless, she went to Parsons School of Design in Manhattan and studied art. Johnson ended up majoring in fashion design, partly, she says humorously, "because she didn't want anyone telling her how to draw." Johnson became a model during her school years and eventually moved to Paris, where she lived working as a model and furthered her study of literature. A few years ago, Johnson returned to live in New York City, determined to develop her drawing, build a portfolio, and get illustration work. She never thought about cartoons until, while working in a job as a photographer's assistant on location at *The New Yorker*, she was invited to the art department. While discussing portfolios, she was given advice by a cartoonist and encouraged to try cartoons. Johnson tried her hand at the art form and began

Carolita Johnson
Photo by Marshall Hopkins

drawing every week. After a few months of submitting her drawings, she sold one. Finding time to sit down and work at getting ideas is frustrating for her, though, and she continually attempts to perfect the most effective daily routine. She gathers ideas on the subway and writes them down on her hand or little pieces of paper, and sometimes she develops ideas as she draws. Johnson was not "awestruck" by *The New Yorker* when she first began submitting, although she admits she is "immensely happy" when her work is published. What she also loves is the "democratic" feeling among cartoonists who meet on Tuesdays at the offices of *The New Yorker*, despite

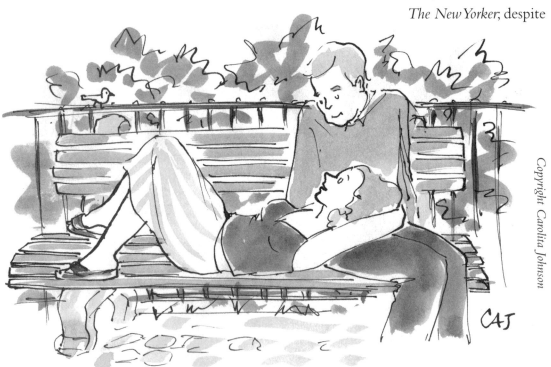

"You're half-decent, Josh. I like that in a man."

being direct competitors, they're all equals and treat each other that way. Johnson jokingly says, "I didn't know what the hell I was getting into."[12]

Kim Warp was born in 1959 in Seattle, Washington, and began submitting to *The New Yorker* soon after graduating from Western Washington University. Though she studied graphic design in college, she was often drawing cartoons. One of her professors chided her about her cartoons: "You think you're going to be in *The New Yorker*, Warp?" After college, she worked as a graphic designer at Boeing and, while

Kim Warp
Photo by Rufe Vanderpool

there, had assignments to draw cartoons for executives. After years of not trying, she sent cartoons again to *The New Yorker* once Mankoff became the cartoon editor. Finally, she made it and was published. Warp gets her ideas from her children, daydreaming, and following strong emotions. She then writes them down in little notebooks. Usually she draws ten cartoons a week following her regular morning writing sessions.[13]

Though she finds politics and world events more

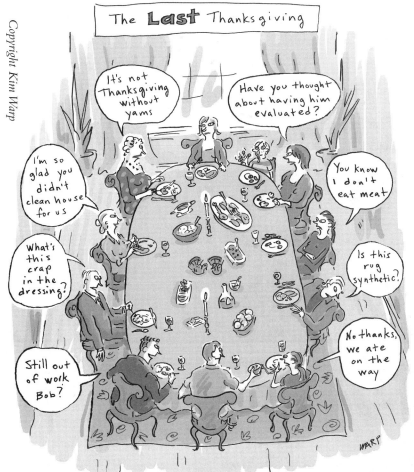

fascinating than other subjects, Warp says her work that focuses on family and business is mostly what is bought. She remarks that "women of our age fought those feminist battles and don't want to be constrained to the 'women's magazine' topics, but the younger female cartoonists I meet don't even see the distinction."[14] Warp is one of the few cartoonists who uses a computer to do her finished drawings, which she e-mails to the magazine. Warp now lives in Virginia Beach, Virginia, with her family.

Emily Richards was born in West Virginia in 1970 and studied at Williams College and the University of West Virginia. She joined the military and worked in intelligence for three years before going to graduate school at Johns Hopkins University to study writing. Once she had her degree, she began teaching and writing at the college, yet she soon found herself drawn to New York City. There, her first job was at *The New Yorker* as a fact checker. A naturally funny person, she was encouraged to try cartooning by Mankoff's assistant, Marshall Hopkins. As soon as she tried the art form, she knew she had found something that she

Emily Richards

loved. Richards submitted drawings not long after and sold a cartoon within a year. Richards's routine for coming up with a weekly batch of cartoons used to be "desperately" staying up all night Monday and Tuesday with plenty of coffee. She now uses a notebook for ideas and is establishing a regular routine. Richards resides in Manhattan.[15]

While the number of new female cartoonists that have recently published cartoons in *The New Yorker* may seem encouraging, Mankoff says that he does not see that many women sending in their cartoons. Though he suggests that perhaps the standard form of cartooning may not be as interesting to women artists as other areas in art, he feels that

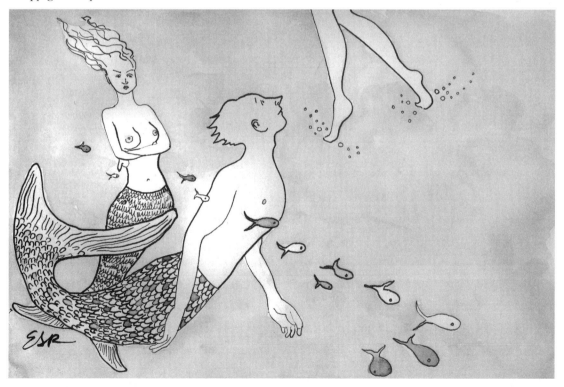

Lars, leg man.

women tend to prefer drawing in other ways. Mankoff divides cartoons into four types: "You [have] the basic 'gag' cartoon, where you have an unusual picture and an ordinary caption. The 'sit-commy' cartoon where someone says a line [and] the picture could be almost anything. You have the fantasy cartoon. Then you have the 'slice-of-life' cartoon." In this last category, there is no manipulation, Mankoff surmises, but rather that "observation [is] of what [is] going on." He believes it is the most difficult form to master.

This "slice-of-life" drawing is the type of cartoon, he says, that women tend to draw. He says: "In women's cartoons you often find the things they are *actually* concerned about. Men, for the most part, aren't concerned about anything. I think women are relating more directly to their lives. It's more expressive. . . . This is not a complete dichotomy, but I think women are more in touch with what's actually going on inside them than men are." He agrees that because of a general tendency to see *The New Yorker* cartoon as only a gag format with the joke as primary, women may not be as drawn to the art form as a means of expression. Thus he laments there are fewer submissions from women cartoonists than from their male counterparts.[16]

The current trend in cartoons pub-

Copyright Liza Donnelly

lished in *The New Yorker* seems to show less evidence of "slice-of-life" cartoons. Mankoff believes this may be because our culture is so demanding of readers' attention that the obvious joke becomes necessary. Two elements enter into this. First, the culture (not necessarily *The New Yorker*) has moved toward obvious, gross humor that is often self-referential (the joke-maker, or speaker, makes it clear that he is making a joke). This type of humor is evident on the Internet and on television. Second, when a "slice-of-life" cartoon is placed in a grouping of strong gag cartoons, it suffers.

The reader, looking for a joke, often doesn't understand the point of the cartoon. Mankoff continues: "I think that women for the most part do a different type of cartoon than men have done and I think sometimes the type of cartoons that women do suffer, not because they are worse but because the default condition is a gag, a strong, manipulative even violent gag, rather than . . . warm or insightful stuff." Mankoff would like to see more "insightful stuff" and says that the editors are trying to open up more to the nuance of that form.[17]

David Remnick has his own distinct perspective on *New Yorker* cartoons. It is Mankoff's task to select a group of cartoons from the large number of submissions and bring them to the weekly art meeting. At

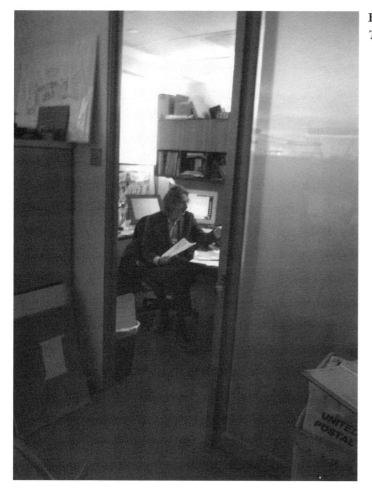

these meetings, the two men sift through Mankoff's preliminary selections and decide on the drawings to be bought that week. Remnick explains what he is looking for when selecting the final cartoons:

> I'm looking and I'm not looking. . . . On one level I am trying to react on an immediate level. Is [the cartoon] original, odd, and above all, funny? Does it make me laugh? And then, on another, perhaps less immediate level, I'm thinking about whether this has something to say about life, about what is going on in the world. . . . And then, perhaps on a more olympian level, when I think about cartoonists . . . [I] think about the artists as a voice, as a writer.[18]

Remnick believes that "the best cartoonists are not just the funniest, they are the most themselves." He continues: "I wish we were getting cartoons from more women. . . . We all have the same overall concerns—love, death, worry, etc.—but we have different expressions of them." Remnick does not easily accept any distinction in the art form along gender lines. In essence, he says, "The stronger artists get at what is true, one way or another." The lower number of submissions from women humor writers is similar to the situation in cartoons, he says. Remnick sincerely wishes

the magazine received more car-
toons—and humor writing—
from women.[19]

Women cartoonists express
themselves in many different
ways now, and their work is in
evidence in strips, animation,
comics, graphic novels, and in
the pages of *The New Yorker.*
Women no longer are drawing
primarily for women's markets,
nor are they drawing only about
stereotypical women's concerns
such as shopping, cooking, and
raising children. What has
changed over the course of the
New Yorker's eighty years is that
women now draw cartoons
about anything, because women

are doing (almost) everything. Men and women now share many of the worlds they used to inhabit separately—consequently, men can do domestic humor and women can do business humor—and we all will be able to relate. The woman drawn in a cartoon today can now be everyman.

The volume of images and ideas in society vying for readers' attention is overwhelming. Given this

onslaught of information, there may be a tendency to cling to stereotypical modes of expression that may be less appealing to women cartoonists. Nonetheless, women cartoonists can and do draw all kinds of humor, as do men. But an environment that encourages a variety of modes of expression—as *The New Yorker* strives to do—may allow for more female cartoonists to emerge and flourish. Even though a confluence of events and personalities may have altered the environment at times, the idealism that began with Harold Ross continues in *The New Yorker* to this day. ◆

BEING TRUE

The early women cartoonists of *The New Yorker* were among the female humorists who emerged in the twenties, almost in response to the question "Do women have a sense of humor?" The female humorists may have broken new ground, but they did not gain acceptance easily. At *The New Yorker*, however, they did.

Helen Hokinson, Alice Harvey, and Barbara Shermund were innovators in the field of cartooning. But they were also innovators in the field of humor, and they worked in an environment—*The New Yorker*—that gave them the room to express themselves. Still, it was a difficult road, and at times, they perpetuated the stereotype of women. But their early work shows a desire to depict women in their new roles in society—as working and independent.

The careers of Hokinson and Sher-

mund, in particular, illustrate how the innovations of these women became constricted by society. The early cartoons of Hokinson, while she used *New Yorker* writers, came from within her, based on her view of the world that she observed around her. The attention that Hokinson received for the matrons she and James Reid Parker created, I believe, led the editors to ask for more of the same. Hokinson's matrons were easy for the public to adore because they fit a stereotype that it was comfortable with. This became almost all she drew at the end of her life, though she sought to erase what she felt was a misconception of her characters. Barbara Shermund was a free spirit whose energy perhaps was difficult for her to maintain. She succumbed to the easier road of using a gag writer. Thus her work changed from the breezy feminist attitude evident in her captions to stereotypes that fit prevailing trends. It would have been

203

interesting to see if Hokinson could have changed the public's perception of her ladies, as she had hoped; but that was not to be. And Barbara Shermund never returned to her original voice.

The fresh views emanating from the early women cartoonists of the twenties lasted about fifteen years. Their work in *The New Yorker* reflected the changing attitudes toward women—in the actual work they published and in the fact, sadly, that their work slowly stopped appearing. More and more male cartoonists entered the field in the forties and the trend in cartoons reflected that. The women cartoonists either changed their style under pressure to make a living or they could not find a common ground at *The New Yorker* or even elsewhere and left the business.

Research indicates there were no female cartoonists at *The New Yorker* from 1959 until 1973. There was a narrowing in society and, to a certain extent, at the magazine of what was considered funny, which included the stereotyping of women. This likely discouraged women from wanting to enter the field. How many women submitted cartoons in this period is not known. But once again, as earlier in the century, society did not encourage women to be funny.

With the cultural shifts of the seventies, and the advent of the second wave of feminism, cartoons drawn by women gradually began to appear again in the pages of *The New Yorker*. Though for a brief period, the notion that women were not funny surfaced when activist feminists were labeled "humorless." Any criticism by feminists of existing comic stereotypes put forth the notion that they did not have a sense of humor. The cartoons drawn by the women of *The New Yorker* were not, at this time, openly feminist; but their acceptance and publication was. As the seventies began, the editors were open to newness in many areas in the magazine, which also included cartooning. Cartoons by Nurit Karlin, Roz Chast, and myself began appearing in the magazine. Because we drew humor that was neither "female" nor "feminist," it was just humor. In that sense, we might be considered innovators. Women cartoonists were no longer confined to certain "female" subject matter, nor to stereotyping women.

The drawings by women cartoonists of *The New Yorker* reflect a varied cross section of types of cartoons that *The New Yorker* has published in its history. However, it appears that they more often than not seek to approach humor from a different angle and may not feel at home in the more standard gag format. Where once the difference may have emanated from a desire not to confront, "to be nice," now new subtleties and variations of what can be humorous are being discovered. As Alice Harvey said to Harold Ross, women cartoonists may be less inter-

ested in getting a laugh, and more interested in "being true." True to their own visions, true to life. This is the ultimate goal of a successful and classic cartoon, as David Remnick expressed, whether it is created by a man or a woman.

Flowing through this line of women cartoonists is a common thread. Like their male counterparts, all have or had a desire to express themselves. On either end of the creative process, these artists had choices to make—what to draw and what will reach others. The first half of that is influenced by the environments that the artists grew up in and where they live; the second half is dependent on how the world receives the artists' work. In the 1920s and again in the 1970s, these two halves were perhaps more in concert with each other for women than at other times, and thus their ability to create and be humorous was more fluid and easier. And the editors at *The New Yorker*, during those two periods in particular, had an openness to what was possible for any given artist. When all these forces work well together, great cartoons can happen. Creating humor requires a sense of freedom, as with any art form—freedom to express oneself through intellect and emotion. *The New Yorker* has always sought to create such an environment to promote talent and artistry. For most of its eighty years, it succeeded. That has been the beauty of the magazine, as most of its artists would agree. Changes in the magazine's staff, plus societal attitudes toward women, made for periods that were less than perfect for female cartoonists. Backlashes may still come and go. But it appears that female cartoonists are able to be freer in their thinking than ever before. Restrictions on their creativity from within themselves—often imposed early from social forces to conform to prevailing modes of humor and expression or a nagging tendency not to want to confront—are fewer. And restrictions from without—the fading stereotype that women aren't funny, often promoted because women are humorous in a different way or even a threatening way—are fewer. With those barriers softening, women can now create wonderfully funny, insightful, poignant cartoons about the world around them in their own *human* voice.

Humorists and literary scholars often dismiss analysis of the genre of cartooning and humor, and this has contributed to the lack of discussion. E. B. White said, "Humor can be dissected, as a frog can, but the thing dies in the process."[1] Humor is considered so subjective as to be virtually impossible (and deadly) to pick apart. And it has always been viewed as a second-class citizen, as lacking in serious artistry. White goes on:

> The world likes humor, but treats it patronizingly. It decorates its serious artists with laurel, and its wags with Brussels sprouts. It feels that if a thing is funny it can be presumed to be something less than great, because if it were truly great it would be wholly serious.[2]

Consequently, humor has lagged behind other genres in the gender dialogue and has instead centered on, until recently, the existence or lack thereof of a sense of humor in women. Critiques of modes of expression should be based on the merits of the artwork, not on the race or gender of the artist. But critics should observe how the breaking down of barriers has contributed to promote more freedom of expression from a wider cast of characters.[3]

While at times cartoonists may confront our world, they, to some degree, are also mirrors of society. Their work reflects the times in which they live, in subject matter and in style of drawing. The women cartoonists of *The New Yorker* drew what they knew, drew what they experienced. The mirror they have given us in their splendid work and in their lives reflects a story of women's struggle for freedom of expression. And laughter. ◆

NOTES

INTRODUCTION

1. Dorothy Parker, foreword to *Most of S. J. Perelman* (New York: Simon & Schuster, 1958).

CHAPTER 1: THE EARLY INNOVATORS

1. Nancy Walker, *A Very Serious Thing: Women's Humor and American Culture* (Minneapolis: University of Minnesota Press, 1988), p. 73.

2. Trina Robbins, *The Great Women Cartoonists* (New York: Watson-Guptill Publications, 2001), pp. 21, 24, 25.

3. Thomas Kunkle, *Genius in Disguise* (New York: Random House, 1995), p. 163.

4. *The New Yorker* Records, Manuscripts and Archives Division, New York Public Library, Astor, Lenox, and Tilden Foundations, Box 58.

5. Kunkle, *Genius in Disguise*, p. 110.

6. Judith Yaross Lee, *Defining "New Yorker" Humor* (Jackson: University Press of Mississippi), p. 179.

7. *New York Times*, December, 5, 1932, p. 14.

8. Dale Kramer, *Ross and "The New Yorker"* (Garden City, NY: Doubleday, 1951), p. 73.

9. Lee Lorenz, *The Art of "The New Yorker," 1925–1995* (New York: Knopf, 1995), p. 49.

10. Kramer, *Ross and "The New Yorker,"* p. 132.

11. Theo Jean Ahrends, "How Shy Girl Became Famous," *Peoria Journal-Star.* From the collection of the Mendota Museum and Historical Society, date unavailable.

12. Ibid.

13. Joseph Mitchell, *My Ears Are Bent* (New York: Knopf), p. 49.

14. Ibid., p. 266.

15. Ahrends, "How Shy Girl Became Famous."

16. Jean C. Lee, "Helena Elena Hokinson," in *Helen Hokinson Polite Society* (Peoria, IL: Lakeview Museum of Arts and Sciences, 1985), p. 8.

17. W. G. Rogers, *Mightier Than the Sword* (New York: Harcourt, Brace & World, 1969), p. 250.

18. Kramer, *Ross and "The New Yorker,"* p. 135.

19. Ibid., p. 80.

20. Ibid.

21. Mitchell, *My Ears Are Bent*, p. 266.

22. *The New Yorker* Records.

23. Edward T. James, ed., *Notable American Women, 1607–1950* (Cambridge: Belknap Press of Harvard University Press, 1971), p. 202.

24. Kramer, *Ross and "The New Yorker,"* p.175.

25. Lee, *Defining "New Yorker" Humor*, p. 182.

26. Ibid., p. 165.

27. ". . . Now!" cartoon by Helen Hokinson, *The New Yorker*, August 22, 1925.

28. "This is 'N'amiez que moi,' Madame—'Don't love nobody but me.'" cartoon by Helen Hokinson, *The New Yorker*, November 7, 1925.

29. Janet Aley to author, 2003.

30. Ibid.

31. Ibid.

32. Ben Yagoda, *About Town* (New York: Scribner, 2000), pp. 60–61.

33. *The New Yorker* Records, Box 932.

34. Yagoda, *About Town*, p. 58.

35. Janet Aley to author, 2003.

36. *The New Yorker* Records, Box 935.

37. Janet Aley to author, 2003.

38. *The New Yorker* Records, Box 935.

39. "Peggy Bacon's American Humor," *New York Times*, March 24, 1929, sec X, p. 13.

40. *The New Yorker* Records, Box 245.

41. Ibid., Box 221.

42. Elisabeth Luther Cary, "Caricature: Daumier, Lautrec—and Peggy Bacon," *New York Times*, March 3, 1935, sec. X, p. 7.

43. *New York Times*, December 27, 1970, Art sec., p. 25.

44. Clipping from personal papers of Nancy Fay, property of Stephen Fay. No date or publication information available.

45. Yagoda, *About Town*, p. 69.

46. Kunkle, *Genius in Disguise*, pp. 170, 171.

47. *National Cartoonists Society Album* (New York: National Cartoonists Society, 1965), p. 150.

48. "Oh, men are alright, I guess—if you have patience." cartoon by Barbara Shermund, *The New Yorker*, February 12, 1927.

49. *The New Yorker* Records, Box 939.

50. Ibid., Box 936.

51. Ibid.

52. Clipping from personal papers of Barbara Shermund, Property of Art Research Associates, Allenhurst, NJ.

53. Ibid.

54. Lee, *Defining "New Yorker" Humor*, p. 199.

55. "He's not abnormal—he's just versatile." cartoon by Barbara Shermund, *The New Yorker*, July 21, 1928.

56. "You know, I don't care for women. I guess I'm a man's woman." cartoon by Barbara Shermund, *The New Yorker*, March 31, 1928.

57. "A very brainy girl, that." "Hm—But she's not a bad sort, really." cartoon by Barbara Shermund, *The New Yorker*, June 5, 1926.

58. "Oh, I beg pardon—I'm just looking for my husband." cartoon by Barbara Shermund, *The New Yorker*, November 8, 1930.

59. "Look what I found—isn't she sweet?" cartoon by Barbara Shermund, *The New Yorker*, April 5, 1930.

60. "She's an exceptional women—thinks like a man." cartoon by Barbara Shermund, *The New Yorker*, September 22, 1928.

61. "It's funny, the minute I put a few beads on I'm a different person." cartoon by Barbara Shermund, *The New Yorker*, July 12, 1930.

62. "I want some face powder to match my stockings." cartoon by Barbara Shermund, *The New Yorker*, May 14, 1927.

63. "Dearie! You're not washing your face!" cartoon by Barbara Shermund, *The New Yorker*, April 4, 1927.

64. "She's got married and she's awfully blue about it." cartoon by Barbara Shermund, *The New Yorker*, December 12, 1931.

65. "What! Not married yet?" "Don't tell me you're *still* married!" cartoon by Barbara Shermund, *The New Yorker*, September 29, 1928.

66. "Poor mama! She's so thrilled about my wedding." cartoon by Barbara Shermund, *The New Yorker*, June 23, 1928.

67. "And does Eloyse still sing?" "Oh, no—she's married now." cartoon by Barbara Shermund, *The New Yorker*, June 16, 1928.

68. "And why didn't you marry him?" "Oh, my dear, he crossed his T's so brutally." cartoon by Barbara Shermund, *The New Yorker*, May 12, 1928.

69. "Yeah. I guess the best thing to do is to just get married and forget about love." cartoon by Barbara Shermund, *The New Yorker*, May 26, 1928.

70. Eldon Dedini to author, 2004.

71. Cheryl Ann Saunders, "The Art and Life of Mary Petty: Cartoonist and Illustrator," Department of Museology, Graduate School of Syracuse University, August 1983, pp. 8, 9.

72. Ibid., p. 8.

73. Alan Dunn and Mary Petty Papers, Special Collections Research Center, Syracuse University Library.

74. Saunders, "The Art and Life of Mary Petty: Cartoonist and Illustrator," pp. 8, 9.

75. Ibid., p. 6.

76. Ibid., p. 7.

77. Frank Modell to author, 2004.

78. Alan Dunn and Mary Petty Papers.

79. Saunders, "The Life and Art of Mary Petty: Cartoonist and Illustrator," p. 33.

80. "The trouble is, Madam, most women pay so little attention to nail health." cartoon by Mary Petty, *The New Yorker*, March 31, 1928.

81. Lorenz, *The Art of "The New Yorker,"* p. 44.

82. Yagoda, *About Town*, p. 110.

83. Saunders. "The Life and Art of Mary Petty: Cartoonist and Illustrator," p. 20.

84. Ibid.

85. *New York Times*, March 23, 1962, p. 37.

86. Saunders. "The Life and Art of Mary Petty: Cartoonist and Illustrator," p. 18.

87. Ibid., p. 32.

88. Yagoda, *About Town*, p. 98.

CHAPTER TWO: BUMPS IN THE ROAD

1. Robert Van Gelder, *New York Times*, August 14, 1934, p. 14.

2. R. L. Duffus, *New York Times Book Review*, August 19, 1934.

3. Gail Collins, *America's Women* (New York: HarperCollins, 2003), p. 328.

4. James Reid Parker, "Helen E. Hokinson," in *The Hokinson Festival*, by Helen Hokinson (New York: E. P. Dutton, 1956), unpaginated.

5. *Helen Hokinson: Polite Society* (Peoria, IL: Lakeview Museum of Arts and Sciences, 1985), p. 8.

6. Parker, "Helen E. Hokinson."

7. *Meet the Artists* (San Francisco: M. H. De Young Memorial Museum, 1943), p. 93.

8. Chuck Thorndike, *The Business of Cartooning* (New York: House of Little Books, 1939), p. 34.

9. *The New Yorker* Records, Manuscript and Archives Division, New York Public Library, Astor, Tilden, Lenox Foundations, Box 280.

10. Ibid., Box 258.

11. Ibid., Box 301.

12. Ibid.

13. Linda Martin and Kerry Seagrave, *Women in Comedy* (Secaucus, NJ: Citadel Press, 1986), p. 107.

14. Eldon Dedini to author, 2004.

15. Amy Janello and Bennon Jones, *The American Magazine* (New York: Harry Abrams, 1991), p. 74.

16. *The New Yorker* Records, Box 936.

17. Dale Kramer, *Ross and "The New Yorker"* (Garden City, NY: Doubleday, 1951), p. 219.

18. *The New Yorker* Records, Box 937.

19. Ibid., Box 934.

20. Ibid., Box 54.

21. Ibid.

22. Ibid.

23. Ibid.

24. Ibid.

25. Kramer, *Ross and "The New Yorker,"* p. 242.

26. Thomas Kunkle, *Genius in Disguise* (New York: Random House, 1995), pp. 242, 243.

CHAPTER THREE: DECADE OF DEPARTURES

1. Thomas Kunkle, *Genius in Disguise* (New York: Random House, 1995), p. 349.

2. James M. Geraghty Papers, Manuscripts and Archives Division, New York Public Library, Astor, Lenox, and Tilden Foundations, unpublished memoirs, pp. 6, 88.

3. Ibid., p. 29.

4. Brendan Gill, *Here at "The New Yorker"* (New York: Random House, 1975), p. 317.

5. Geraghty Papers, unpublished memoirs, pp. 13, 14, 15.

6. Trina Robbins, *The Great Women Cartoonists* (San Francisco: Chronicle Books, 1999), pp. 58, 65.

7. "But what will you do with it on weekends?" cartoon by Roberta McDonald, *The New Yorker*, August 14, 1942.

8. *Waterloo Sunday Courier*, Waterloo, Iowa, November 26, 1944.

9. *The New Yorker* Records, Box 54.

10. Kunkle, *Genius in Disguise*, p. 330.

11. Geraghty Papers, unpublished memoirs, p. 97.

12. Kunkle, *Genius in Disguise*, p. 118.

13. *The New Yorker* Records, Box 346.

14. Ibid.

15. Letter from Shermund to Dedini, undated.

16. *The New Yorker* Records, Box 939.

17. Letter from Shermund to Dedini, 1961.

18. Dedini suspected Shermund may have had a falling out. Dedini conversation with author, 2004.

19. R.C. Harvey, http://www.RCHarvey.com.

20. *The New Yorker* Records, Box 51.

21. Ibid.

22. Ibid.

23. Ibid.

24. Ibid., Box 51.

25. Ibid.

26. Ibid.

27. Ibid.

28. Geraghty Papers, unpublished memoirs, p. 84.

29. *The New Yorker* Records, Box 51.

30. Geraghty Papers, unpublished memoirs, p. 21.

31. "Her 'Girls' Upheld by Helen Hokinson," *New York Times*, February 3, 1949, p. 28.

CHAPTER 4: ABSENCE

1. Ben Yagoda, *About Town* (New York: Scribner, 2000), p. 257.

2. Mary F. Corey, *The World through a Monocle* (Cambridge, MA: Harvard University Press, 1999), p. 37.

3. Yagoda, *About Town*, p. 276.

4. Doris Matthews to author, 2004.

5. Ibid.

6. Ibid.

7. Yagoda, *About Town*, p. 311.

8. Alan Dunn and Mary Petty Papers, Special Collections Research Center, Syracuse University Library.

9. William A. McIntyre, "War of the Sexes in Cartoonland," *New York Times Magazine,* September 1, 1957, pp. 18, 44.

10. Alan Dunn and Mary Petty Papers.

11. Ibid.

12. Cheryl Ann Saunders, "The Life and Art of Mary Petty: Cartoonist and Illustrator," Department of Museology, Graduate School of Syracuse University, August 1983, p. 18.

13. Ibid, p. 35.

14. *The New Yorker* Records, Manuscripts and Archives Division, New York Public Library, Astor, Lenox, and Tilden Foundations, Box 1331.

15. Alan Dunn and Mary Petty Papers.

16. *The New Yorker* Records, Box 1331.

17. Saunders, "The Life and Art of Mary Petty: Cartoonist and Illustrator," p. 42.

18. Yagoda, *About Town*, p. 282.

19. Ibid., p. 271.

20. Lee Lorenz, *The Art of "The New Yorker," 1925-1995* (New York: Knopf, 1995), p. 84.

21. James M. Geraghty Papers, Manuscript and Archives Division, New York Public Library, Astor, Lenox, and Tilden Foundations, unpublished memoirs, p. 23.

CHAPTER FIVE: NEW VOICES

1. *The New Yorker* Records, Manuscripts and Archives Division, New York Public Library, Astor, Lenox, and Tilden Foundations, Box 6.

2. Lee Lorenz to author, 2004.

3. Ibid.

4. Nurit Karlin to author, 2004.

5. Ibid.

6. Ibid.

7. Ibid.

8. Ibid.

9. Ibid.

10. Ibid.

11. Ben Yagoda, *About Town* (New York: Scribner, 2000), p. 367.

12. Roz Chast to author, 2004.

13. Ibid.

14. *Newsday,* July 27, 1986.

15. *New York Times Magazine,* November 27, 1988.

16. Roz Chast to author, 2004.

17. Ibid.

18. Lee Lorenz, *The Art of "The New Yorker," 1925-1995* (New York: Knopf, 1995), p. 131.

19. Roz Chast to author, 2004.

20. Ibid.

21. *New York Times Magazine,* November 27, 1988.

22. Lee Lorenz to author, 2004.

23. "Who ordered the special prosecutor?" cartoon by Liza Donnelly, *The New Yorker,* March 12, 1997.

24. "Daddy, can I stop being worried now?" cartoon by Liza Donnelly, *The New Yorker,* March 4, 2002.

25. "I had a headache, but he went away." cartoon by Liza Donnelly, *The New Yorker,* March 24, 1997.

CHAPTER SIX: THE MORE THE MERRIER

1. *New York Times,* November, 9, 1987.

2. Lee Lorenz to author, 2004.

3. Ann McCarthy to author, 2004.

4. "Pop-Up Toaster" cartoon by Ann McCarthy, *The New Yorker,* November 27, 1989.

5. "Throw Pillows" cartoon by Ann McCarthy, *The New Yorker,* December 4, 1989.

6. Ann McCarthy to author, 2004.

7. Victoria Roberts to author, 2004.

8. Ibid.

9. Ibid.

10. Huguette Martel to author, 2004.

11. Ibid.

12. Letter from Stephanie Skalisky to author, 2005.

13. Ibid.

14. Ibid.

15. *New York Times,* July 1, 1992, p. 69.

16. Ibid.

17. Ibid.

18. Roz Chast to author, 2004.

19. Lee Lorenz, *The Art of "The New Yorker," 1925-1995* (New York: Knopf, 1995), p. 173.

20. Roz Chast to author, 2004.

21. Barbara Smaller to author, 2004.

22. Ibid.

23. Ibid.

24. "Richard and I are planning to take some time off just to enjoy our purchases." cartoon by Barbara Smaller, *The New Yorker*, October 4, 1999.

25. "His first words were, 'Been there, done that'." cartoon by Barbara Smaller, *The New Yorker*, July 28, 1997.

26. "Your attitude is sucking all the fulfillment out of motherhood." cartoon by Barbara Smaller, *The New Yorker*, July 31, 2000.

27. "So now you're going to tell me what friends I can have?" cartoon by Barbara Smaller, *The New Yorker*, April 8, 2002.

28. "If it says to add water, and I'm the one who adds it, I'm cooking." cartoon by Barbara Smaller, *The New Yorker*, July 30, 2001.

29. Linda Martin and Kerry Seagrave, *Women in Comedy* (Secaucus, NJ: Citadel Press, 1986), pp. 313–14.

30. Barbara Smaller to author, 2004.

31. Ibid.

CHAPTER SEVEN: THE FUTURE

1. Bob Mankoff to author, January 2005.

2. Ibid.

3. *Register Star*, November 9, 1997.

4. Jon B. Cooke "M. K. Brown's Romance: The Artist on Cooking Up Comic Strips for National Lampoon," *Comic Book Artist* 24 (April 2003): 94.

5. Ibid., p. 94.

6. Ibid., p. 97.

7. Marisa Marchetto to author, 2004.

8. Ibid.

9. Bob Mankoff to author, 2005.

10. Benita Epstein to author, 2005.

11. Donna Barstow to author, 2004.

12. Carolita Johnson to author, 2004.

13. Kim Warp to author, 2004.

14. Kim Warp e-mail to author, 2005.

15. Emily Richards to author, 2004.

16. Bob Mankoff to author, 2005.

17. Ibid.

18. David Remnick e-mail to author, 2005.

19. Ibid.

AFTERWORD

1. E. B. White and Katharine S. White, eds., *A Subtreasury of American Humor* (New York: Coward-McCann, 1941), p. xii.

2. Ibid., p. xviii.

3. Nancy A. Walker, *A Very Serious Thing: Women's Humor and American Culture* (Minneapolis: University of Minnesota Press, 1988), p. 82. Walker writes: "Intellectual freedom, independence and the free play of a sense of humor are closely interdependent. The creation and perception of humor are above all the activities of an intellect that can perceive irony and incongruity, and a consciousness that is sufficiently detached from self-effacement to be able to play. The humorous vision requires the ability to hold two contradictory realities in suspension simultaneously—to perform a mental balancing act that superimposes a comic version of life on observable 'facts' The intuition of illogic requires a prior perception of accepted logic, and those who deny woman the sense of humor thus have begun by denying her the capacity for logical thought."

BIBLIOGRAPHY

Acocella, Marisa. *Just Who the Hell Is She, Anyway?* New York: Harmony Books, 1994.

Barreca, Regina. *Last Laughs.* New York: Gordon and Breach, 1988.

———, ed. *The Penguin Book of Women's Humor.* New York: Penguin Books, 1996.

———. *They Used to Call Me Snow White . . . but I Drifted.* New York: Viking, 1991.

———, ed. *Women and Comedy.* Philadelphia: Gordon and Breach, 1992.

Bruere, Martha Bensley, and Mary Ritter Beard. *Laughing Their Way.* New York: Macmillan, 1934.

Chast, Roz. *The Party after You Left.* New York: Bloomsbury, 2004.

Collins, Gail. *America's Women.* New York: William Morrow, 2003.

Complete Book of Covers from "The New Yorker," 1925–1989. New York: Knopf, 1989.

Corey, Mary F. *The World through a Monocle.* Cambridge, MA: Harvard University Press, 1999.

Davis, Linda H. *Onward and Upward: A Biography of Katharine S. White.* New York: Harper & Row, 1987.

Douglas, George H. *The Smart Magazines.* Hamden, CT: Archon Books, 1991.

Dunn, Alan. *Who's Paying for This Cab?* New York: Simon & Schuster, 1945.

Esquire Cartoon Album. New York: Esquire, Inc., distributed by Doubleday, 1957.

Faludi, Susan. *Backlash.* New York: Crown Publishers, 1991.

Fass, Paula S. *The Damned and the Beautiful: American Youth in the 1920s.* New York: Oxford University Press, 1977.

Finney, Gail, ed. *Look Who's Laughing.* Langhorne, PA: Gordon and Breach, 1994.

Fraser, Kennedy. *Ornament and Silence: Essays on Women's Lives.* New York: Knopf, 1996.

Gaines, James R. *Wit's End: Days and Nights of the Algonquin Round Table.* New York: Harvest/Harcourt Brace Jovanovich, 1977.

Gill, Brendan. *Here at "The New Yorker."* New York: Random House, 1975.

Gingrich, Arnold. *Nothing but People.* New York: Crown Publishers, 1971.

Grant, Jane. *Ross, "The New Yorker" and Me.* New York: Reynal and Company, 1968.

Gray, Frances. *Women and Laughter.* Charlottesville: University Press of Virginia, 1994.

Heilbrun, Carolyn C. *Writing a Woman's Life.* New York: Ballantine Books, 1988.

Helen Hokinson: Polite Society. Peoria, IL: Lakeview Museum of Arts and Sciences, 1985.

Hokinson, Helen. *The Hokinson Festival.* New York: E. P. Dutton & Company, 1956.

———. *The Ladies, God Bless 'em!* New York: E. P. Dutton & Company, 1950.

———. *So You're Going to Buy a Book!* New York: Minton, Balch & Co., 1931.

Horowitz, Susan. *Queens of Comedy.* Amsterdam, Netherlands: Gordon and Breach Publishers, 1997.

Janello, Amy, and Brennon Jones. *The American Magazine.* New York: Harry N. Abrams, 1991.

Karlin, Nurit. *No Comment*. New York: Charles Scribner's Sons, 1978.

Kaufman, Gloria, and Mary Kay Blakely. *Pulling Our Own Strings*. Bloomington: Indiana University Press, 1980.

Kesterson. David B., ed. *Studies in American Humor: Vol. 3, Number 1.* San Marcos, TX: Department of English, Southwest Texas State University, Spring 1984.

Kramer, Dale. *Ross and "The New Yorker."* Garden City, NY: Doubleday, 1951.

Kunkle, Thomas. *Genius in Disguise*. New York: Random House, 1995.

Lee, Judith Yaross. *Defining "New Yorker" Humor.* Jackson: University Press of Mississippi, 2000.

Lorenz, Lee. *The Art of "The New Yorker," 1925–1995.* New York: Knopf, 1995.

Mankiller, Wilma, et al., eds. *Reader's Companion to U.S. Women's History.* New York: Houghton Mifflin, 1998.

Mankoff, Robert, ed. *Complete Cartoons of "The New Yorker."* New York: Black Dog & Leventhal Publishers, 2004.

Martin, Linda, and Kerry Segrave. *Women in Comedy.* Secaucus, NJ: Citadel Press, 1986.

Meet the Artist. San Francisco: M. H. De Young Memorial Museum, 1943.

Pearson, Judy Cornelia. *Gender and Communication.* Dubuque, IA: Wm. C. Brown Publishers, 1985.

Petty, Mary. *This Petty Place*. New York: Knopf, 1945.

Robbins, Trina. *From Girls to Grrrlz: A History of Women's Comics from Teens to Zines.* San Francisco: Chronicle Books, 1999.

———. *The Great Women Cartoonists*. New York: Watson-Guptill Publications, 2001.

Roberts, Victoria. *Biographees*. London: Chatto & Windus, Ltd., 1986.

———. *My Day*. London: Chatto & Windus–Hogarth Press, 1984.

Rogers, W. G. *Mightier Than the Sword*. New York: Harcourt, Brace & World, 1969.

Sheppard, Alice. *Cartooning for Suffrage*. Albuquerque: University of New Mexico Press, 1994.

Sochen, June, ed. *Women's Comic Vision*. Detroit: Wayne State University Press, 1991.

Thorndike, Chuck. *The Business of Cartooning*. New York: House of Little Books, 1939.

Walker, Nancy A. *A Very Serious Thing: Women's Humor and American Culture.* Minneapolis: University of Minnesota Press, 1988.

Walker, Nancy, and Zita Dresner, eds. *Redressing the Balance: American Women's Literary Humor from Colonial Times to the 1980s.* Jackson: University Press of Mississippi, 1988.

White, E. B., and Katharine S. White, eds. *A Subtreasury of American Humor.* New York: Coward-McCann, 1941.

Yagoda, Ben. *About Town*. New York: Scribner, 2000.

INDEX

Page numbers in italic indicate photographs.